ART OF THE NORTHWEST COAST INDIANS

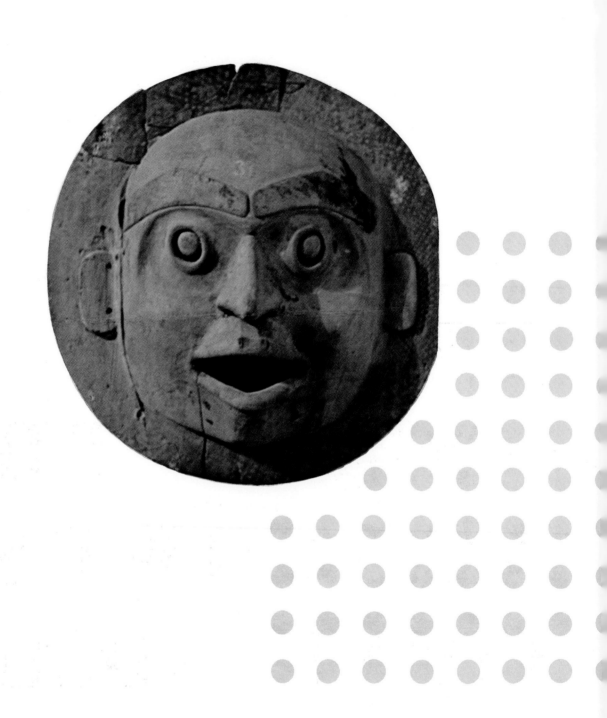

ART OF THE NORTHWEST COAST INDIANS

ROBERT BRUCE INVERARITY

UNIVERSITY OF CALIFORNIA PRESS

BERKELEY, LOS ANGELES, LONDON 1971

UNIVERSITY OF CALIFORNIA PRESS
BERKELEY AND LOS ANGELES
CALIFORNIA

UNIVERSITY OF CALIFORNIA PRESS, LIMITED
LONDON, ENGLAND

COPYRIGHT, 1950
BY THE REGENTS OF THE UNIVERSITY OF CALIFORNIA

FOURTH PRINTING, 1971
ISBN: 0-520-00594-5 CLOTH
0-520-00595-3 PAPER

PRINTED IN THE UNITED STATES OF AMERICA

FOREWORD

After twenty years of research among the tribes of the Northwest Coast, supplemented by the study of collections in museums and art galleries, as well as of the relatively meager literature on the subject, Robert Bruce Inverarity is adequately equipped to give expression to the extensive knowledge he acquired during this long period. It is true that many works on the Indians of the Northwest Coast have appeared, but with few exceptions the arts of the Indian inhabitants of this area have been treated only incidentally, and none have hitherto given attention to the many phases of their aesthetic product.

In a way the art of the Indians under discussion compares favorably with that of the aborigines of the Western Hemisphere. To comprehend

the extent and the underlying concepts of this remarkable art, our author has not been content with the study of art objects themselves, but with the social and religious beliefs that inspired them—in this way we have both an anthropological and an aesthetic approach, resulting in a work that will prove of interest to the professional researcher and to the students of ethnology and primitive art alike.

It is scarcely necessary to remark that for a work of this kind, as with any work that treats so comprehensively of a subject, adequate illustration is necessary for its proper elucidation—and this the author has done in full measure.

The present writer does not hesitate to commend the book to professionals and to the laymen interested in ethnology or art, with the full assurance that it will prove to be replete with information on those topics.

F. W. HODGE

Southwest Museum, Los Angeles, California

PREFACE

During the last few years there has been a growing public interest in the arts of "primitive" peoples. The great exhibition of American Indian Art at the Golden Gate International Exposition in 1939 and later the two fine shows at the Museum of Modern Art—Indian Art of the United States and Art of the South Seas—brought before the public art forms with which it was unfamiliar. These three exhibitions did much to bring to public attention the work which many museums have been doing quietly for a period of years, and at last there are many persons in this country who are vitally interested in the arts of the Eskimo, Filipino, Indonesian, Polynesian, Melanesian, Bushmen, Sudanese, and the highly developed aboriginal cultures of Middle and South America.

Maori wood carving, Ashanti gold weights, Mayan sculpture, Peruvian weaving, and Eskimo masks are now becoming known and appreciated as great art, and many individuals, who are neither anthropologists nor artists, are collecting objects which once were found only in museums and in dusty cellars. All this activity is a healthy sign of a widening art horizon.

It is good to see that a part of this interest is being expended on the arts of this continent, and that the American Indian is becoming known for things other than wigwams, arrowheads, and feathered headdresses. The jewelry of the Navaho, the Pueblo pottery, the beadwork of the Plains people, the pre-Columbian art of Middle and South America are all valued. But the art of the Northwest Coast tribes is still relatively unknown, and it is with these people and their works that this book is concerned. The Indians of the Northwest Coast of America had a vitality and an initiative which led to many independent developments that are culturally interesting and aesthetically exciting. They developed a social structure almost as complex as our own, and out of this grew an art which ranged from complete realism to abstraction and fantasy. As woodworkers they are not equaled by any other group on this continent; as sculptors, they take their place with the great artists of the world. Theirs is the only North American culture which rose to such a high level and yet, apparently, was independent of the Middle American cultures.

The Northwest Coast of North America, beginning near the Columbia River in Oregon and extending north more than a thousand miles through western Canada and into Alaska, and from the seacoast to the mountains, embraces an area of islands, beaches, inlets, and mountains in which lived several Indian tribes—Tlingit, Haida, Kwakiutl, Tsimshian, Nootka, Salish—which had essentially one basic culture. These Indians spent most of their lives on or near the sea, for it was the sea which gave them their food and gave it to them in an abundance that

permitted a great deal of leisure. The great rain forests, particularly the spruce and the cedar, provided materials for houses, canoes, implements, and clothing.

During the long, cold winter months village life flourished; the time was spent in ceremonies and festivals, in entertaining and outdoing one another in the lavishness of their feasts. The richness of the country and the ample leisure time which resulted made possible the development of a complex culture and its expression in works of art. It is not yet possible to date the beginnings of this culture or its earliest works of art, but certainly the art was developed before the coming of the white man in the eighteenth century. Pieces collected by Captain Cook in 1778 can be seen in the British Museum today. It is interesting to note that the general configuration of the art form—the style, the materials, the concepts, and the symbols—has changed very little since then. When the white man came in numbers—first the fur traders, then the settlers—the Indian and his culture were doomed. A few thousand people still live in reservations and in the towns, but it can be said that the creative activity of the Northwest Coast tribes ended with the turn of the last century. Today the Indian is still a fisherman; he lives among the white men and fishes for the canneries in his gasoline launch. The tall totem poles, leaning rakishly skyward in many deserted villages, and the objects in museums and private collections are all that remain of a once vital culture and a great art.

The megalomanic desire for material riches beyond the individual's need had as great a role in Northwest Coast Indian society as it sometimes does in our own. Because of the profusion of natural resources which were easily appropriated for man's use, it was possible to create great collections of material goods—tremendous sea-going canoes, great wooden houses with carved totem poles and house posts, carved and painted wooden chests, rattles, masks, and many other rich and highly decorated ceremonial objects.

Here were people whose lives, whose religion, whose art impulses were so intermingled that men, animals, gods, fact and fancy were all parts of one great weaving. The Indian's art was interwoven with the religious, social, and material sides of his life like the warp and weft of a tapestry; remove one or the other and the structure falls apart. Where one thing ends and another begins is not discernible. His aesthetic expressions were a direct outgrowth of all other factors in his life. There was a social system, there were religious beliefs, and there were flexible materials to work with. The materials were turned into artistic creations which met the needs of the socio-religious factor, and the socio-religious factor met the need for aesthetic expression.

The age of the culture and the length of the creative period are debatable until much more archaeological work is done in the area. But for the purposes of this book, which is but a survey and an appraisal of a little-known field of art, such points are unimportant and need not be considered at length.

Many anthropologists have written about the Northwest Coast Indians, but their papers are not readily available to the general public. With the growing appreciation of primitive art today, a new field is developing and there is a need for people with training in both art and anthropology, specialists who can view an object both as a scientific specimen and as a work of art. This book is an attempt to do something of the sort—to approach the material as an art but to do so with an adequate understanding of the people and the culture that produced the art.

In this book I have gathered illustrations of a large and well-rounded selection of Northwest Coast art, most of which have never before been published. Pieces which have been illustrated before—some of them, many times—have been included when they were sufficiently outstanding or when they were needed to cover the subject adequately, but my object has been to present primarily works which have not previously been reproduced.

The culture of the Northwest Coast was a wood culture and the art was essentially a carver's art. Designs were painted on totem poles, canoes, masks, rattles, figures, dishes; house fronts were decorated in paint and painted screens were made for inside use. It is probable, but impossible to prove at this time, that among these people two-dimensional art developed first and three-dimensional art later.

In the field of two-dimensional art I have included examples of painting, weaving, and appliqué. Bas-reliefs, both with and without painting, are included with the two-dimensional work.

Three-dimensional art is far more common. In this category are objects such as masks, rattles, clubs, dishes, storage boxes, small figures, and totem poles. The totem pole is perhaps the one art form from the Northwest Coast that is well known to the general public. These great pieces of sculpture may still be found on their original sites, but the number is fast dwindling, since they rot away at the base and fall to the ground, and the delicate and subtle carving also rots in a few years' time. I have walked over hundreds of these great poles, flat on the ground, covered with moss, and with the features long since obliterated by the moist climate of the region. It is a shame that so little was done to preserve this great native art in its own environment. Only a few totem poles have been reproduced in this volume because they have been dealt with at some length in other works, and because the purpose of this general survey is to show the range and the richness of the entire art.

Basketry, although highly developed on the Northwest Coast, was less important than painting and sculpture. It has not been included in this book since it is too complex a subject to be handled adequately in a general survey. Textiles are omitted for the same reason, although a few of them are illustrated because their designs are closely related to other designs in the book.

With the illustrations is a short text, intended as a brief introduction

to the art and divided in two parts. First is a section on the people them-selves, their social life, material culture, and religion; this arrangement has been followed because the art cannot be adequately understood and appreciated without some understanding of its origins. Since the culture of the entire area is, in general, homogeneous, I have not tried to give more than a general idea of the variations in the caste system among the Haida, the Kwakiutl, and other tribes.

The second part of the text is a short discussion of primitive art in general and a more detailed account of some of the principal features of Northwest Coast art. Here are described a good many of the symbols customarily used; the reader will soon learn to recognize them wherever he sees them.

I have included a reference list of books dealing with art, primitive art, and anthropology, together with definitive material on the North-west Coast which should be interesting and invaluable to anyone who wishes to pursue the subject further.

This book was written twenty years ago, and I am pleased that it is being reprinted now. In the main there are few changes I would make— perhaps to remove some of the repetitious writing, update the bibliog-raphy, and indicate that items in personal collections may have changed hands since that time. However this is not feasible, and I merely add this note to make the reader aware that I am also aware of these needs.

<div align="right">Robert Bruce Inverarity</div>

Ridgefield, Connecticut

ACKNOWLEDGMENTS

I wish to make grateful acknowledgment to the many museums in this country and abroad that generously supplied many of the photographs as well as otherwise assisting me in collecting material for this book.

American Museum of Natural History, New York City
Anthropological Museum, University of British Columbia, Vancouver, B.C.
British Museum, London, England
Denver Art Museum, Denver, Colorado
De Young Museum, San Francisco, California
Musée de l'Homme, Paris, France
Museum of The American Indian, Heye Foundation, New York City
Museum of Anthropology, University of California, Berkeley, California
National Museum of Canada, Ottawa, Canada

Oakland Public Museum, Oakland, California
Provincial Museum of Natural History and Anthropology, Victoria, B.C.
Smithsonian Institution, Washington, D.C.
Southwest Museum, Los Angeles, California
Washington State Museum, University of Washington, Seattle, Washington
Vancouver Historical Museum, Public Library, Vancouver, B.C.

I also desire to express my appreciation to those who kindly permitted me to reproduce photographs of objects in their private collections.

Ralph Altman, Los Angeles, California
Walter C. Arensberg, Los Angeles, California
Julius Carlebach, New York City
Max Ernst, Sedona, Arizona
Viola Garfield, Seattle, Washington
Wolfgang Paalen, San Francisco, California
Frank Smith, Vancouver, B.C.

To the following persons who assisted me in various ways I extend my sincere gratitude: Professor George W. Brainerd, H. J. Braunholtz, E. K. Burnett, Dr. G. Clifford Carl, Adrian Digby, Dr. F. H. Douglas, Professor E. W. Gifford, Professor Erna Gunther, Professor John Haley, Audrey Engle Hawthorne, Professor Robert F. Heizer, Dr. George G. Heye, Dr. F. W. Hodge, Isabel King, H. W. Krieger, Professor A. L. Kroeber, Charles Lindstrom, T. P. O. Menzies, Professor Verne Ray, Ruth D. Simpson, Dr. T. D. Stewart, Harry Tschopik, Jr., Professor Glenn Wessels.

I wish particularly to thank Lucie E. N. Dobbie and John B. Goetz of the University of California Press who aided materially in making the book.

CONTENTS

THE PEOPLE

Along the rugged Northwest Coast of North America are the remnants of a highly developed and sophisticated Indian culture unlike that of any other on the continent. Edged by the ocean on one side and by a series of high mountains on the other is a narrow strip of land extending from the Columbia River in Oregon to Yakutat Bay in Alaska. This roughly serrated coastline is pierced by innumerable inlets and fiords at the bases of jagged mountains rising abruptly from the shoreline. Scattered along the coast, and protecting it from the broad sweep of the Pacific, are thousands of islands of all shapes, sizes, and elevations.

The impenetrability of the coastal area caused communication along this narrow strip of land to be principally by sea. Along the shore, and

the inlets, and on the islands the coastal tribes built their villages. The rugged terrain between the shore and the highland of the interior forms a natural barrier which prevented, because of the physical hardships of transportation, the coastal Indians and those of the interior from easy communication. The geographical environment, then, was important in the development and maintenance of a coast culture little influenced by any other.

The coastal Indians comprise three main groups: the northern tribes, Tlingit, Haida, Tsimshian; the central, Kwakiutl, Bella Coola; and the southern, Nootka and Coast Salish. North of the Tlingit is the Eskimo, and on the other side of the eastern mountain barrier live the Déné, one of the Athabascan group. The Salish make up the most southerly group; south of the Salish it is difficult to draw any hard and fast line, for below the Columbia River the intermingling of the minor tribes makes distinction a complex problem.

In physical appearance the coastal Indians are much alike. They are of medium stature in the north, but somewhat less so in the south. Their skin is a pale brown with a slightly yellow cast; the hair is straight and black; the beard, scant; the nose, somewhat flat; and the eyes, a deep, dark brown.

It might very well be assumed that, since the culture of this area is homogeneous, the language would also be common to all tribes. The languages of the various tribes are alike in structure, although there is morphological dissimilarity, but the vocabularies show great differences. Indians of one tribe often resort to the trade language called Chinook Jargon when speaking to Indians of a different tribe. A good many years ago, J. W. Powell classified the languages of this area in five distinct stocks. More recent studies by linguists, such as Edward Sapir, have suggested that these stocks are not distinct but differ fundamentally from one another in vocabulary, grammatical form, morphology, syntax, and phonetics. Slight resemblances in vocabulary and

2

phonetics are very often due to the borrowing of one language from another. Scientific comparative work in linguistics in this area is hampered by the fact that many of the languages have survived among a mere handful of people. Sapir made an interesting comment on the languages of this area when he said that although subsistence among these Indians was relatively easy, and the climate was not too rigorous, yet the languages rivaled those of the Caucasus in phonetic harshness. The Salish, Kwakiutl-Nootka languages are grouped by Sapir in the polysynthetic group called the Algonkin-Wakaston. The Haida and Tlingit are grouped with the tonal languages called by him the Nadene; and Tsimshian is included in a fourth class called the Penutian.

THE COMING OF THE WHITE MAN

The first European voyager along the Pacific Coast of North America was Juan Rodriguez Cabrillo in 1542. The more renowned navigator, Francis Drake, was the next to make a landfall on this coast, taking possession of "Nova Albion" for the Queen of England in 1579. The Northwest Coast, the region of particular interest in this book, lying far to the north of the land first seen by Cabrillo and Drake was first visited in 1741, more than a century after Drake, by the Russian explorers Vitus Behring and Peter Cherikof. The reports of the new land coming from Russian expeditions gave great stimulus to what was to become an important fur trade between the Russians and the natives of the Aleutians.

More than thirty years after the first Russian explorations two Spanish expeditions made explorations along the Northwest Coast. During the interval between the Spanish expeditions and those of the Russians there must have been some degree of association between the aborigines and the white fur traders. In 1774 Juan Pérez in the *Santiago* sailed from San Blas as far north as lat. 51° 50′ and, in August, anchored offshore, probably at Nootka Sound, Vancouver Island, and engaged in

trading with the Indians. The next year, July–August, 1775, Bruno de Heçeta in command of the *Santiago* with Pérez as pilot reached lat. 47° 24′. In August of the same year another Spanish vessel, the *Sonora*, in command of Juan Francisco Bodega y Quadra, reached a latitude of about 58°, near the entrance of Salisbury Sound, Alaska. Bodega went ashore some miles farther south to take on wood and water, as well as to take possession of the land in the name of the King of Spain. In March, 1778, Captain James Cook, on his third voyage, reached the Northwest Coast, where he collected a few sea otter skins, as well as some examples of the arts and crafts of the Northwest Coast Indians. The specimens which Captain Cook collected are now in the British Museum (see pls. 111, 197). It is interesting to note that they do not show any stylistic variations from the main theme of Northwest Coast art. Spanish, French, and other English ships soon followed after Captain Cook, and a brisk trade in sea otter skins and other furs brought Europeans in great numbers to the area.

It has been estimated that 48,500 skins were shipped from the Northwest Coast during the years from 1799 to 1802. Probably the earliest traders had little contact with the Indians, since the trading ships anchored offshore and the natives came out to them in their canoes to barter. This superficial contact, of course, precluded any close study of the arts and crafts of the Indians which would be of value today. However, the continued growth of trade brought about the establishment of permanent trading posts. Thus began the relations between the white man and the Indian which were to have such significant effects on native life and culture.

In 1778 the English established a trading post at Nootka; five years later the Russians established a post at Kodiak Island, and in 1799 they founded Sitka. In 1789 the Spanish captured Nootka from the English and developed an intensive trade along the coast. In 1814 Astoria was founded by the Northwest Company, and by 1835 the Hud-

son's Bay Company had three posts along the Coast. Thus in less than fifty years the white man's influence was spread from the Columbia River to Alaska. The later increase in the number of these trading posts and forts provided the Indians with a permanent source of supply for tools, clothing, and other goods. It was not long before the natives collected around each trading post and, in time, these posts became centers of Indian population.

The accounts of early explorers give some indication of the native life which they observed. Etienne Marchand gives one of the earliest descriptions of the Indians in his *Voyage Autour du Monde, pendant les Années 1790, 1791, et 1792*. From the descriptions in this book it may be assumed that Northwest Coast art was in a flourishing state when the first white man visited the area. Marchand writes of what was obviously a totem pole: "This opening (entrance to a house) is made in the thickness of a large trunk of a tree which rises perpendicularly in the middle of one of the fronts of the habitation, and occupies the whole of the height; it imitates the form of a gaping human mouth, or rather a beast, and it is surmounted by a hooked nose about two feet in length, proportional in point of size, to the monstrous face to which it belongs . . . over the door is the figure of a man carved in the attitude of a child in the womb . . . and above this figure rises a gigantic statue of a man erect, which terminates the sculpture and the decoration of the portal; the head of this statue is dressed with a cap in the form of a sugar loaf, the height of which is almost equal to that of the figure itself. On the parts of the surface which are not occupied by the capital subjects, are interspersed carved figures of frogs, toads, lizards, and other animals . . ." Marchand's description of these figures is probably accurate and is sufficient to prove the existence in 1791 of a sculptor's art which was highly developed and stylistically the same as that reproduced in the present book. Marchand was describing here the Haida houses on North Island, one of the smallest and the most northwesterly

of the Queen Charlotte Islands. In 1930 I found no evidence or remains of such sculpture on this island. Marchand wrote, "that everywhere on the Queen Charlotte Islands, appear traces of an ancient civilization, everything indicates that men with whom they have had the opportunity of being acquainted have belonged to a great people, who were fond of the agreeable arts, and who knew how to multiply the productions of them."

The contact thus established between the white man and the Indian proved injurious to the closely knit culture pattern of the Northwest Coast people. When the white man came, he came for gain, and since the Northwest Coast Indian depended mainly upon the sea for his subsistence there was no hinterland to which he could retire and still successfully carry on his way of life. This situation was unlike that in the American Southwest, among the Navaho tribe particularly. In that area the Navaho retreated before the advance of the white man and was thus enabled to maintain his culture.

It was much easier for a Northwest Coast Indian to trade an easily obtained skin for goods which he needed than for him to make them. The readily available supply of trade goods removed the incentive for native manufacture and contributed to the breakdown of the material culture. On the other hand, the white man's tools gave the Indian artist greater technical facility in working stone or wood and this technical advance led to a sporadic increase in the quantity of art works produced.

The Northwest Coast area once supported a large native population, but with the coming of the white man the aboriginal population rapidly decreased. The ravages of smallpox, first introduced by the Spaniards in 1775, and the high incidence of venereal diseases were contributing factors in the decline. The Haida, at one time numbered in the tens of thousands, are today less than a thousand. It has been estimated that the indigenous population of the area was about 50,000 to 60,000 at the end of the eighteenth century; today it is less than 20,000.

6

Concomitant with the decline in population occurred a breakdown in the social structure of the tribes. As his own social patterns crumbled away, the Indian tried to emulate the white man and to follow the white man's pattern of life. In this attempt the aborigine vacillated between his own culture and that of the white man and that vacillation was his undoing. Today the Indians of this region live on reservations as wards of the government or attempt to maintain a precarious existence as independent citizens. Most of the men are occupied as fishermen or work for the white man. In the summer the women work in the salmon canneries. It is only a matter of time before the culture of the Northwest Coast people will disappear completely.

MATERIAL CULTURE

The villages of the Northwest Coast people were generally built along the curve of a good beach and near a source of fresh water. It was customary, among the northern tribes, to erect a row of wooden houses somewhat back from the seashore. Frequently there would be a single row of houses, occasionally two or three rows with a kind of street between the rows. Tall totem poles stood in front of the houses, their painted surfaces heightened by the dark greenness of the surrounding trees.

The material culture of the Northwest Coast Indians was different from that of any group in North America. They had no pottery, a little chipped stone, no footwear, no agriculture, no domesticated animals

except the dog. Although the tobacco plant was known, the leaf was not smoked. Despite the absence of these indications of cultural level, the abundance of natural resources from the sea and forest enabled these people to feed and clothe themselves and to build with superb craftsmanship huge houses and canoes, to create innumerable implements, and to design a great variety of masks and elaborate regalia for ceremonies.

WOOD CULTURE

The winters on this coast are long, with gray, overcast skies, fog, and abundant rainfall, which nourishes a luxuriant forest growth. The moist climate supports the huge cedar trees which were such an integral part of the material culture of the Indians. The cedar provided wood for the houses, for the totem poles, and for the great sea-going canoes. Indeed, the cedar tree was to these Indians what the bamboo is to the Chinese. Wood from the spruce, pine, cypress, fir, hemlock, yew, maple, and alder was also utilized.

Trees were felled by stone axes and the trunk was then split into planks. The method of splitting used was to force wooden or bone wedges into the end of the grain sometimes while the tree was still standing. I have seen in the Queen Charlotte Islands a cedar tree with a cut across the width of the trunk and about three feet above ground level. The first cut was many inches deep, and a second was made about thirty feet above the first cut. Wedges were then driven into the end of the cut and huge planks split off the side of the living tree.

Wood was used throughout the area for countless objects: houses, totem poles, canoes, and a great variety of shapes and sizes of boxes for the storage of food, blankets, and clothing. Watertight boxes were made for cooking food, and large blocks of wood were carved out for dishes. Most of the interior furnishings of the houses were also made of wood. Mats, tool handles, fish hooks, clubs, fish and animal traps, spoons, rat-

9

tles, masks, bows, and armor were among the many articles made of wood. Aside from securing food through hunting and fishing, the chief occupation of the men was the making of all these wooden articles so essential to daily life.

Tools.—Before the advent of metal, work in wood was accomplished by means of stone and bone tools. The principal tool was the adze. The method of hafting was ingenious. The haft of the large adze was formed from the limb of a tree where it met the trunk at an angle; the blade was bound to the wood at the angle. The small hand adze was made from a piece of wood in which a hole had been cut to permit the fingers to enter and grasp the handle; the blade was bound to the underside. (See plate 57.) The blades of woodworking tools were made from stone, serpentine, shell, bone, jade, or, in later years, metal. A very interesting carving knife made from a beaver's tooth mounted in a wooden handle is in the British Museum. The cuts made by the adze produced a chipped surface which, to some extent, could be controlled in size to add a decorative quality to the surface. When no texture was desired the wood was smoothed by stones and finished with the rough surface of the shark's skin. With these tools and a few others, the Indians carved objects ranging in size from small, delicate wood pieces to giant totem poles.

The introduction of metal tools apparently took place before the arrival of the first European explorers in the last half of the eighteenth century, since iron was found in use among the tribes by the first visitors. Captain Cook, who visited the Nootka in 1778, makes this interesting comment. "Their great dexterity in works of wood, may, in some measure be ascribed to the assistance they receive from iron tools, for, as far as we know, they use no other; at least we saw only one chisel of bone. And though, originally, their tools must have been of different materials, it is not improbable that many of their improvements have been made since they acquired a knowledge of that metal, which now is universally used in their various wooden works."

10

Dwellings.—The houses were generally of two types: simple structures used as fishing camps during summer, and large, permanent buildings coöperatively built. The most common permanent dwelling had a rectangular framework covered with large planks and a gabled or shed roof. The horizontal supports were up to sixty feet in length; the vertical posts, often more than two feet in diameter. The planks used for the four sides of the structure were placed horizontally or vertically along the framework and were secured in place. They were obtained by splitting sections of trees and were about three feet wide and several inches in thickness. An opening was left in the middle of the roof for a smoke hole. Ordinarily the entrance end of the house faced the sea with the doorway placed near the middle, there was usually a rear exit as well.

Houses varied in size and construction among the different tribes. In the northern area they were nearly square and from forty to sixty feet wide; in the southern settlements they were long and narrow; there is a record of one which was five hundred feet by sixty feet with an almost flat roof. Most houses were occupied by several related families. The interior of houses of persons of rank among the Haida had one or two earthen terraces set back from the main floor level. Below the first terrace, in the center of the floor, was the main house fire, which was tended by slaves. At the rear of the house on the upper terrace lived the person of highest rank and his family, in a kind of enclosed cubicle. On the other sides of the house lived the other members of the family in their cubicles. Each house had a name, such as Killer Whale House, Sun House, or Shark House.

Types of Totem poles.—A characteristic feature of the Northwest Coast is the tall cedar column carved and painted with intricate designs and symbols, commonly called the totem pole. There are at least four types of columns which can be distinguished by their erection at designated places for specific purposes.

The tall cedar columns, ten to seventy feet in height, one to three

feet in diameter, erected in front of rows of houses are properly memorial columns. Such memorials to the dead were carved with designs representing animals, heraldic insignia, and prestige of the person which it commemorated. This type of column was common to the Haida and Tsimshian, and it was among these two tribes that it was especially developed. Another type of memorial pole is a pillar three to twelve feet high which served as memorials in or near cemeteries. The carving customarily represented a single human figure or animals and birds. There are, of course, various styles, details, degrees of carving and ornamentation which permit the distinguishing of the columns made by various tribes.

The house frontal pole is similar in height, the diameter somewhat greater than the memorial column. The house frontal poles were erected in front of the house or attached to the fronts, and, among the Haida, round openings were sometimes cut in them for entrance into the house. These poles were carved with the totemic crests of the family of the owner or with figures illustrating traditional family myths.

The short, thick posts placed inside the houses to support the roof beams are called house posts. House posts were common to all the tribes of the area. They measured five to fifteen feet in height and about three feet in diameter. In the houses of the very wealthy carved posts were placed in the middle of the floor, directly behind the fire, and marked the seat of honor. The carving was usually crests of the owner or legends, although practices varied from tribe to tribe.

A fourth type is the mortuary column, one means of disposing of the high ranking dead. These columns were of two kinds: one in which an opening was made large enough to receive a box containing the body of the dead, and another, a type in which the coffin box was placed on top of the column or a totem animal placed at the top of the column and the ashes or body of the dead placed within a hollowed section at the top. (Plates 275, 277 illustrate these mortuary columns.) The making

12

of mortuary columns gradually ceased after European missionaries introduced Christian burial.

The early explorers of the region mention carved pillars used for supporting the roof beams. Alejandro Malaspina described several Tlingit mortuary columns he had seen at Yakutat Bay, in 1792. *Viaje Alrededor del Mundo, 1789–1794* shows a drawing of such a column. Captain George Vancouver in his visit, 1793–1794, also described several mortuary columns. From the descriptions of these and other explorers it seems fairly certain that interior house posts, house frontal poles, and mortuary columns were known throughout the Northwest Coast. The memorial column, however, seems a later development which achieved a wide distribution through the extension of the carver's art, itself brought about by the more plentiful supply of metal tools with the coming of fur traders in the early years of the nineteenth century.

Canoes.—One of the singular accomplishments of the Indians of the Northwest Coast was their canoe. Particular types of canoes were made for different purposes, but two main types can be distinguished. The northern tribes used a canoe with a raised bow and stern, both projected over the water. In the southern area the canoe could be distinguished by the vertically rising stern and the graceful sweep of the bow, which rose upward from the water in much the same way as the bow of a clipper ship. The canoes varied in size from the fourteen-foot sliver used as a one-man racing dugout to the tremendous Haida war canoe, which was more than fifty feet in length and which could carry forty men. The canoes were equipped with long paddles with a cross-bar handle, as well as with sails made of matting or wooden slats. It was not uncommon for these sea-going canoes to carry raiding parties five hundred miles or more from their own villages.

In building a canoe the first requisite was a suitable tree, preferably one near the water's edge. The tree was felled during the winter and, after the log had dried, the general exterior shape was adzed out. The

interior of the canoe was then hollowed out by building fires on the upper side of the log and chipping out the charred wood until the general shape of the canoe was attained. Fine finishing was done with hand adzes, and the maker would place a hand on each side of the thickness of the wood and by moving his hands about accurately judge the thickness and the variations which he wished to remove.

When a canoe had been completed in this manner, it was partly filled with water and, from a near-by fire, hot stones were dropped into the water. As the water became hotter the whole canoe was covered with mats and a steaming process began. Cross pieces just slightly larger than the natural width of the tree were placed between the gunwales and when the wood softened these pieces would be changed for larger ones until the desired width of the canoe was secured. Finishing the canoe entailed sewing the permanent thwarts into place and adding any wooden pieces desired by sewing them in position. When left on the beach, the canoes were partly filled with water and covered with mats so that the bottom would not dry out and split.

Boxes.—A unique practice of the Northwest Coast Indians was an ingenious method of joining wood by sewing. Edges of boxes were sewn together so carefully with sinew or spruce-root fibers that the joint was often not visible. When a root thread was used, the path of the sewing was often gouged out so that no surface indication of the joining was apparent. This method of joining was also used to patch cracks or seams in canoes and on the wooden sails of large canoes.

Food dishes were made by adzing them out of a solid piece of wood, usually alder. For the large vessels long shapes were used and the surface of the dish was elaborately carved with animal forms or the dish itself was carved in the shape of an animal.

Large boxes for the storing of food and materials were made in an unusual manner. A board of sufficient length to form the four sides of the box was first prepared to the desired shape and thickness. On the

inner side of the board, where the corners were to be, a "v" was cut and part of the wood removed, reducing the thickness of the board. The sections intended for the corners were then steamed until the wood could be slowly bent to a right angle. The two ends of the box were then drawn together and the edges sewn or pegged with spruce root. Finally a solid bottom was made with a groove to receive the box edges; this was also sewn or pegged into position. Some boxes were provided with tight fitting covers and others were used without covers. The finished box was then often painted or carved depending upon its use. Boxes of this type were especially made for cooking, the contents were heated by dropping hot stones into the liquid mixture. Larger boxes were made and used as coffins to receive the flexed body of a person of rank.

BASKETS AND TEXTILES

Although this book is not concerned with the textile arts, a brief mention will not be out of place. Carving—wood, bone, horn, slate, and other materials—and painting were the arts of the men in the Northwest Coast; weaving and basketry were the arts of the women. Blankets, nets, and matting from this area are not so well known as the baskets, perhaps because of the flurry of basket collecting which began about forty years ago.

Fishing nets were made from the fiber of nettles; strands of this nettle fiber were twisted on a spindle to form the desired weight of twine for the net. The spun twine was then tied to form a regularly shaped opening, the size being determined by the purpose for which the net was to be used. The spun twine was then tied to form a mesh of regular openings, the size again being determined by the purpose for which the net was to be used.

Mats were made from rushes, reeds, or the inner bark of the cedar. Cedar bark was cut into strips of the desired width and thickness and then woven while moist into a twill or checkerboard pattern. Rushes and

reeds were also made into mats by threading the material with a large wooden needle. Mats were used for bedding, seats, food service, canoe and box covers, rain capes, and coverings.

The baskets of this area present a great variety of weaves, shapes, and colors in a high degree of expertness. They were used for carrying water, for cooking, and for storage. Baskets were made from spruce root and cedar bark and ornamented with geometrical designs accentuated by use of colored fibers, or other materials. Various colors for dye were obtained from mud, mosses, roots, berries, and tree bark.

Woven blankets of cedar bark were made by soaking the bark in salt water and then beating it with a beater made from a whale bone. (See plate 14.) The separated strips were woven on a simple frame; the cedar strips formed the warp and wool from the mountain goat the woof. Animal furs and mountain-goat wool were often used as borders.

Some tribes bred a white dog for the purpose of supplying wool for weaving. The blankets produced from this wool were woven in a variety of simple colors and patterns, although they were by no means so complex in design or technique as the famed Chilkat blanket.

The glory of the textile art of this area is a ceremonial blanket made by the Chilkat, a subdivision of the Tlingit tribe. The Chilkat blanket is a beautiful example of the weaver's art and is equal to the finest weaving produced by any people on the continent. The material used is the wool of the mountain goat for the woof and cedar bark for the warp. Although this blanket is still being made commercially by the Chilkat, its prototype is attributed to the Tsimshian, who today know nothing of its manufacture. Blankets of the same peculiar shape of the Chilkat blanket are found throughout the area. Both Francisco Mourelle and Comte de La Pérouse, who visited the area between 1779 and 1785, mentioned native weaving.

The weaving technique and design content indicate that the original conception was in no way influenced by contact with Europeans. It is

clear that such a complex creation would require a slow evolution through many generations. In the New World, ancient Peruvian textiles, in which the units are made in separate pieces and sewn or woven together, are closest in similarity to the Chilkat blanket technique.

A simple loom of two solid, upright members, placed the desired distance apart, and a horizontal member bridging the top was used. The warp, made of two-strand fiber coated with wool from the mountain goat was cut in various lengths to give the customary capelike shape and tied in a complex manner to the horizontal spreader. As a preliminary to the beginning of weaving, the warp strands were gathered in groups and placed in bags to keep them clean, since the actual weaving might be a year in progress. The woof was made from two-strand wool from the mountain goat. Three colors were generally used for the woof: black, yellow, and blue green. Although weaving was a woman's art, the blanket designs were the creation of the men: they were drawn on pattern boards which were used over and over again as design sources. Only one half of the design was placed upon the pattern board, since the blankets were customarily bilaterally symmetrical.

Broad bands of a twilled diagonal weave surrounded the ornamental field. The body of the blanket was usually a geometrical decoration, composed of many small areas of color in sections; these were interwoven to form divisions which were joined by a fine sinew cord. Where colors and divisions were joined, an overlay of three-strand plaiting was used to hide any irregularities; this overlay gave the effect of a raised surface to the particular area. The lower edge of the blanket was fringed, an effect achieved by the addition of more wool to the existing warp.

FOOD

Abundant sea life, easily obtained, furnished most of the food of the Northwest Indians. Porpoise and seal, all the varieties of fish, particularly salmon, halibut, cod, herring, olachen, clams, mussels, and other

life of the sea were gathered and used as food. Since the whole area had no agriculture, the Indians were dependent on what nature offered them for their food supply. The women gathered sea weed, edible leaves and mosses, birds' eggs, berries, ferns, roots, bulbs, and other wild vegetable foods. Bear, deer, mountain goat, and birds were killed or trapped by the men to provide variation in the main diet of seafoods.

The seasonal nature of the food supply and the need to store food during the long winter or in the event of a period of scarcity meant that much time and care was given to preserving food. Various methods were followed such as drying fish in especially constructed smoke houses or erecting drying frames in the sunlight. Certain kinds of shellfish, such as clams, were steamed and then placed in pits lined with wood. The wood was set afire and eventually the cooked clams were removed, finally to be dried in the sun. Roots and bulbs were preserved by a similar method. Berries were boiled, dried, and then compressed into hard cakes.

These Indians cultivated small patches of herbs and clover and a species of tobacco plant. The tobacco leaf was not smoked, but was dried and mixed with lime from clam shells, pounded in a mortar, and shaped into small cakes. The cakes were chewed or held in the lip. When the Europeans first came slate and wooden pipes were made by the Indians in replica of the European pipe, but the Indians themselves did not take to smoking until much later.

Besides hunting and killing seals and sea-lions, the Indians also killed whales. Throughout the area whenever a whale was found stranded on the beach, it was killed, since the flesh and blubber were desirable items for food and for trade. One tribe, the Nootka of the southern region, actively pursued the whale. The Nootka whale hunters loaded several canoes with as many as eight men in each for pursuit of a whale. The chief harpooner, a man of great eminence, sat in the lead canoe. The harpoon had a detachable shaft which could be withdrawn after strik-

ing the whale. Long lines of whale sinew with floats of seal skin were attached to the harpoon head. When the whale was sighted, the lead canoe approached close enough for the harpooner to make his throw and, after his harpoon had been successfully lodged, the harpooners in the other canoes in turn sank as many harpoons as possible in the animal. The great number of seal floats restricted the activity of the whale and, when exhausted, it was finally killed with lances. The whale was then towed to a beach where the carcass was divided and distributed; nearly every part of the animal was used for some purpose.

CLOTHING

In the winter months a woven mat of cedar bark or a fur garment was worn over the shoulders by both sexes as a protection against the weather; in the summer the men went about without any covering. The women wore an apron of shredded cedar bark and often another garment over this, also made of cedar bark, which covered them from the shoulders to the knees and was drawn in at the waist. Leggings were made from the wool of the mountain goat. In summer and winter the Indians went barefoot, but, since most of their daily lives were spent on the beaches or in canoes, this practice was not a hardship. Men wore their hair in a bunch on the top of the head or loose and long. Women wore the hair parted in the middle and braided. During the winter rains spruce-root hats were worn by both sexes.

The women of the Haida and Tlingit wore labrets, bracelets, and nose and ear decorations. Among the Haida tattooing was practiced by both sexes; it does not seem to have been practiced often by the other tribes, although lower body painting was found throughout the area. The designs tattooed were customarily family crests. Children of the nobility were tattooed on the backs of the hands and on the chest, adults had tattoos on the front of the legs, the back of the arms and, occasionally, on the torso. This custom had a practical advantage, for the crest

19

identified the victim of a battle or of a sea disaster if only one part of the body was found.

Head deformation was customary in certain areas along the coast and indicated the free status of an individual; slaves were not permitted to practice deformation. The principal type of deformation flattened the head and caused it to slope backward to a peak. A second type, in which the head was bound, was practiced by the Kwakiutl and Nootka. Binding the head decreased its diameter and elongated it to a peculiar shape usually termed "sugarloaf."

SOCIAL PATTERNS

The culture pattern of the Northwest Coast tribes was unique among North American Indians. Their special ideas of property and the importance of the acquisition and manipulation of wealth permeated all aspects of life, indeed they were the bases of the culture.

The principal points of difference between Northwest Coast social customs and those of most North American Indians were: one, the existence of an aristocracy which inherited rank, property, specific duties, and powers; two, the institution of the potlatch, a ceremonial feast, at which a man who had accumulated great material wealth gave it away to his guest and, by so doing, added to his own prestige; three, the custom of keeping slaves who were taken in battle or in planned raids.

All festivals and tribal ceremonials were concerned with the advancement in rank, wealth, or prestige of an *individual* member of a family, clan, or tribe, save the salmon ritual, the object of which was the welfare of the *whole* group.

STRUCTURE OF SOCIETY

Society was made up of four ranks, each of which had many gradations and distinctions which were rigidly kept and enforced. The chiefs of tribes composed the highest rank; chiefs of clans and house chiefs were next in rank; the freemen, or the common people, made up the largest group; below them were the slaves. Clans consisted of groups of households, each member of which traced his origin to a common remote ancestor. Among the Haida, Tlingit, and Tsimshian the numerous clans were united into two or more phratries; that is, groups of related families. The Haida had two phratries whose symbol was the Raven and the Eagle; the Tsimshian had four, the Raven, Eagle, Wolf, Bear; the Tlingit had two, Wolf and Raven.

The social organization of the Kwakiutl, Nootka, Bella Coola, and Coast Salish was slightly different. The clans among these tribes were not organized into phratries. The clan system was less prominent among these southern tribes and the village community was the important social unit. Such communities were made up of several house groups, the members of which lived in a community house headed by a house chief.

Members of the same phratry were forbidden to marry when descent among the tribes organized into phratries was reckoned from the maternal parent. A male thus inherited his clan and social position from his maternal relatives; his names, crests, property rights came to him through his maternal uncles. Among the non-phratry tribes a child was made a member of a clan to which either his parents, grandparents, or great-grandparents belonged, as with the Kwakiutl. The Nootka male could will privileges or rights either to his own children or to those of

22

his sisters, since descent among this tribe was reckoned either in the male or female line. Briefly, then, the Haida, Tlingit, Tsimshian had an exogamous matrilineal system; the Kwakiutl practiced a kind of compromise system wherein descent was given to the child. The Nootka, Salish, and Bella Coola system was patrilineal.

The Kwakiutl, Nootka, and Coast Salish prohibited marriages between members of the same clan, the Nootka avoided marriages between near relatives. Among the Haida, Tlingit, and Tsimshian marriage between members of the same phratry was strictly forbidden as well as marriage between members of different tribes but of the same phratry.

Among these people wealth brought to the industrious a higher social status. Any man not born a slave could, theoretically, rise to become a chief by acquisition of wealth. The chiefs were assisted in the performance of their office by a group of hereditary councillors.

The bulk of the population was made up of freemen who, regardless of their birth and economic position, engaged from childhood in an intense rivalry to outdo one another in the acquisition of property, both tangible and intangible, and to rise to a higher social status.

Slaves formed about a third of the population yet had no social position and had to marry within their own group. Slaves were not permitted to hold property, and performed all the drudgery and menial tasks for which they received adequate food and clothing. They were acquired by warfare or capture in raids or kidnapped. Occasionally a slave might be given his freedom. The lot of slaves does not seem to have been unbearable, although on the occasion of a great feast or ceremony they might be put to death by the owner. In this way the owner of slaves could show public disdain for his wealth and force his rivals to kill their slaves. Among the Tlingit, when a new house was being constructed, a living slave was sometimes placed in the hole dug to receive the house post before it was raised. It has been stated that the Kwakiutl often killed slaves during the winter, to provide food for ceremonial use.

Property.—The coast tribes had various kinds of possessions and prerogatives which constituted a complex and fundamental part of their social structure. Hunting and fishing areas were owned by individuals or held in common by kinship groups and inherited by the descendants of the individual or passed down to the group. Personal possessions, such as carved house posts, masks, charms, spoons, and crests were highly valued articles. Regarded in the same way as tangible possessions were intangibles such as myths, songs, dances, and names. These also were handed down from one generation to another.

Names were the most important of intangible possessions; they indicated family, riches, and status in the tribe. Each family had a series of titular names, the use of which was strictly observed and inherited or acquired by giving a potlatch to raise the individual's rank within the tribe. All the qualities and special privileges belonging to the original owner of the name were acquired by the new owner; slaves of course, were excluded from this custom. Validation of the right to any intangible possession such as a name was secured by the distribution of property at a ceremonial feast. Those prerogatives which were confined to a specific blood lineage were not held in common, but could be acquired by marriage, by murder, by supernatural means, or by becoming a shaman. Names could also be gained by these methods. In the winter months, particularly among the Kwakiutl and Haida, the whole secular structure of society was put aside and the members of tribes were ranked according to the titles they held as members of the societies which performed the winter religious rituals. These titles were inherited in the same way as titles of secular nobility.

Material or tangible possessions, such as canoes, boxes, dentalium shells, and etched or painted sheets of native copper, were the currency of the peculiar monetary system of the Northwest Coast tribes. The sheets of copper, called "coppers," were made in the form of a shield, two and a half to three feet in height and twelve to twenty-five inches in

width, a sixteenth or an eighth of an inch in thickness. A vertical groove or raised line was made down half the length of the shield and a line was made across the shield at the narrowest width to form the cross bar of a "T." This sheet of copper was often painted or etched with a design or with the crest of the owner. It was carried by a servant before the owner on ceremonial occasions and often beaten as a gong at such times. These coppers were of small intrinsic worth but were valued as high as ten thousand blankets and when they changed hands were valued according to the last amount paid for them.

At great ceremonial feasts these possessions were given as gifts or destroyed to shame a rival chief. When such possessions were broken or otherwise destroyed, rivals, present at the feasts, were required by custom to demolish equivalent objects of their own. Gifts made on the occasion of feasts were actually loans made at excessive rates of interest; hence wealth was estimated according to the amount of a man's property which he had distributed as gifts; that is to say, property which he had loaned out at high rates of interest. The return of the gift—that is, the repayment of the loan—took place at a return feast on the occasion of a marriage, the erection of a totem pole, the birth of children, or on the coming of age of the heir, or on other potlatch occasions.

The Potlatch.—The word "potlatch" is usually applied, erroneously, to the many elaborate feasts and ceremonies held by the Indians of this area. The Indians had their own names for different feasts, but the word "potlatch," originally a Nootka word meaning "gift," was taken over by the Chinook Jargon and applied by white men to all Indian ceremonials held on this coast.

The institution of the potlatch was perhaps the most remarkable custom of the northern coastal tribes; around it the whole tribal life was centered. It has been defined briefly as a "concentrated effort on the part of a man or his kinship group to display wealth, to raise his rank, and to maintain the standard of his name." It was a contest in rivalry,

the object being to humiliate and shame rivals by outdoing them in the distribution of property. By it a man contracted debts or he paid them.

Potlatchs, elaborate feasts, were given by a chief to members of his own clan or by an individual to members of other clans and tribes invited from distant places. A chief gave a potlatch to celebrate the erection of a house, on the birth or adoption of a son, on the coming of age of a grandchild, on the occasion of a marriage or, in a somewhat different category, on the erection of a totem pole, on the attainment of a chieftainship, on the assumption of a new name, or on advancement in rank, or for validation of a right, when a man wished to advance the social position of his children.

Guests were often invited from long distances, the invitation to attend having been extended some time in advance of the actual celebration, and all guests brought quantities of gifts for the host. The celebrations lasted for several days; feasting, dancing, speeches, and other entertainment were offered. In the course of the celebrations the host of the potlatch distributed slaves, canoes, clothing, blankets, and other prized possessions to his guests. These gifts could not be declined. With the gifts made at a potlatch there were associate and often onerous obligations. The recipient of a gift was obligated to return it at a later time with interest. If a man was unable to return the gift with interest, his heirs and relatives were liable for him, or the property of the tribe might be taken for repayment of such a debt. The host at the potlatch often presented his guests with gifts which represented in property value more than the recipient could return. He might break a copper valued at thousands of blankets, or burn his canoes, or set fire to his house; such destruction meant that his rival must sacrifice an equal amount in value to save himself from humiliation. This kind of rivalry carried to excessive lengths often resulted in the pauperization of one or both contestants. To the Indians, and especially to the southern Kwakiutl, the subjugation of a rival, by shaming him at a potlatch

whether by presenting him with more gifts than he could possibly return with the required interest or by destroying his valued objects and stripping himself of his own goods, was counted the highest goal of life, the peak of ambition, for rivalry was at the heart of the culture. This peculiar prestige cult was particularly manifested at the potlatch, but permeated the whole culture. At every point in life the Northwest Coast Indian by his behavior constantly sought to demonstrate his superiority over his fellows. Self-glorification was carried to great lengths and so, inextricably connected, was the fear of ridicule, of public disgrace. Any affront was removed by the distribution of property, by warfare, or by suicide. These Indians, then, had a behavior pattern which at its peak was a megalomania and at its depth a morbid fear of ridicule.

Secret Societies.—During the winter months societies of a predominantly religious character functioned throughout parts of the Northwest Coast. At this time the usual clan rankings were exchanged for their membership rank in the secret societies. The last half of the year was regarded as the time in which the spirit world was in especially close relationship with man; hence it was the time in which great religious activity with elaborate ritual and ceremonial took place. Members of the tribe were divided into groups each of which corresponded to a secret society. Space does not permit a discussion of the complex system of membership and the intricacies of the organization of the society. However, membership gave great prestige to an individual; the privileges and secrets of the societies added luster to the position of a member.

The ceremonials, special performances, and dances of the secret societies were directed by medicine men. Those who took part in the ceremony, the dancers and the singers, wore elaborate costumes and masks to represent the supernaturals of the spirit worlds. The Kwakiutl had the largest number of secret societies, but only four celebrations were permitted in any one winter. These elaborate rites usually lasted three or more days and took place in the largest communal house.

Warfare.—Warfare was undertaken in revenge for an injury or a crime or for the purpose of securing slaves. It mattered little if the person who had committed the crime was dead; and if it was committed against a member of a family of high rank, the entire clan took revenge upon the group to which the culprit belonged.

In warfare the element of surprise was the principal strategic move and early morning assault was the preferred method. The fighting was hand-to-hand, but it was not long continued, for the Indians were unaccustomed to sustained battle. In warfare waged for revenge, the attackers killed both sexes indiscriminately. However, if a raid was planned for the purpose of taking slaves, then the attack was confined to that purpose and unnecessary slaughter was avoided.

Protection in battle was afforded by double elk- or moose-hide shirts worn over a cuirass made of small sticks of wood held in place by cords and leather strips. The hide shirts were decorated with painted designs. Carved and painted wooden helmets were the head coverings. The most effective weapons for close combat were daggers and knives, often double-edged and made of polished stone, or bone with carved handles of wood or horn; and short spears were of wood, stone, and bone; bows and arrows were also used. The bows were made of yew or cedar and customarily backed with sinew; bow strings were made of sinew and hide. Arrows were made of flint, stone, bone, shell, or copper. The shafts were of cedar, dogwood, or hazelwood, and feathered with owl or grouse feathers.

Burial Customs.—Throughout the Northwest Coast area burial customs varied greatly. The corpse might be placed in a richly carved box and then deposited in a cave; it might be cremated or buried in a small surface grave house. Other methods of disposing of the dead included placing the body in a canoe and lashing the canoe to a tree; placing the body or its ashes inside a mortuary column, as described on page 12. Following the burial of an important member of the group elaborate

feasts were held. The body of a Tlingit chief was displayed dressed in his ceremonial robes and surrounded by his personal possessions; his relatives fasted and visitors came to pay their last respects. Burial took place only after decomposition set in. Common people were, among the Tsimshian, buried in the ground, and the bodies of slaves were thrown into the ocean.

RELIGION

The religious beliefs of the Northwest Coast Indians were not a clear-cut, formulated set of easily defined beliefs. They varied with the tribal groups, and concerned their explanation of natural phenomena, of the past and the future, and of human modes of behavior, and similar subjects. These beliefs were so intertwined with mythology, with totemism, and with ceremonials that no distinct religious area can be outlined. The supernatural world played a great part in the life of each Indian from childhood to death.

The Haida, Tlingit, Kwakiutl, and other tribes had one conception in common: men, animals, trees, plants, and every growing thing were habitations for spirits. The belief that animals had immortal spirits was particularly important, for animals were thought to have supernatural powers which might be used to harm or to benefit man. One or two tribes of the area seem to have had a belief in a supreme being served by secondary deities who acted as man's intermediaries with the supreme one. There was no rigid demarcation between natural and supernatural phenomena so that in their daily lives the people easily shifted their viewpoint in considering the world about them. They identified themselves with animals and bestowed human characteristics on animals. Associated with religious beliefs was, of course, the observance of taboos which were, essentially, adjustments made in daily life to ensure harmony between man and the supernaturals.

Totemism.—Totemism is a widespread feature of the religion as well as of the social organization of primitive peoples and is found throughout North America. The word itself is a derivative of an Chippewa word, but it has come to mean an association between groups of people and some animal, plant, or inanimate object. Tribes are divided into several totemic groups and each of the groups has a definite relationship to a totem. An Indian who is by birth a member of a totemic group is rarely permitted to change his affiliation. The clan is perhaps the most important group in this society, and the totem serves as the sign of clan relationship. In exogamous groups, as among the Northwest Coast people, marriage is forbidden within the group.

Ceremonials, dances, the use of masks, and so on are expressions of the group attitude toward its totem. In the totemic clans of the Northwest Coast Indians the totem is the badge or crest of the clan. In this area, too, the totem had a religious aspect. The totem animal was thought of as the guardian of the tribe or of the individual and was propitiated; various taboos were observed in connection with it.

Shamans.—Among the most primitive groups there exist certain individuals variously called shamans, witch doctors, or medicine men. These men and women exert a tremendous influence in the tribe because of the character of their activities. They function more or less individually, as a kind of priesthood. The shaman among the Northwest Coast Indians—either a man or a woman—was supposed to have abilities and powers which other members of the group did not have and these powers were derived directly or indirectly from supernaturals and received through the medium of dreams, visions, encounters, or remarkable experiences.

The relationship between a shaman and the spirit world was not possible for an ordinary member of the tribe and the shaman was, accordingly, respected and feared. His powers enabled him to communicate with the spirits, predict the future, forecast good hunting, detect

30

crime and witchcraft, create misfortune for the enemies of a tribe, and cause or cure disease. It was thought that the shaman could cause sickness by stealing the soul or that he could cure it by recapturing the vagrant soul and returning it to the rightful owner. In the conduct of his profession the shaman relied on various external aids: masks, dances, rattles, drums, elaborate dress, and similar accessories.

Ceremonies.—The theatricalism which was practiced among the shamans found its greatest expression in the winter ceremonies in which the usual clan system was suspended and the rank and position which the individual occupied in the particular secret societies came in to power. The leaders of the societies were individuals who were believed to be under the influence of certain spirits. Privileges of a special nature and ceremonial rights were very evident in the long and elaborate rituals. In these activities many of the masks and ceremonial regalia so characteristic of the Indian's art were used. The spirit of any being could become the spirit of a man during the period of these elaborate rites. Throughout the legends supernatural beings played a most active part and in the winter ceremonials their acts were dramatized along with manifestations of the supernatural powers in the Indians' daily lives. Performers appeared to the uninitiated audience to be actually possessed by supernaturals, for the trickery, drama, deceptions, and the rituals produced an almost hypnotic effect on the audience.

The way in which man secured the sun, moon, and stars, and the reason why the raven is black are among the hundreds of legends preserved through oral tradition by these people. The raven is a culture hero of the Northwest Coast tribes; he has the power to assume the guise of man, as well as to take on other shapes. The glossy black raven, larger than a crow, is a common sight along the Northwest Coast, and the natives, observing the bird's intelligence, mischievousness, and predaceous nature, endowed their culture hero with the same and other characteristics. For instance, Raven is usually depicted, whether in leg-

end or ceremony, as something of a clown, given to amusing antics and presented as adept in trickery. Many of the Indian myths deal with the time in which their ancestors came down from the heavens, took off their cloaks and masks, and became human beings. In this way the Indians supposedly acquired many of their dances, songs, masks, totems, and powers. In the secret societies' ceremonies youths were initiated into the society. During the dances which were part of the ceremony of initiation the spirits which were thought to possess the young men were exorcised. These ceremonies were conducted to the accompaniment of songs and dances and each dancer when impersonating his hereditary spirit wore a mask representing that spirit. According to the beliefs of these Indians, the person who wore the mask actually became the spirit he was impersonating. In the huge houses lit by crackling fires, with the smoke and sparks vanishing through the smoke hole into the night, the stage is indeed well set to produce acts of magic and mystery. In recent years I have seen dances in which I was so impressed by the drama and by the perfect characterizations that my actual surroundings in time and place were forgotten.

Some of these magical acts are simply explained; for instance, the apparent ability to make small ducks appear in a kettle of water. Actually the ducks were carved from wood and tied to the bottom of the kettle; at the correct signal they were released to float upward. In one dance a woman was burned to death. In actuality a box was placed at the rear of the house and the woman was seemingly pushed from behind into the box. The truth was that she slipped into a blanket-covered pit which had been dug in preparation for the ceremony. Safely covered by the blanket, the woman remained in her position while the box was lifted and thrown into the fire. During the performance the woman was heard singing in the flames, and when the box was completely burnt bones were seen in the fire. At the completion of the ceremony the bones were gathered from the fire and then thrown into the blanket-covered

32

pit from which the woman arose restored to life. The reproduction of the voice in the flame was accomplished by the use of kelp tubes which ran from the woman's hiding place to the fire pit; the box, of course, had a double bottom and a skeleton was placed in it before the ceremony.

The use of puppets controlled by strings was very common. The strings sometimes ran over the great beams of the house and were pulled by hidden manipulators who received their cues from the songs. The Sisiutl, a mythical snake, would be conjured up, the dancer concealing it in his palms and releasing it during his dance. The Sisiutl would then fly about pursued by the dancer until he suddenly caught it. Then the dancer, by sleight of hand, would put the Sisiutl in his mouth and begin to vomit and spit blood as if trying to rid himself of the spirit. In this performance there were two Sisiutls, one made of tubes that could be collapsed in the dancer's hands and the other controlled by strings which held it in the air. A small bag filled with blood and held in the dancer's mouth to be bitten by him on the right cue similarly created an illusion of reality.

The following synopsis of a myth about Raven, generally regarded as the creator of all things and the benefactor of man, is typical of those which are often portrayed in ceremonies or interpreted by specific motifs and painted or carved on works of art.

In that far-away time when the people of the earth had no light and wanted it they asked Raven to get it for them. Light was kept in the house of a supernatural being. Raven flew to the home of the supernatural and hid himself near by and watched for several days. Every day he saw the daughter of the supernatural being go to the stream for a cup of water. One day Raven changed himself into an evergreen needle and floated down the stream. When the daughter of the house came to the stream for a drink Raven floated into her cup. However, the daughter was suspicious and, thinking the needle might be Raven, brushed it out of the cup before drinking. The next day Raven changed

himself into a grain of sand and this time when the daughter came to drink he rolled into her cup. Since he was so tiny, she did not see him and drank both the water and the grain of sand. Soon after the daughter of the supernatural gave birth to a child, which was Raven in disguise. The child grew rapidly, but one day he began to cry. He was given some bits of wood to play with, but continued to cry, all the time calling for the sun which was kept in a box in a corner of the house. Various playthings were offered the child, but he went on crying. Finally his grandfather relented and permitted the child to play with the sun. Now, the child was happy as he rolled the sun around the floor, flooding the house with light. As time went by the sun became his plaything, but it was put back in the box each night. One night, when all the supernaturals were asleep, Raven resumed his own form as a bird and, taking the sun out of the box, started to fly out through the smoke hole in the roof. Unfortunately, the sudden burst of light awakened the grandfather who called to the flames of the fire to catch Raven and hold him. The flames leaped upward trying to hold Raven and he became so discolored by the smoke that he turned black. However, Raven managed to break free of the flames and flew toward the earth with the sun. The grandfather started in pursuit; since Raven was burdened by carrying the heavy sun, the grandfather gained on him, and came closer and closer. Just as he was about to be captured Raven broke off a few bits of the sun to make it weigh less and threw the pieces into the sky, where they became stars. Again the grandfather drew closer and closer to Raven, and once more Raven broke off a piece of the sun, a large piece this time, and threw it into the sky, where it became the moon. With his last burst of strength the grandfather nearly reached Raven, but this time Raven threw the remaining piece of the sun into the sky. All the pieces of the sun were now so scattered that they could never be put back together again, and Raven returned to the earth. It was in this way that Raven became black and all the people acquired the sun, moon, and stars.

THE ART

Human history should not be thought of as a regular and consistent progression from a simple, rude beginning to the complex, civilized present. People in different stages of cultural development live today in various parts of the world. Natives of Australia and pygmies of Africa are living in a Stone Age culture today.

Lacking a more adequate word, the term "primitive" is applied to art of so-called primitive peoples, ancient and modern, as well as to certain qualities found in art of peoples on a much higher level of cultural development. A crude, unskilled piece of work is likely to present a "primitive" appearance to most contemporary observers. The reasons are various: the piece of work may have been executed by someone un-

35

skilled in the medium; it may have been produced by someone who lacked the necessary degree of knowledge of his own cultural standards; or, and this is the more common, the work presents an appearance which is below the standards of the culture of the observer. Observers, however, usually lack sufficient knowledge of the artist's cultural milieu and, therefore, are prone to label the production "primitive."

In our own culture the work of early American folk artists and of contemporaries such as Grandma Moses is called "primitive" because, although the work is highly decorative, it reveals a lack of technical competence, and exhibits a childlike approach, an unconscious naïveté.

Distinct from the "primitive" paintings of Grandma Moses are the primitive characteristics to be found in the work of some of the most sophisticated of modern painters: Pablo Picasso, Henry Moore, and Paul Klee. These artists deliberately sought stimulus and inspiration in primitive art; they have utilized primitive conceptual approaches and design elements in their own works for consciously new ends.

Some of Paul Klee's paintings seem to have been derived directly from the art of various Oceanic peoples. Picasso and other Parisian painters found inspiration in the work of Negro sculptors of Africa, and Henry Moore has, in the *Partisan Review*, acknowledged his debt to the sculpture of Middle America. "I admit clearly and frankly that early Mexican art formed my views of carving as much as anything I could do." It is indeed true that primitive art has been the catalyst for much of modern art.

In the art of primitive peoples, in the work of untrained folk artists, and in modern art that has been influenced by the primitive certain typical characteristics are found. Some of the more obvious of these may be described briefly before considering in detail the work of the Northwest Coast Indians.

Portrayal of things unseen.—The artist, knowing particular and definite things about his subject, portrays them in his own work whether

36

they are visible or not. When painting a barn as part of a landscape, he may see the barn itself, but not the linear pattern of the vertical siding and its construction. However, he knows that they are there and, for subjective reasons, includes them in his painting. In the paintings of Henri Rousseau, such as "The Waterfall," the exotic landscape was the result of a conscious elaboration and reorganization of nature, in which minor objects were enlarged to heroic proportions and shown in great detail. The Indians of the Northwest Coast frequently depicted the internal structure of an animal with detailed anatomical representations, as well as its external form. The whale depicted on the Chilkat blanket is an example (see color plate).

Distortion or overemphasis.—When an artist has great interest in a particular feature of his subject he may overemphasize or distort this feature. Often a beginning art student draws the nose of his subject out of all proportion to the rest of the head. Or a child, whose greatest interest is in the head, hands, and feet, may draw these out of proportion to the rest of the figure. As the child grows older, the greater knowledge of its own body minimizes these distortions. Overemphasis is common in the art of primitive peoples. Plates 247, 248 show a few examples of distortion in Northwest Coast art.

Distorted perspective.—The primitive painter often shows more objects or more sides of one object than could ever be seen from a single vantage point. The artist may paint a barn from one side and include, as well, an end view of the building in order to show its shape or to satisfy a subjective need. Or, he may paint the barn from one angle and other objects from another and thus discard entirely architectural perspective.

Outlining.—In some types of two-dimensional representation the artist attempts to keep his objects separated, and outlines each one with a heavy contour line. (See plate 8.) The paintings of Rouault present modern examples of such outlining.

Condensation.—Most artists condense their material and restrict the tendency to portray all they know or see. This condensation and restriction has been carried so far in much primitive and in much modern art that the effect is a greatly stylized rather than a natural representation. (See plate 160.)

Horror vacui.—Some artists feel a psychological necessity to fill blank spaces. To them a vacant place in a composition is unsatisfactory until it has been filled in with detail and any bareness overcome. This urge to "fill in" is a characteristic of the art of many primitive groups; indeed it is found throughout the history of art. However, it is a less common characteristic in our culture because our artistic and aesthetic training tends to lead us away from the desire to fill blank spaces.

The common habit of doodling, in which an entire area within an outline is filled, half-consciously, with a maze of detail, is a good example of this subjective need. Whether this urge to cover a surface with designs is an unconscious reluctance to stop the enjoyment derived from the drawing or a subconscious fear of blank spaces is open to conjecture. Perhaps a similar feeling is responsible for the type of design on the Chilkat blanket shown in plate 9.

Socio-religious elements.—In all primitive societies the socio-religious factor is the prime mover in the life of the individual and the channel through which most artistic activity is expressed. With some exceptions, the near-identification of religion and art is less apparent in more advanced cultures. The wide use of animal and other forms in nature as symbols and as design elements in primitive art is a natural outcome of the prevalence of animistic beliefs in primitive society.

Form and content.—In the study of art the relation between form and content is not often enough considered; the tendency is to place undue emphasis on one or the other. Most works of primitive art show a highly satisfactory combination of form and content. However, it is true that contemporary observers are more likely to derive enjoyment

from the form, since the content is lost in the symbolization of the culture in which the work was created.

Most primitive artists had great respect for the immediate readability of their work. They were concerned with having the object easily recognizable and this desire on their part often meant that certain changes in the customary way of rendering an object or part of an object came into being. This treatment for readability is apparent also in the work of the ancient Egyptians. In drawing a head the ancient Egyptian would often portray it in profile. There is no doubt that a profile silhouette is far easier and more quickly read than a full face view. In the drawing of a head the artist instead of placing an eye in profile, which would be the view most difficult to read, draws it as if viewed full face, again the most easily read view point. Contemporary painters, such as Picasso, have also used this arrangement. Similar treatment and arrangement of parts is found also on the Northwest Coast. In plates 10 and 11 the change in design necessary to accomplish easy readability or strong silhouette can be noted.

All peoples of the world create and enjoy works of art. It is unwise to assume that a Melanesian obtains a lesser aesthetic reaction from a work of art than we do. Probably there is little difference in the degree of enjoyment derived by different peoples from their art, although the art itself may vary in form and concept. The artist's ability to work within the standards set by his own culture is one of the criteria by which his work is judged. However, because we are unfamiliar with the standards, with the artistic concepts, and with the myths of another culture, we find it more difficult to understand and appreciate its art than our own.

The basic formal principles, such as arrangement, space breaking, rhythm, are universally found in the art of all periods. Yet the art of each cultural area has specific formal characteristics which differentiate it from the works of art produced in different parts of the world.

ART OF THE NORTHWEST COAST

It is impossible to write an account of the development, chronological or stylistical, of Northwest Coast Indian art until further archaeological work is undertaken. In the humid climate of the Pacific Northwest, a wood culture leaves little evidence of its past. Although examples of stone carving are extant, most of them probably belong to the period before the coming of the white man, but information by which the archaeologist might date them more closely is, unfortunately, lacking.

At Eburne Midden, near the mouth of the Fraser River in British Columbia, excavation has revealed bone implements, harpoons, spears, trepanned skulls, and other evidence of great Indian activity in prehistoric times—estimated by some anthropologists as two to three thousand years ago. Here, and in other areas seventy or eighty miles up the river, have been found pieces of stone sculpture that are different from anything known to have been produced in historic times. The lower Columbia River area has yielded objects that are similar in technique and not too different in concept. All of the stone sculpture so far found is strikingly different from the sculpture of the Indians farther north, but there are certain characteristics in common. The striking difference in approach may indicate that prehistoric stone workers were supplanted by the wood sculptors of the historic era, or that prehistoric wood sculpture has, because of the nature of the material, disappeared with the passage of time.

Northwest Indian art as it has come down to us was flourishing when Captain Cook, on his last voyage, reached the coast in 1778; it had passed its peak by 1910, and is almost dead today. It is the art of this period, the last quarter of the eighteenth century to the present day, that is the primary concern of this book.

In the portrayal of mythological creatures, animal and human symbols often appear together but, if the observer understands what fea-

tures are stressed in each animal, recognition is not too difficult. Here is a list of many totemic animals which appear in Northwest Coast art and the symbols by which they may be recognized. Usually one or more of these features will identify the animal.

Sea monster: Bear's head; paws with flippers; gills and body of killer whale; several dorsal fins.

Killer whale: Long and large head; round eyes; large nostril; blow hole; big mouth set with teeth; dorsal fin.

Sculpin (the bullhead belongs to this family): Continuous dorsal fin; two spines rise over mouth or eyebrows.

Snail: Long snoutlike nose turned abruptly downward.

Wolf: Long snout; knoblike form at nostril; many teeth; ears slant backwards.

Sea lion: Large teeth; round nose; eye near nose; small ear.

Double-headed serpent: Plume-like forms rising above forehead, ending in round knob; spiral nose.

Squid or octopus: Rows of suction cups.

Dragonfly: Segmented body; round head, patterned wings.

Raven: Long straight beak.

Eagle: Curved beak with tip turned downward.

Hawk: Curved beak with tip turned inward, generally touching the face.

Beaver: Big teeth; round nose; scales on tail; stick held in fore feet.

Shark and dogfish: Corners of mouth turned down; curved lines on an elongated cone rise over the forehead; round eyes; sharp teeth; tail with upper lobe larger than lower.

Frog: Wide toothless mouth; flat nose; no tail.

Bear: Large mouth with prominent teeth; protruding tongue; large round nose with abrupt upturn where it meets the forehead; standing ears; large paws.

Fins are represented with square, cut-off ends. Feathers are usually represented as pointed. A labret in the lower lip indicates a woman.

In masks the symbols are often applied as painting on the human face represented by the mask. On important occasions—ceremonies, potlatches, warfare—these symbols were actually applied to the human face to indicate totemic affiliation.

Although the most commonly known form of Northwest Coast art falls in the realm of the abstract or semiabstract, it should be emphasized that these people produced representational work which has a degree of realism seldom found in the arts of primitive cultures. Carefully executed portrait heads showing the death agonies of participants in winter ceremonies are superb examples of this kind of sculpture. The ease with which the Indians made wooden masks or carved slate to represent Europeans, with the utmost economy of expression, is astounding.

The basic characteristics of any art can often be best indicated by means of a stylistic analysis. Here is a simple analysis of characteristics found in the art of the Northwest Coast together with a few descriptive statements.

General style.—Northwest Coast art is exact, intellectualized, symbolical. It is predominantly symmetrical and curvilinear.

Medium.—The medium was primarily wood. When stone, bone, metal, and other materials were used the tendency was to treat them like wood, except, of course, for archaic stone objects. There is, then, a consistency throughout the art form which might very well not have developed if the various media had been exploited for their own ends.

Line.—The importance of line cannot be overestimated. In two-dimensional art and in painting a flowing line usually begins as a fine, narrow line, swells out, and returns to a narrow line. The line may trace the outline of the form and then become part of the form itself. This technique provides a rhythmic movement in decorated flat surfaces and emphasizes planes and contours in wood sculpture.

Color.—Pigments were made from fungus, moss, berries, charcoal, cinnabar, lignite, white, red, and brown ochre, and various vegetable compounds. A brilliant green blue was produced by allowing copper to corrode in urine. Most pigments were mixed with chewed salmon eggs,

and the resulting material was a form of tempera paint. The proper consistency for paint to be used on the body was secured by mixing pigments with oil. The colors were ground in small mortars. The principal colors were red, black, yellow, and green blue; however, with the advent of trade the range of color increased with the use of manufactured paint. Although cool colors were used, the general appearance of the color arrangement is warm, since the warm tones of the unpainted natural wood appear as the background. The use of color for symbolization appears to be inconsistent; for example, either red or black was used on lips.

Tones.—Color tone is generally medium or dark. On wood the tone may be light or dark depending on the type of wood, but it is predominantly dark. Chilkat blankets present a medium value over-all tone which is enlivened by bright color areas. Painted skins are medium or dark, according to the skin color itself.

Form.—Round, oblong, oval, circular, curvilinear, and free-flowing forms predominate. In sculpture the use of a full-blown concave or convex form is used, except in the art of the Salish area where flat surfaces are utilized.

Texture.—Hair, rope, fur, and so on were indicated on sculptured objects by a skillful minimum of texture. The texture of the tool work was often left as a decorative element. Attached and inlaid materials, such as hair or abalone shell, provide differences in texture. Wood, metal, and hard slate have a similar high surface finish. The deliberate use of the grain of wood as a texture element is uncommon. Stone was pecked and left with that finish or highly polished like wood and slate objects.

Organization.—Forms were always organized with respect to the shape of the object being decorated or carved. Forms seem to be contained within the over-all shape and are interlocked as much as possible in totem poles, horn spoons, batons, rattles, and similar carved objects.

Although the forms are interlocked in totem poles, yet each element is sufficiently interesting to maintain the eye interest until the eye moves to the next element. There is always an excellent combination of interesting shapes and sizes of shapes to contrast or harmonize with the dominant form.

Pattern.—Hatching is commonly used to achieve a pattern, as is also the regular mark of the tool. Great repetition of shape as well as of form is found throughout the art. The employment of the "split" design obviously gives repetition and symmetry to any work in which it is used. Chilkat blankets present a good example of the repetition of shape.

Development of design.—In much of the work there is a sequential development of form. Not only does form grow into form, but line flows into line. The simplification obtained by making one form flow into another in a simple movement is very evident in the sculpture, particularly of single figures in which the shoulder flows with pleasing simplicity into the upper arm.

Proportion.—Variance in proportion is common and is much in evidence, for example, in figures which have small bodies supporting large heads, and vice versa. The tendency to emphasize one element, such as the hands, naturally reduces the size of the surrounding parts. Proportions were made to vary, of course, in fitting the design into the available space.

Other stylistic practices are the handling of the features of the human or animal face. The mouth, nose, eyes, and eyebrows are given great emphasis and the head itself is usually exaggerated in size. The eyebrows have a standardized form, and the eyes vary somewhat within the accepted standard for each animal. The ears of humans are placed in their usual position, but the ears of animals rise above the forehead.

A particular feature is the constant recurrence of eyelike forms, especially at the joints of figures. There are two explanations of this representation. The first explanation is that the eye forms are said to

44

represent the ball and socket joint, the outer circle being the socket and the inner eye the ball. The second is that since all joints are movable, they are represented as having eyes so that they may see. Eye forms have also been used as space fillers; they often have no obvious meaning or relationship to the object portrayed other than a design value.

The rectangle with rounded corners is common in Northwest Coast art. It often forms the basis of the eye shape and is also designed to enclose other features. In two-dimensional work this feature is easily recognized; in carving it is more subtle but may often be part of the underlying structure. The appearance of this eye shape in Northwest Coast art, in Middle American sculpture, and in Chou bronzes is worthy of investigation.

Art may be representational, abstract, and nonrepresentational. Representational art has its greatest immediate appeal in content. Abstract art is stimulated by actuality and may become so simplified that its origin is undecipherable. Nonrepresentational art has no obvious origin in actuality. Each of these types is often called by other names; for example, representational art is often termed realistic, and abstract is called conventionalized art.

In the art of the Northwest Coast Indians two styles are clearly perceptible. The women worked principally in weaving and basketry, and their style was abstract and nonrepresentational. The men worked in stone, wood, and painted wood, and their style ranges from representational to abstract. Their abstract art was highly symbolic, elaborately conventionalized, and full of meaning. Nonrepresentational art was not common.

The individual artist's style was always a group style, acceptable in its symbolism, conception, and craftsmanship to the whole group.

In the period since the coming of the European, Northwest Coast art presents one basic style, with minor divergences. No known earlier

styles are available for study. The introduction of metal tools did not change the style so much as it made possible the easier technical creation of works of art, and for that reason there was an increase in the number produced, but no great change in style.

It is difficult to believe that such a complex and mature art could have developed in a short period of time. The geographical environment of the peoples of this area is one of abundant natural resources, a physical condition which must have endured through centuries of time, and thus have permitted ample leisure in which to create the rich art forms which have come down to us. The art which developed in the Northwest Coast culture was strongly influenced by the totemic aspect of the social structure. It is, apparently, impossible to tell whether the society was the impetus of the art or whether the art developed and stimulated totemic life. The great use of animal symbols or motifs in all art forms of the area is a characteristic feature, in greater or less degree, in the work of all tribes inhabiting the coast from southern Alaska to southern British Columbia. Whether the widespread use of totemic symbols originated in a conventionalized or abstract form and then developed into a more representational form, or whether the reverse development took place, poses another seemingly unanswerable question. The anthropologist and the art historian are confronted by the same problems in other culture areas—in Polynesia, New Guinea, and Costa Rica. It has been possible in many instances to trace in the art forms from these areas the development from representational to abstract forms or the reverse order. However, since it is difficult, if not impossible, to date most of the art specimens from the Northwest Coast, there is doubt about which style was the progenitor of the other.

Many designs which are abstract or which may appear nonrepresentational are identified by the Indians as specific animals or objects. Often too, the designs will be interpreted differently by individuals within the same group. The reasons for such variance in interpretation

lie in the nature of abstract forms. The widespread use of symbols, their multiplicity, and occasionally their fusion, their totemic affiliations, together with the individual interpretation of the artist, play a part in the identification of a design. The practice of reading content into form is universal. Probably in every culture an artist looked at some existent shape and, seeing in it the form of an animal, he then proceeded to draw or carve the likeness until it was recognizable by his fellows.

Most of the characteristics of primitive art which I have mentioned are found in the work of the Northwest Indians. The portrayal of a reality beyond that which is seen is particularly evident in two-dimensional representations in which the internal anatomy of an animal is depicted in detail, the various parts arranged in design patterns. Great emphasis is placed on certain features of the animal; symbols or parts of symbols are used.

Indeed, the use of symbols was so highly developed that a rigid conventionalization became established and various creatures were recognizable by one or two minor symbols. For example, the conventionalized fin and blow hole alone were sufficient to represent the killer whale. Distortions, resulting from the adjustment of the animal form to the decorative field, the practice of combining several views of a subject in one representation, the interlaced animal forms on totem poles, for example; and excessive ornamentation and profusion of detail are all characteristics of the art of the Northwest Coast Indians.

The use of the object was the first concern of the maker, and the design was subordinated to function. The adaptation of design to use naturally created distortions which increased the decorative qualities of the work. Although the symbolization was consistent in form, the versatility of the artist permitted him to relate the design elements to objects of varying shapes and to different materials. Thus the same symbol, variously arranged, may be found painted on wood, carved in bas-relief, or in three-dimensional sculpture. A design painted on the

47

side of a food box might also be adapted to a conical hat. The artist had so complete a concept and had it so firmly in mind that he was able to maintain the same relationship of detail to scale in a small delicately carved handle of a horn ladle or in a sixty-foot totem pole.

In adapting the design to specific shapes and varying sizes, certain formulas for splitting the design came into being and are found throughout Northwest Coast art. In one type, the animal design is split from head to tail, leaving the two halves attached at the tip of the nose and the tail. This arrangement is extremely common on objects where the animal's body must circumscribe an area, as on food dishes and silver bracelets. An adaptation of the same formula is used in flat decorations: the animal is split in two so that the profiles are joined in the middle of the design, or the front view of the head is shown with two adjoining profiles of the body. In another type of splitting, designed to fill a more or less square area, a four-legged animal is portrayed in a sitting position, split from head to tail and unfolded so that the center line of the back forms the lines at the right and left of the design; the two parts of the animal may be joined at the mouth or along the front of the body.

The unfolding may be reversed, with the back line becoming the center of the design and the chest profile the extreme right and left edge of the design. In some examples, the two split halves of the body are separated completely and joined together only in a common head viewed from the front. In still another form of splitting, the animal is portrayed in cross section, having been split from head to tail; the internal anatomy of the animal is drawn in an abstract manner. Variations of splitting the design may be found on slate dishes, wooden bowls and dishes, silver work, tattooing, wooden boxes, painted leather, and other objects.

To date there has been insufficient research in tracing design similarities in the art forms of the Indians of the Northwest Coast and those of other cultures of the Pacific Coast area to warrant making any definite statements about possible culture influences. However, it may be said

48

that such a sophisticated culture as that of the Northwest Coast Indians with its well-developed art, which certainly antedates the appearance of the white man in the area, is not likely to have borrowed many design elements from less highly developed cultures.

The Tlingit, the most northerly of the Northwest Coast tribes, had contact with the Eskimo, and they probably influenced each other's culture; for example, the practice, held in common, of placing small figures on the faces of masks may have arisen in either area and passed to the other. The Athabascan use of floral design and beadwork has crept into some of the art of the coastal people. To the south, the art forms of the Salish are subtly different from the rest of the culture of the coast, yet they are sufficiently like to fall within the category of Northwest Coast art. The similarity between the slat armor of Asia and that used by the people of the Northwest Coast, together with the sinew-backed bow—which first appears more than three thousand years ago in Asia—also found on the Northwest Coast, indicates contacts between the people of the two continents in very early times. Such contacts are not improbable if we consider the seaworthiness of the Northwest Coast canoe and the hardiness of its seamen, indeed, speculations have been made about possible voyages by these Indians to other parts of the Pacific basin. Actually, the early European explorers of the coast bobbed around on the ocean in very small ships, many of them shorter than the large Northwest Coast canoe. For example, the *Santiago*, commanded by Bruno Heçeta on his voyage along the coast in 1775, was only thirty-six feet long, had a beam of twelve feet, and drew eight feet of water.

So far, then, I have surveyed the culture which produced the conventionalized and highly symbolic art of the Northwest Coast Indians and have discussed briefly the more important features of this art. The intention has been to orient the reader so that he can, in studying the examples shown in the plates, perceive for himself the excellence of the art and evaluate it in relation to that of other cultural areas.

The plates which follow are arranged in two groups: first, the two-dimensional work; second, the plastic three-dimensional objects. Each plate has a descriptive legend which gives pertinent information about the object: measurements; present location if in a museum or private collections; the museum number; if known, the date collected and the collector's name; and any other information which gives a better understanding of the object and of the art it represents. Certain specimens shown in the plates do not have the name of the tribe indicated. Although many can be readily identified from particular features or characteristics, it is not always possible because of the overlapping of minor differences. Since the general art form is stylistically the same, differences between objects produced by different tribes are often slight. I have chosen not to attribute any specimens whose provenience is not known to specific tribes solely on the basis of my familiarity with tribal styles. Such attribution is a common practice, but it is certainly not good procedure. The tribe indicated in the legend is generally that which the museum has recorded; for most specimens the attribution is correct, but occasionally it is incorrect. For some of the latter, I have indicated what I believe is the correct attribution.

As mentioned in the text, many of the decorative symbols used in the art of the Northwest Coast are not readable to anyone but the artist, hence it is not always possible to say that a particular animal is a bear or a wolf, since it might well be a sea bear or some combination known only to the artist.

All photographs taken by museums, fieldworkers or persons other than the present writer are noted in the legends. Mention should be made here of the professional photographer R. Maynard of Victoria, British Columbia, who took many pictures of the Indians and their villages in the 1880's. Some of his photographs are reproduced in plates 264, 266, and 267.

The rattle illustrated in plate 112 is the earliest known object shown

in this book; it was collected by Captain James Cook in 1778. The United States Exploring Expedition, which was organized in 1836, visited the Northwest Coast in 1841 under the leadership of Lieutenant Charles Wilkes. This expedition collected many examples of the art of the area, some of them doubtless of considerable antiquity. The collection made by this expedition is today in the Smithsonian Institution, Washington, D.C. For many years, beginning in 1855, James G. Swan worked and collected among the Northwest Coast tribes. Much of the material which he brought together is also in the Smithsonian Institution.

The British Association for the Advancement of Science sent a group to the Northwest Coast which did fieldwork from 1888 to 1897. From the latter date further work was undertaken by the Morris K. Jesup North Pacific Expedition sent out by the American Museum of Natural History. The work of the Jesup Expedition was presented in a series of publications under the editorship of the distinguished anthropologist Franz Boas. These publications are the main source of information for most of the present-day workers in the field. The members of this last large expedition to the Northwest Coast included many experts who continued to publish the results of their investigations: Franz Boas, George T. Emmons, George Hunt, Filip Jacobsen, C. F. Newcombe, F. W. Putnam, Harlan I. Smith, J. R. Swanton, James Teit, and many others. Another early collector in the area was a Captain Jacobsen who obtained many examples of the arts and crafts of these Indians; much of his collection went to European museums.

Collections of Northwest Coast art are to be found in many museums in this country and in Canada. The largest collections are in the Smithsonian Institution, Washington, D.C.; the American Museum of Natural History, New York City; the Museum of the American Indian, Heye Foundation, New York City; the Chicago Museum of Natural History, Chicago, Illinois; the Washington State Museum, University

of Washington, Seattle, Washington; the Portland Art Museum, Portland, Oregon; the Canadian National Museum, Ottawa, Ontario; the Provincial Museum of Natural History and Anthropology, Victoria, British Columbia; Anthropological Museum, University of British Columbia, Vancouver, B.C.

Other important collections are in the British Museum, London, and in the Musée de l'Homme, Paris. During World War II the great collection in the Museum für Völkerkunde in Berlin was destroyed.

PLATES

Photograph of Charley Swan at Neah Bay, Washington, about 1938. Modern dance robe of the Makah tribe, worn by the owner. Made of canvas, design painted in red, blue, and black. The modern artist has copied the general style and fringe of an old blanket.

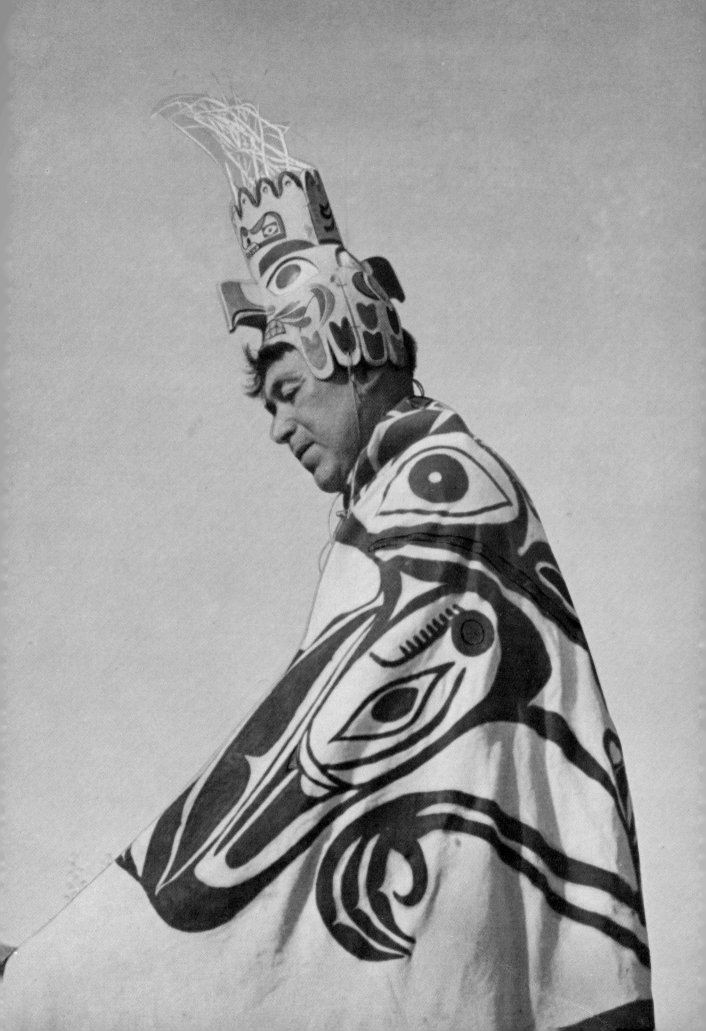

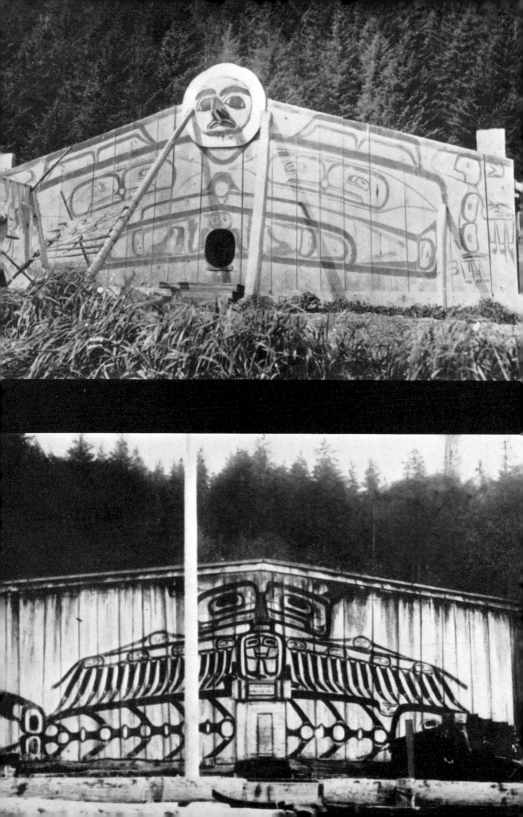

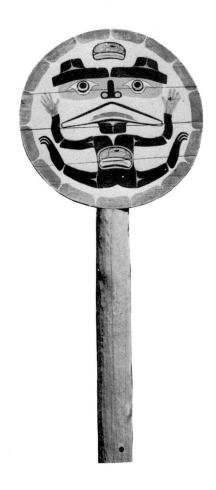

1 UPPER LEFT
Photograph, Washington State Museum.
Chief's house at Gold Harbor near Skidegate, Queen Charlotte Islands, B.C.
Instead of the usual totem pole erected in front of the house there is here a large carved
face, similar in style to the carving on masks. The house entrance, by means of a small
hole in the front, is traditional. Occasionally when a totem pole is erected in front of
the house, the entrance is through a hole at the base of the totem pole. These small open-
ings were useful in time of war, since defenders standing inside the opening could strike
down attackers as they tried to enter one by one. The painted symmetrical design com-
pletely fills the space to be decorated.

2 LOWER LEFT
Photograph, Washington State Museum.
Chief's house, Alert Bay, British Columbia.
The fronts of houses were often elaborately painted. The symmetrically arranged paint-
ing on the front of this house depicts the legend of the thunderbird carrying off a whale.
The whale is split vertically through the center from the nose to tail, and the interior
anatomy is depicted by design arrangements; the thunderbird is shown full face; the
body and head arranged symmetrically.

3 ABOVE
Photograph, Natural Resources Intelligence Service, Department of the Interior, Canada.
Grave marker, Bella Coola, British Columbia.

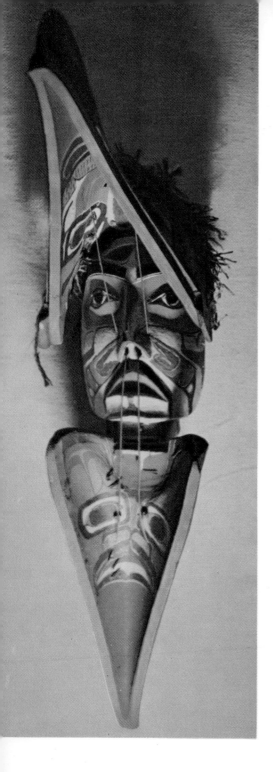

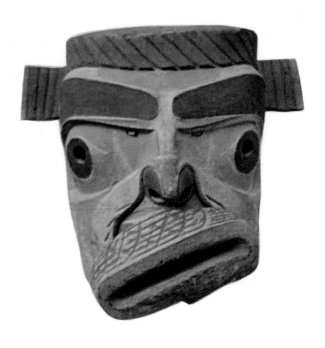

Tribe: Kwakiutl Location: Frank Smith Collection, Vancouver, B.C.
Size: 4 ft. when open
Mask made from poplar wood and decorated with cedar-bark strips. When closed the mask represents a raven, when opened it reveals a human head. The painted designs on the face represent a whale. The inner side of the upper beak shows designs representing a whale; the lower, a bear. The mask is manipulated by strings held by the wearer.

Tribe: Kwakiutl Location: Provincial Museum, Victoria, B.C.
Length: 16 in. Museum Number: 57
Width: 12 in.
Collected by F. Jacobsen, 1893.
Wooden mask with movable mouth.

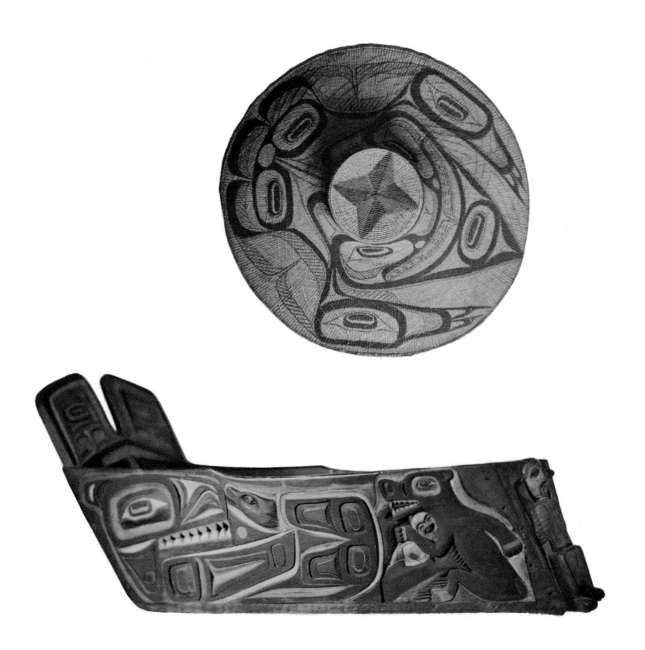

Tribe: Unknown Location: Frank Smith Collection, Vancouver, B.C.
Diameter: 15 in.
Conical hat woven from split cedar roots. The design represents a bird which has been split and carefully arranged to fit the space available. The rise of the crown is an integral part of the design.

Tribe: Nootka Width: 9 in.
Length: 26½ in. Location: Frank Smith Collection, Vancouver, B.C.
Carved and painted red cedar cradle. The sides show the free-flowing asymmetrical design characteristic of the Nootka artist. Probably the most sophisticated type of two-dimensional design from the area. The large sea animal is a shark or dogfish. In the lower left section a wolf holds a whale's tail in its mouth. A small human head and arm are used as space fillers to the right of the whale. A reclining frog occupies the lower right-hand corner. Note the distortion of the symbols for emphasis and space relationships. The headboard and figure at the end of the cradle are traditional in the area.

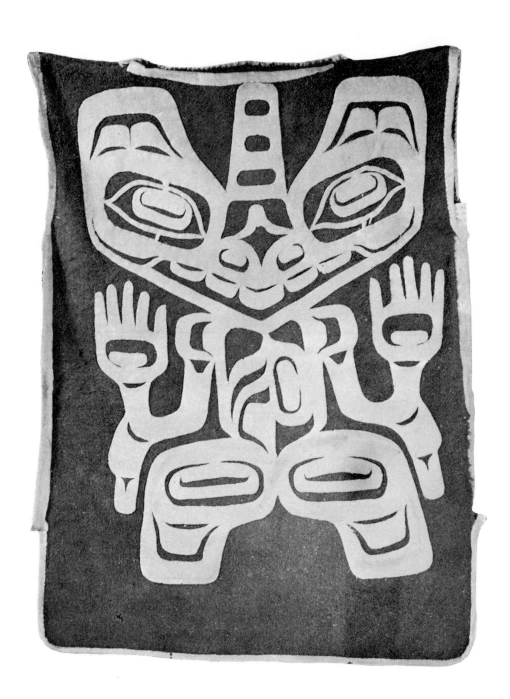

4

Tribe: Haida Location: Washington State Museum
Length: 31½ in. Museum Number: 1
Width: 24½ in.
Collected by James G. Swan, 1893.

Dance shirt made from a Hudson's Bay Company blanket. The opening at the top of
the shirt permits the head to be slipped through; the wide side openings permit the arms
to move freely. The design of a bear is appliquéd in red flannel. The bear is split ver-
tically so that the halves of the anatomical rendering fall on each side of the vertical axis.
The form above the nose and between the ears represents the segments of a dance hat.

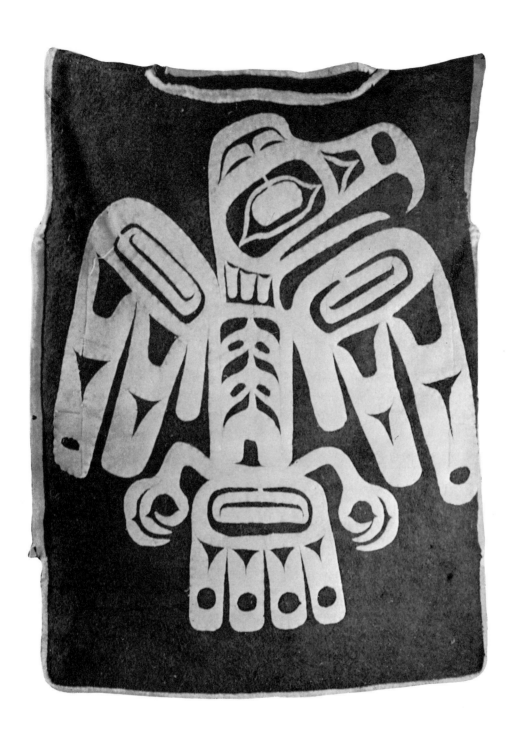

(The more segments the greater the prestige of the wearer.) The bottom of the design appears to represent the tail of a sea mammal, perhaps a sea bear. The head shape is repeated in reverse by the tail, the same shapes rising above the head are repeated by the flukes of the tail. Note the rhythmical repetition of the angles where the head joins the body, and where the dance hat, and ears meet at the forehead, and where the flukes join together. The use of circular shapes, of curved lines, against or with straight lines, permits each to work against the other and optically to enhance its opposite.

ABOVE. Design of an eagle appliquéd in red flannel; the head portrayed in profile, the body split vertically, and anatomically rendered. The hunched-up wings give more feeling of flight than if they were dropped or placed parallel.

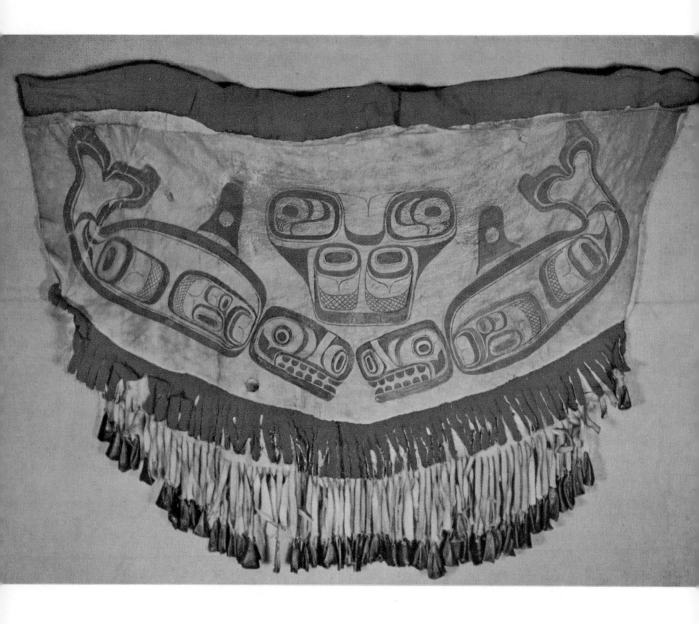

Tribe: Tlingit

Width: 40 in.

Depth: 27½ in.

Location: Washington State Museum

Museum Number: 1956

Collected by G. T. Emmons at Cape Fox, southeastern Alaska.

Dance apron made of deerskin trimmed with red flannel and decorated with deer hoofs attached to the fringe. The symmetrical design, adapted to the shape of the apron, is painted on the skin and represents two killer whales in profile split to show the interior anatomy depicted in designs. The tails of the whales are turned to permit recognition as tails of sea mammals. The center design apparently represents a sea mammal's tail. The series of squarish ovals of diminishing sizes creates a rhythmic pattern.

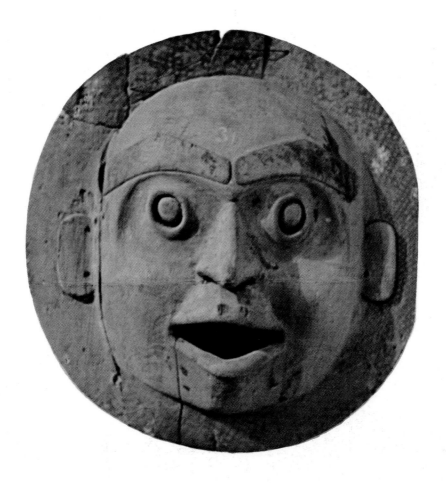

Tribe: Kwakiutl
Circumference: 12 in.
Location: Provincial Museum, Victoria, B.C.
Museum Number: 31
Collected by F. Jacobsen in 1893.
Wooden mask carved to represent the moon,
painted black, red, and green. One of the
finest masks from the Northwest Coast. The
subtlety of carving throughout, the expres-
sion of the mouth, the unusual treatment of
the eyes all help make an unusually fine
mask. Although the eyebrows show the styli-
zation traditional to the area, the rest of the
mask has none of the stylized features. The
mouth shape is skillfully handled, the carv-
ing of the eyes is most unusual, and the
plumpness of the face make a satisfying rep-
resentation of a genial man in the moon.

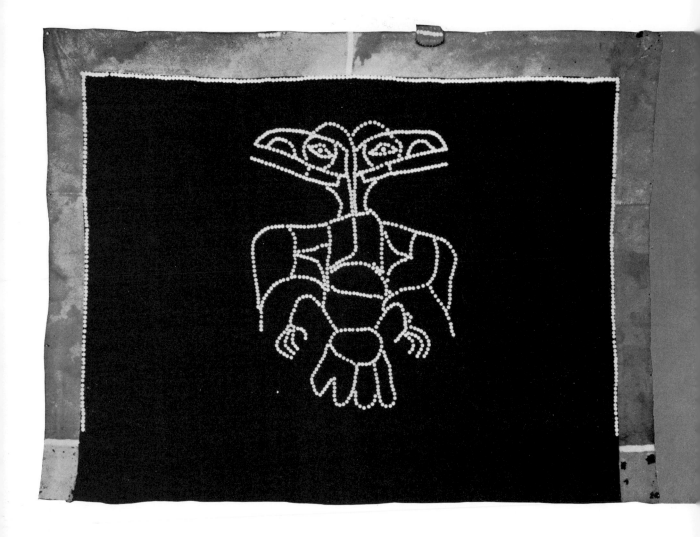

5 ABOVE
Tribe: Tlingit
Length: 68½ in.
Width: 51½ in.
Location: Washington State Museum
Museum Number: 7223
Photograph by Robert Donaldson.
Collected by Mrs. Anna Pennell at Ketchi-
 kan, Alaska, 1908.
A ceremonial blanket of dark blue Hudson's
Bay Company blanketing edged with red
flannel and decorated with pearl buttons.
The design represents a thunderbird.

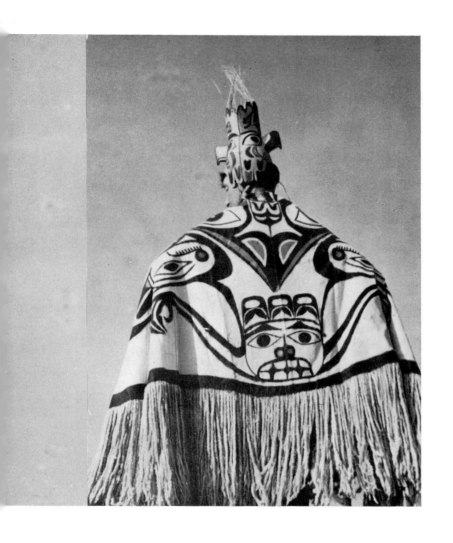

6 LEFT

Photograph taken of Charley Swan at Neah Bay, Washington, about 1938.

Modern dance robe of the Makah tribe, worn by the owner. Made of canvas, design painted in red, blue, and black. The modern artist has copied the general style and fringe of an old blanket.

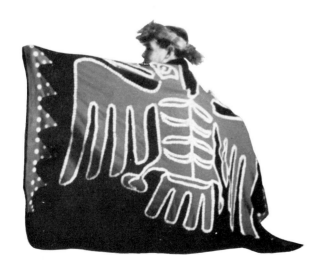

7 LEFT

Photograph taken at Neah Bay, Washington, about 1938, showing the late Luke Markishtum wearing a blanket with an appliquéd red eagle outlined with mother-of-pearl buttons. Made by Makah tribe.

8 UPPER RIGHT
Tribe: Tlingit Location: British Museum
Length: 60 in.
Copyright photograph, British Museum.
An early example of a Chilkat blanket. The weaving is fine and the designs instead of being woven are painted on the blanket. The free, asymmetrical design is excellently arranged and unusual. The bird depicted is the raven; note the unusual eye and the manner of rendering the tail and wing feathers. The zigzag border design is occasionally found in other works. The varying width of the line so consistently found in the art of this area appears also in this blanket. The free-flowing design represented in this blanket is more associated with painting on screens and boxes. Recent Chilkat blanket designs, more abstract in character, are very different from this early blanket.

9 LOWER RIGHT
Tribe: Tlingit Location: Washington State Museum
Length: 66 in. Museum Number: 2454
Width: 48½ in.
Photograph by Robert Donaldson.
A Chilkat blanket woven of wool from the mountain goat; dyed black, yellow, and green with the natural white of the wool left in many sections of the design. These blankets were the most valued of ceremonial robes and were worn by both sexes at ceremonies and, on the death of a chief or important owner, the blanket was placed on the grave and allowed to disintegrate as a mark of esteem. Since these blankets were woven from pattern boards many duplicates or near duplicates were made. The present author owns an almost exact duplicate of this blanket. The design represents a whale diving and is so conventionalized that the symbols are no longer clearly recognizable.

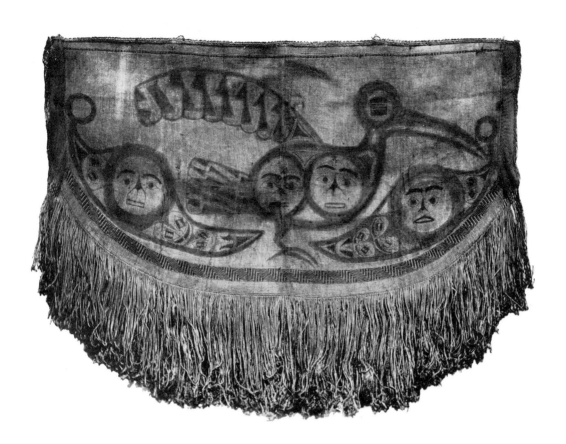

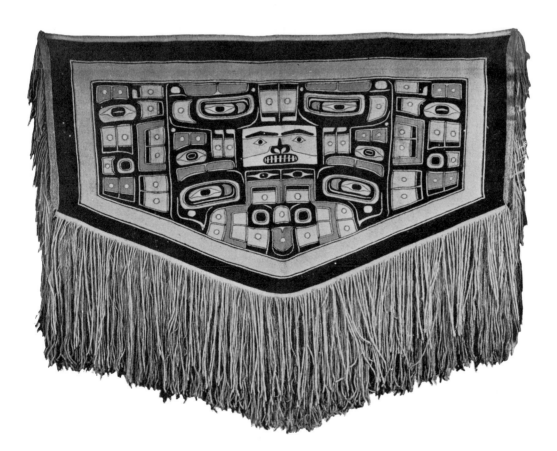

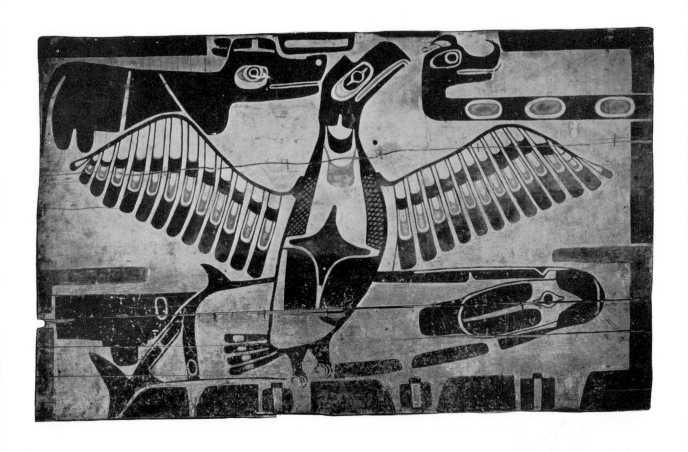

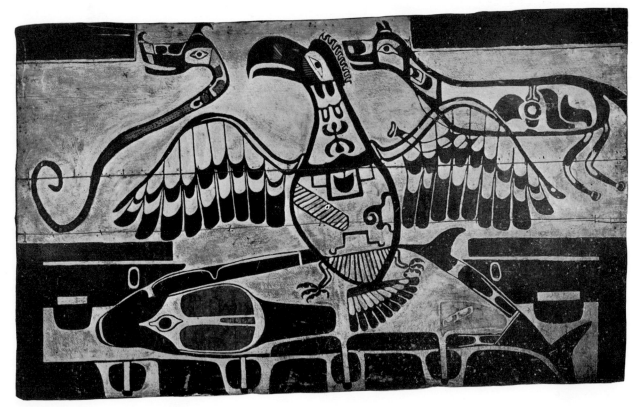

10 AND 11
Tribe: Nootka Location: American Museum of Natural History
Height: 68¼ in. Museum Numbers: 16./1892A; 16.1/1892B
Width: 118 in.

Photograph, American Museum of Natural History.

Collected by G. T. Emmons in 1929; made, however, about 1850.

These painted panels were made on hand-adzed cedar planks with native brushes (see pl. 56). The boards were prepared for painting by being sized with a paste made of mashed salmon eggs and oil. The pigments were made from ground charcoal for black, and alder or hemlock bark for red, and mixed with an emulsion of salmon eggs. These boards are fine examples of primitive tempera painting. The boards stood at the back of the house and were brought forward for display at potlatchs. Both panels represent the thunderbird carrying off a whale, the wolf on one side and the lightning snake on the other. Plate 2 shows another version of the same myth. These two boards were probably painted at different times and I think that the lower panel is the older because of the character of the painting and the more traditional manner of handling the symbols. The anatomical type of rendering appears in both panels. Compare the wolf and lightning snake in the two panels. The lower panel shows a far greater delicacy and feeling for the forms themselves; and the upper is a more labored rendering in its whole concept.

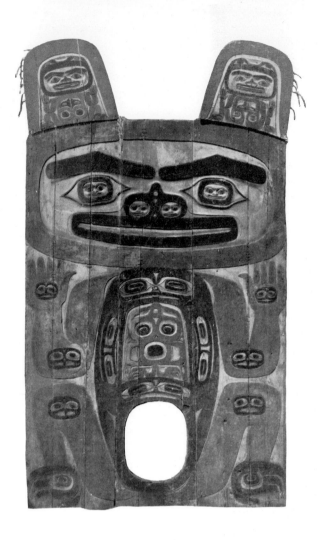

12 ABOVE

Tribe: Tlingit Location: Wolfgang Paalen Collection
Height: Approximately 15 ft.
Photograph by Manuel Alvarez Bravo.

Carved wooden house screen painted red and black. In a letter published in *Dyn*,
G. T. Emmons wrote to Wolfgang Paalen several interesting facts about this screen.

"You are fortunate in getting this piece, as such carved and painted screens were only
to be found in half a dozen of the chiefs' houses in southeastern Alaska. This one repre-
sents possibly the most important clan-crest of the Shakes family—the Brown bear. Shakes
was the hereditary chief of the principal family of the Wolf Phratry at Wrangell. They
migrated to the interior of Alaska ... later settled some twenty miles south of Wrangell
and after the Russians came south from Sitka and built a fort at Wrangell, the Stikine
Tribes deserted the more southern village and settled at Wrangell (about 1840)....
The carved posts in the house are said to have been brought from the older house, so
they must be upwards of 100 years old ... Your carving represents the principal crest
of the clan and mythically goes back to the flood where two Brown bears climbed a moun-
tain on the Stikine river to escape the flood. They killed one of the bears later and took
the head and skin and wore both in festivals as the family crest, the most valued of all
others ... Shakes had many animal crests or totemic emblems, Bear, Dogfish, and the
house named Kut-du (Dogfish) house and the interior house posts carved to represent
the dogfish ... The old house has been pulled down and a terrible excuse has been put
up in its place and a figure copied from your screen placed in front (instead of inside
where the screen actually was)."

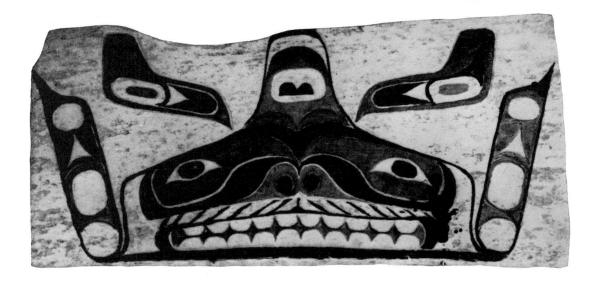

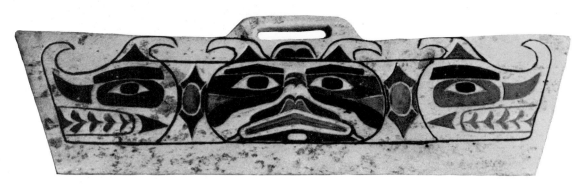

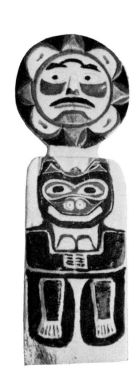

13 UPPER

Tribe: Kwakiutl Thickness: ½ in.

Length: 15 in. Location: Provincial Museum, Victoria, B.C.

Height: 6⅞ in. Museum Number: 4415

Whalebone slab incised and painted red, black, and blue, representing the killer whale.

14 MIDDLE

Tribe: Kwakiutl Thickness: ½ in.

Length: 20½ in. Location: Provincial Museum, Victoria, B.C.

Depth: 5¾ in. Museum Number: 4414

A practical tool used to beat bark into shreds. Made of whalebone, incised, and painted red, black, and blue, represents the Sisiutl, a double-headed snake. The design shows a single-horned snake head at each end of the beater and a two-headed human head in the center. The Sisiutl had the power to assume many shapes; to see it or to touch it meant death, except to those who had its help.

15 RIGHT

Tribe: Kwakiutl Thickness: ⅜ in.

Length: 8½ in. Location: Provincial Museum, Victoria, B.C.

Width: 2½ in. Museum Number: 4416

A figure representing the sun and a bear, carved from whalebone and painted black, red, and blue; the natural color of the bone appears in the unpainted areas. The outline of the bear's legs is incised, but the black area forms the shape of the leg, as well as a new form outside the leg. An interesting use of color.

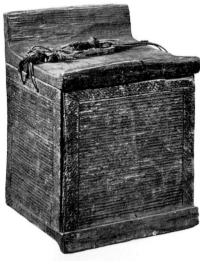

17 LEFT
Tribe: Nootka
Height: 10¾ in.
Width: 9½ in.
Depth: 8 in.
Location: Washington State Museum
Museum Number: 1-11339
Photograph by Robert Donaldson.
A wooden food-storage box which shows the surface texture and pattern produced by the particular tool used.

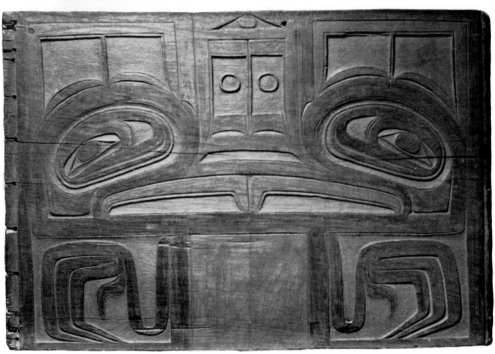

16 LEFT
Tribe: Haida
Location: Canadian National Museum, Ottawa
Collected by the author in the Queen Charlotte Islands, B.C., 1930.
This burial box shows the method of joining the corner in a bent wood box. The depth of the carving can be seen on the front of the box, the sides are painted.

18 ABOVE
Tribe: Tlingit Location: Washington State Museum
Width: 16¾ in. Museum Number: 1735
Depth: 11½ in.
Collected by G. T. Emmons from a burial cave at Kluckwan, Alaska.
End of a box made of red cedar. The design carved in low relief represents an eagle split vertically, the design unfolding so that the back, split edges appear on the exterior sides of the box. The slightly curved beak identifies the bird.

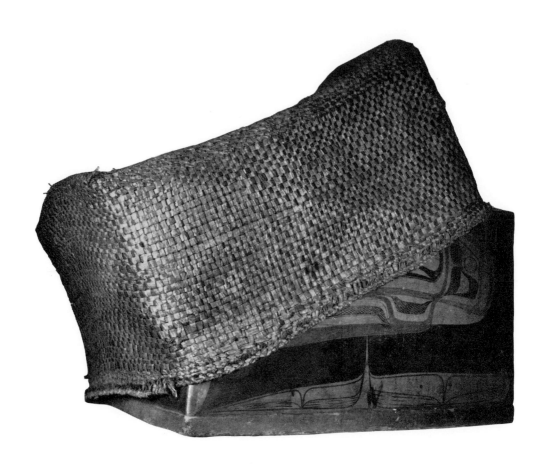

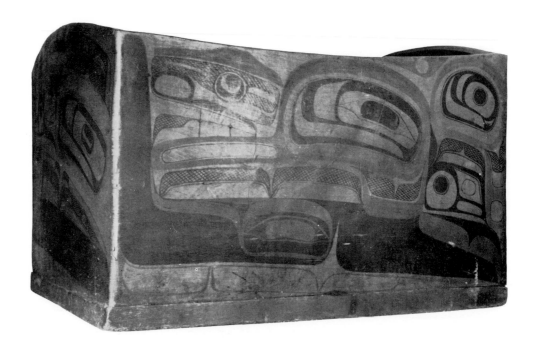

19 AND 20
Tribe: Unknown Width: 13¾ in.
Height: 13¾ in. Location: Frank Smith Collection
Length: 21 in.

Storage box made from one piece of bent wood. The covers of woven cedar made for this type of box are usually missing, hence this is a rare specimen. The two-dimensional abstract design shows the use made of the line which swells and contracts. The dark mass on the face of the box sweeps down the side, moves over and downward with a narrow break in the lower right-hand corner, thus breaking the space from a rectangular shape into a more subtle area. This dark moving mass is predominant in the design. Rhythmic repetition of ovoid shapes in varying sizes is a common feature of Northwest Coast art. The use of hatching provides a contrasting pattern to the flat, dark areas, middle-tone color areas, and unpainted wood of the box itself. Optical balance is achieved by the dark form on the right balancing the dark area on the left.

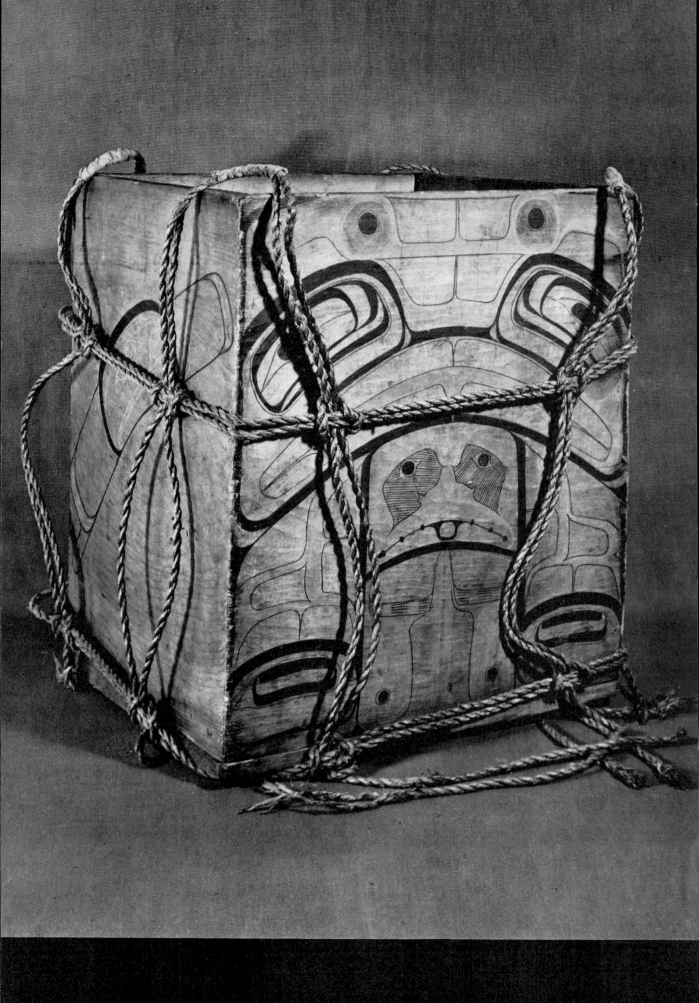

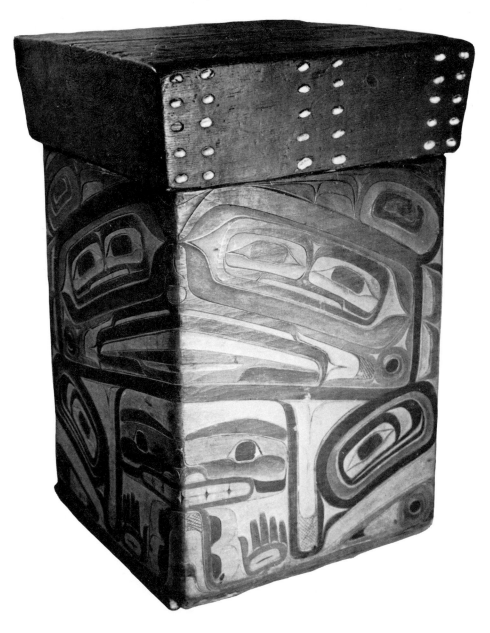

21 LEFT
Tribe: Haida
Height: 21 in.
Width: 15¾ in.

Length: 18¾ in.
Location: Washington State Museum
Museum Number: 1508-62

Photograph by Robert Donaldson.
Collected by Ernest P. Walker at Howkan, Alaska, 1917.
Storage box of bent wood painted with totemic designs in black and red. The careful way in which the box is securely tied is well illustrated here.

22 ABOVE
Tribe: Tlingit
Height: 22 in.
Width: 13½ in.

Depth: 13½ in.
Location: Washington State Museum
Museum Number: 1396

Collected by G. T. Emmons at Wrangell, Alaska.
Food storage box, carved and painted, the sides made from one piece of red cedar. The lid is inlaid with the operculum of the sea snail. The photograph has been taken to show how one edge of the box splits the design vertically; this feature is particularly apparent in the figure in the lower center of the design. The design represents a mythical sea spirit, Kow-e-Ko-Tate. Although the design is carved in low relief, it is essentially a two-dimensional concept.

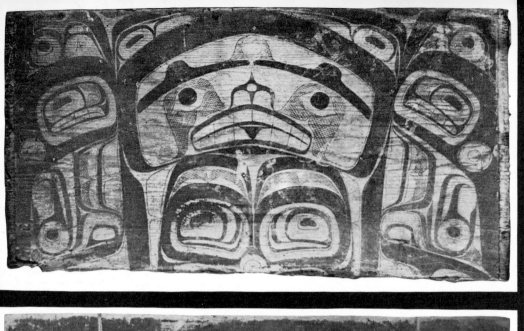

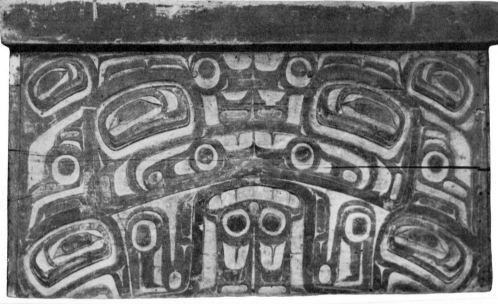

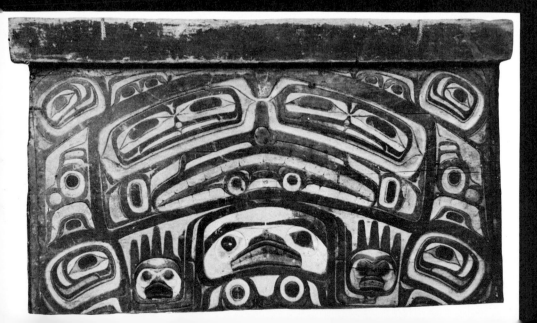

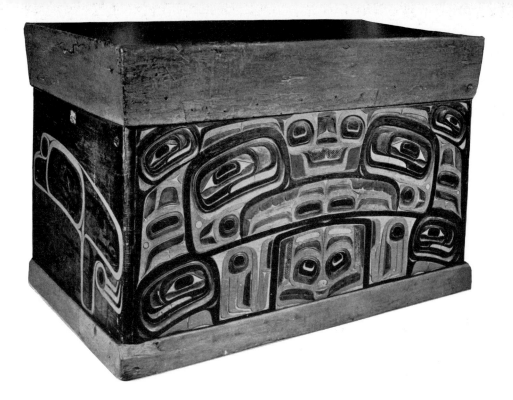

23 UPPER LEFT

Tribe: Haida Width: Approx. 15 in.

Length: Approx. 30 in. Location: R. B. Inverarity Collection

Collected by the author in the Queen Charlotte Islands, B.C., 1930.

One side of a painted, bent wood box. The design is split vertically into three sections, the center section wider at the top than at the bottom. The side panels form shapes diminishing in size as they approach the top. The design is so planned as to seem to be constructed on curved lines. The typical swelling line is used extensively and to good effect. Circles and ovoid shapes appear both as accents and as rhythmic repetitions.

24 MIDDLE AND LOWER LEFT

Tribe: Haida Height: Approx. 28 in.

Length: Approx. 44 in. Location: Canadian National Museum, Ottawa

Collected by the author in the Queen Charlotte Islands, B.C., 1930.

A fine example of a painted burial box, the symmetrical design carved in low relief. The large center design is made up of eyes of individual faces, a common stylistic variation in Northwest Coast art. The complexity of design is similar to the space-filling conventions in Chilkat blankets (see pl. 9). The design of regular interlocking shapes, each skillfully varied, indicates the artist's predilection for filling all spaces.

25 ABOVE

Tribe: Haida Length: 36½ in.

Height: 23½ in. Location: Washington State Museum

Width: 25 in. Museum Number: 2291

Photograph by Robert Donaldson.

Collected by G. T. Emmons at Kluckwan, Alaska.

Bent wood chest painted red, black, blue; both sides are carved and painted to represent the bear on one side and Kow-ko-tate, the mythical sea spirit on the other. The ends are painted and represent the flippers of Kow-ko-tate. Valuable blankets and dance paraphernalia were stored in this chest. This chest illustrates how material made by one tribe often appears in another; a fact which leads to mistaken attributions unless the history of the article is known or the article itself is peculiar to one tribe. The chest was procured in trade from the Haida by the Khow-nah-ta-tee family at Kluckwan, a Tlingit village.

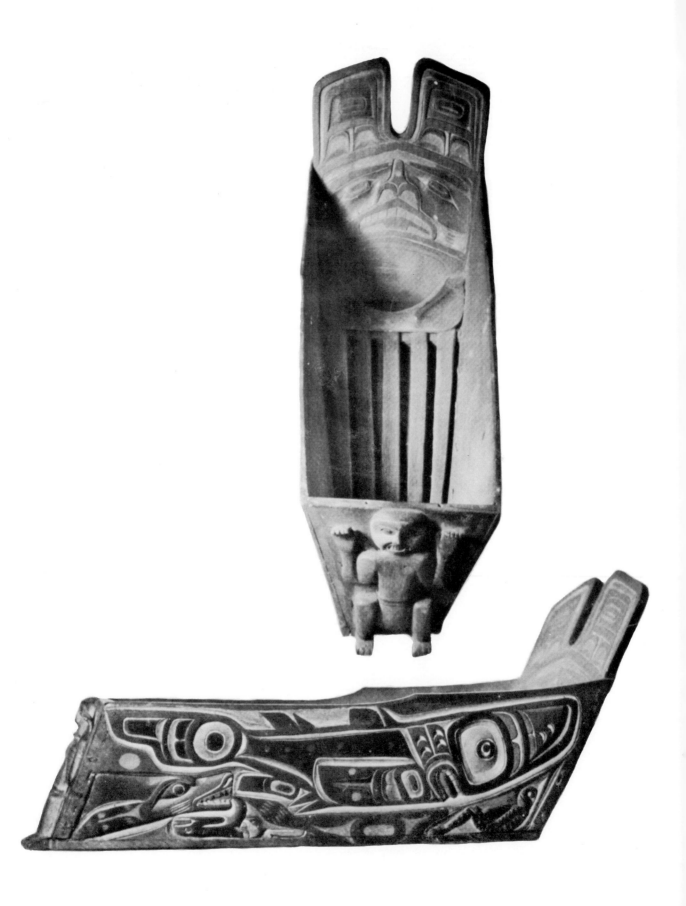

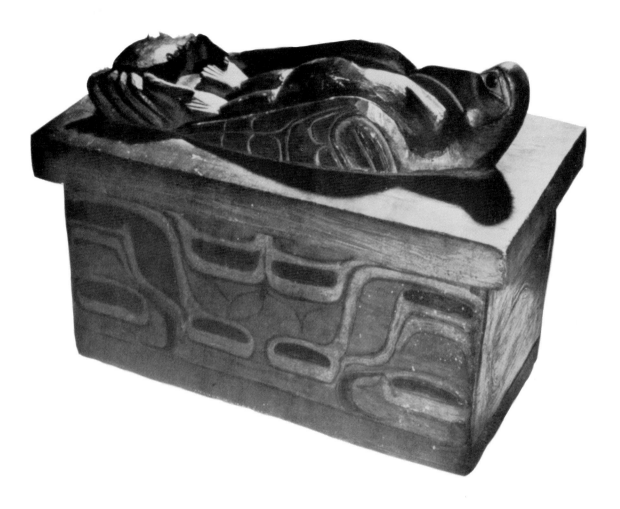

27 ABOVE
Tribe: Unknown Location: Anthropological Museum, Univ. British Columbia,
Height: 9 in. Vancouver, B.C.
Width: 14 in. Museum Number: A1776, Raley Collection
Photograph, Visual Education Service, University of British Columbia.
Carved wooden box used by a shaman for his collection of paraphernalia. The lid is
carved to represent a raven with a crab in his talons.

26 FACING PAGE (TWO VIEWS)
Tribe: Nootka Width: 9 in.
Length: 26½ in. Location: Frank Smith Collection
Carved and painted red cedar cradle. The sides show the free-flowing asymmetrical de-
sign characteristic of the Nootka artist. Probably the most sophisticated type of two-
dimensional design from the area. The large sea animal is a shark or dogfish. In the
lower left section a wolf holds a whale's tale in its mouth. A small human head and arm
are used as space fillers to the right of the whale. A reclining frog occupies the lower
right-hand corner. Note the distortion of the symbols for emphasis and space relation-
ships. The headboard and figure at the end of the cradle are traditional to the Northwest
Coast.

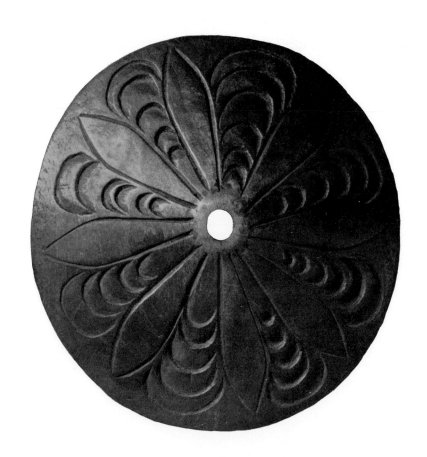

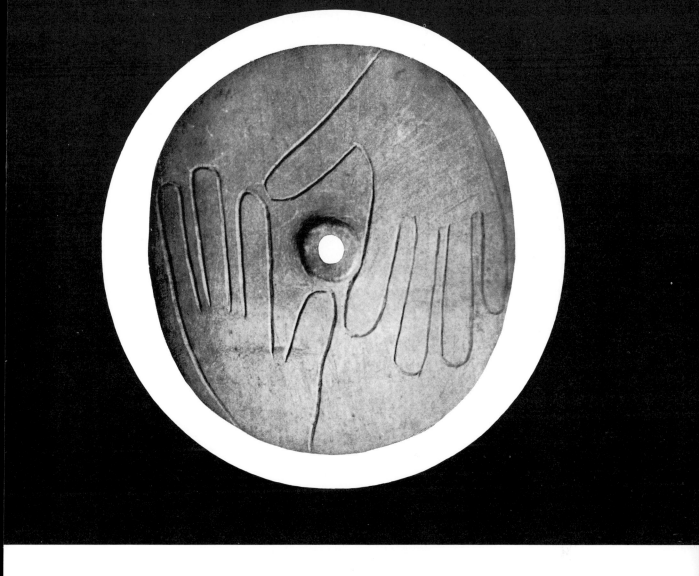

28 UPPER LEFT
Tribe: Salish Location: Provincial Museum, Victoria, B.C.
Diameter: 8½ in. Museum Number: 456
Collected at Nanaimo, British Columbia, 1884.
A spindle whorl crudely carved in maple wood.

29 LOWER LEFT
Tribe: Salish Location: Provincial Museum, Victoria, B.C.
Diameter: 9¼ in. Museum Number: 1180
Collected by C. F. Newcombe at Beecher Bay, British Columbia, 1908.
Spindle whorl carved in maple wood. The designs of spindle whorls are various and
complex. A simple design with elements radiating from a point in the center is the usual
one.

30 ABOVE
Tribe: Salish Location: Provincial Museum, Victoria, B.C.
Diameter: 8½ in. Museum Number: 2389
Collected by C. F. Newcombe at Nanaimo, British Columbia, 1912.
Spindle whorl carved in maple wood, the outline of the hands incised. A more sophisti-
cated design than those shown on the left. Note that both are left hands and that one is
minus a finger, perhaps omitted because of lack of space.

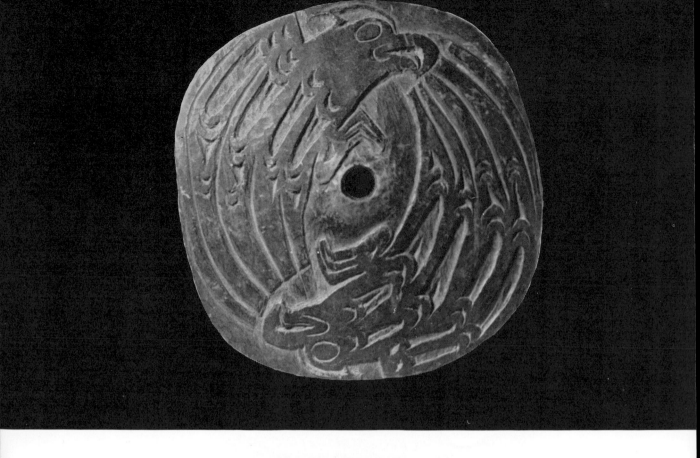

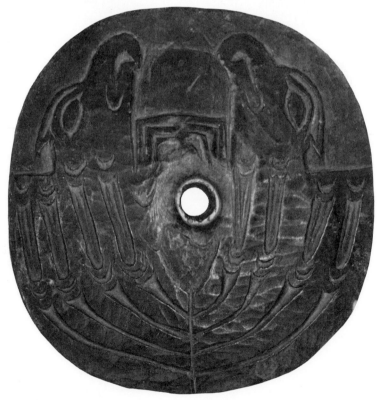

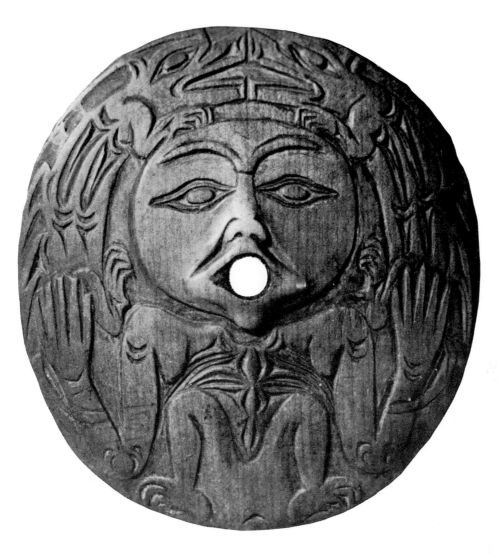

31 UPPER LEFT
Tribe: Salish Location: Provincial Museum, Victoria, B.C.
Diameter: Approx. 8 in. Museum Number: 2906
Spindle whorl carved in maple wood, representing two thunderbirds. The design is based on the shape of the whorl itself.

32 LOWER LEFT
Tribe: Salish Location: Washington State Museum
Diameter: 8 in. Museum Number: 1-276
Collected by W. F. Shelley on Vancouver Island, British Columbia.
Carved wooden spindle whorl, the design represents two thunderbirds. The area is split in half and then one of the halves split again and the design fitted into the spaces.

33 ABOVE
Tribe: Salish Location: Provincial Museum, Victoria, B.C.
Diameter: 8½ in. Museum Number: 2454
Collected by C. F. Newcombe at Cowichan, British Columbia, 1912.
Spindle whorl carved in maple wood, represents a man and what appears to be two otters. This is an excellent example of the finest type of carved spindle whorls from the Salish area. A circle is placed inside the circular whorl, but off center. In this way three circles, counting the center hole, each different in size, provide variation. The designs on the bodies of the otters, as well as on the forearms of the man, his eyebrows, feet, and so on, are all related to the circular space to be filled. The man's body occupies an area about the same size as his head, yet is squarish in shape to provide contrast. The shoulders of the man, his elbows, and knees all repeat the same curves.

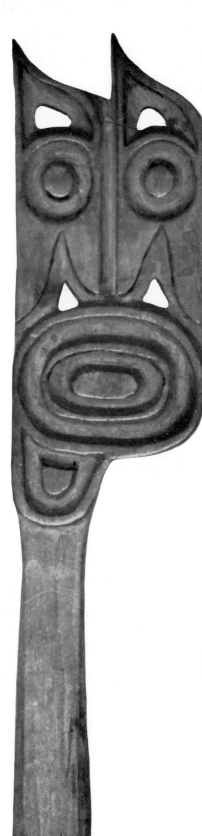

34 LEFT

Tribe: Tlingit Thickness: ⅝ in.
Length: 7½ in. Location: Washington State Museum
Width: 1¾ in. Museum Number: 1869
Collected by G. T. Emmons.
Raven's wing carved from red cedar; used to stamp the totemic design on the face of the owner. Both sides of the stamp are carved alike so that the impression can be stamped on both cheeks. The face of the stamp was rubbed with tallow, then covered with charred wood powder, and pressed on the face.

35 BELOW

Tribe: Haida Location: Washington State Museum
Diameter: 15½ in. Museum Number: 1-357
Height: 7 in.
Collected by Mrs. Thomas Burke, Queen Charlotte Islands, B.C.
Hat woven from spruce roots with painted design of an eagle. The split design permits the crown of the hat to rise. A good example of the way in which an animal is adapted to fit the space.

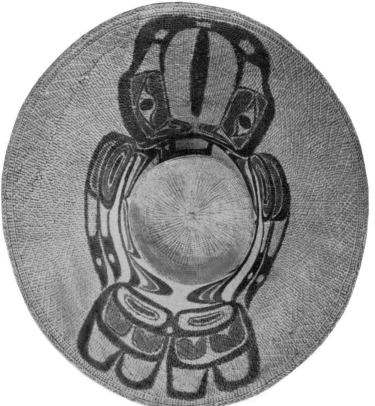

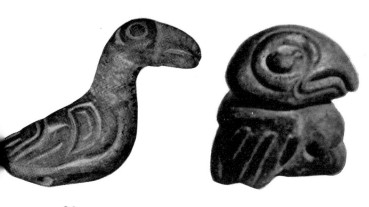

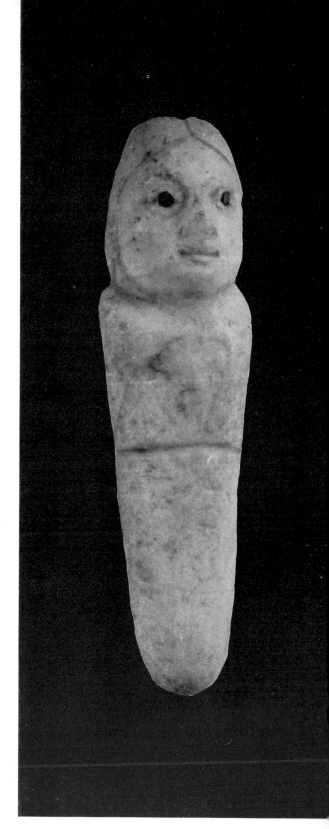

36 UPPER LEFT
Tribe: Tlingit
Length: 1⅝ in.
Height: 1½ in.
Location: Washington State Museum
Museum Number: 4769
Collected by J. T. White in southeastern Alaska, 1894.
This small piece of carved shale in the shape of a raven was probably used as a blanket fastener or worn as an ornament.

37 UPPER RIGHT
Tribe: Tsmishian
Height: 2¼ in.
Width: 2½ in.
Thickness: 1½ in.
Location: Provincial Museum, Victoria, B.C.
Museum Number: 1585
Collected by C. F. Newcombe at Grenville, British Columbia, 1913.
Carved sandstone charm representing an eagle, traces of red paint remain.

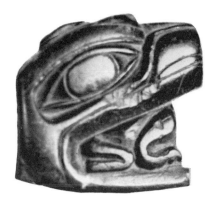

38 ABOVE
Tribe: Tsimshian
Height: 2 in.
Width: 2½ in.
Thickness: ½ in.
Location: Provincial Museum, Victoria, B.C.
Museum Number: 1586
Collected by C. F. Newcombe at Grenville, British Columbia, 1913.
Black stone charm carved to represent a bear eating a man. The man's head has been broken off. This carving originally came from Skidegate, Queen Charlotte Islands, B.C., although attributed to the Tsimshian because of the place of collection.

39 ABOVE
Tribe: Tsimshian
Length: 6 in.
Diameter: 1½ in.
Location: Provincial Museum, Victoria, B.C.
Museum Number: 4214
Marble fetish carved as a human head, the eyes inlaid with abalone shell. Such fetishes were attached to war canoes.

40

Tribe: Salish Location: Provincial Museum, Victoria, B.C.

Height: 10½ in. Museum Number: 3151

Width: 6½ in.

Collected by J. R. Butler at Departure Bay, Vancouver Island, B.C., 1921.

Ceremonial dish carved from pumice to represent a seated figure. One of the many dishes of this type found only in the Salish area. The portrayal of the ribs of the figure is highly unusual. Objects of this type from the Salish area do not seem to fall into the stylistic form of most Northwest Coast art; perhaps because they were carved by an older group.

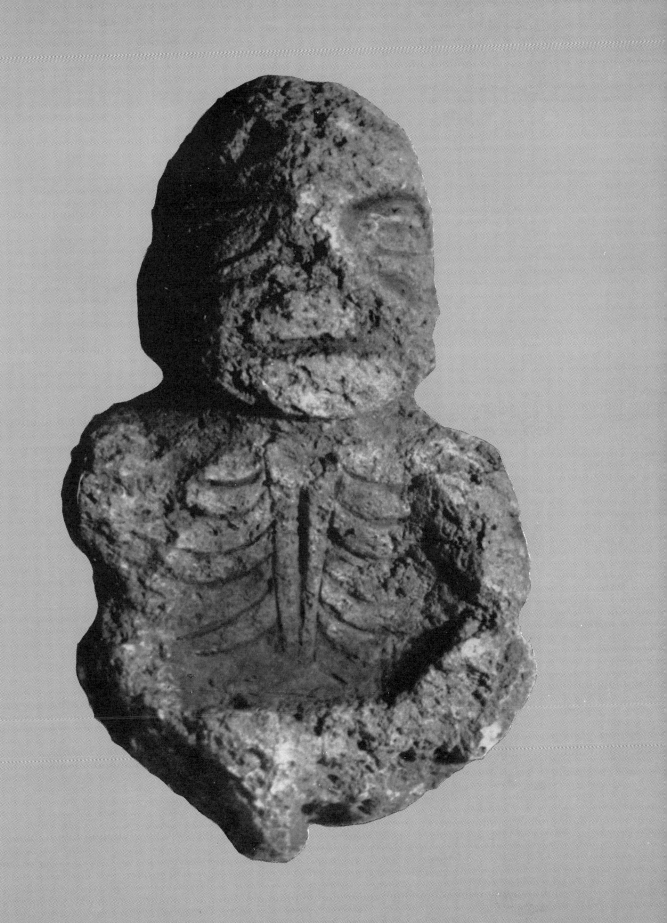

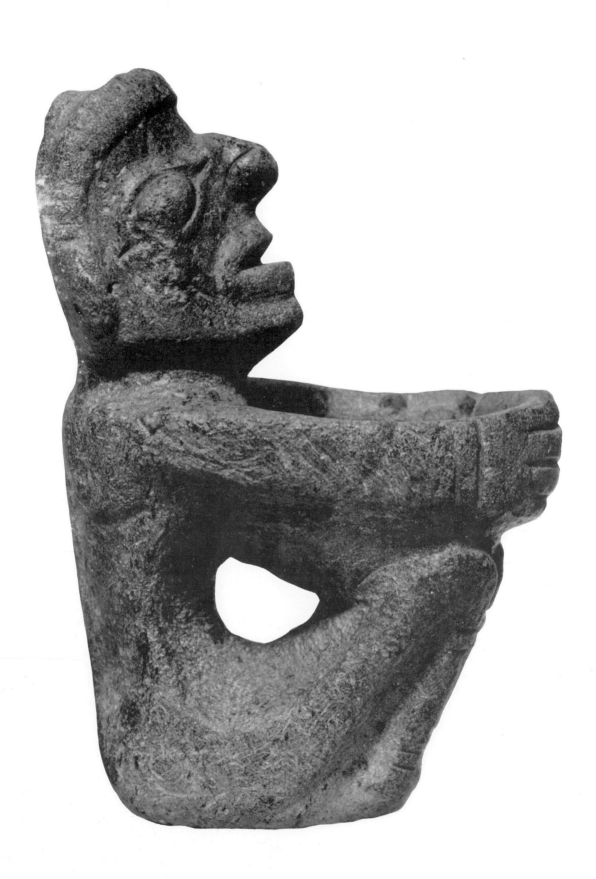

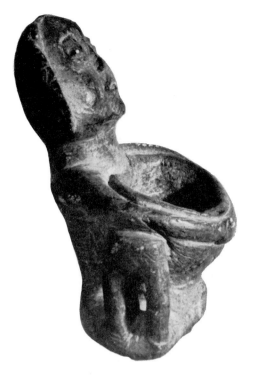

41 LEFT
Tribe: Unknown
Measurements: Unknown
Location: British Museum
Copyright photograph, British Museum.
Stone figure similar in form to Salish figures. Except for the rendering of the eye, which is typical of the Northwest Coast, the figure might have come from many other areas in the world, it is reminiscent of Mayan sculpture.

42 ABOVE AND RIGHT
Tribe: Salish
Height: 9 in.
Width: 5½ in.
Depth: 5 in.
Location: Provincial Museum,
 Victoria, B.C.
Museum Number: 2996
Collected by the Rev. Groucher at
 Yale, British Columbia.
Ceremonial dish carved from steatite in the form of a human figure. This dish is the unusual type found in the Salish area.

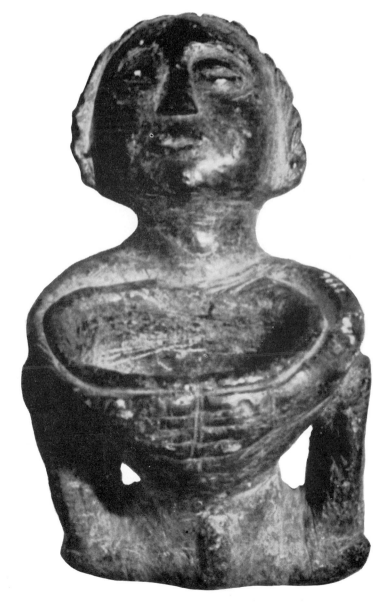

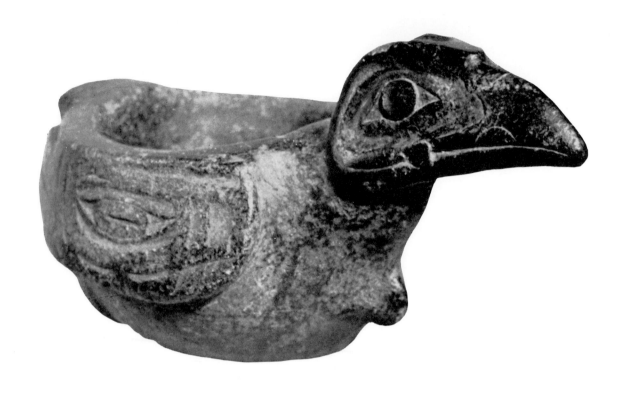

43 LEFT

Tribe: Haida
Length: 13 in.
Width: 7 in.
Depth: 5 in.
Location: Provincial Museum, Victoria, B.C.
Museum Number: 4115

Stone mortar carved in the shape of a bird, probably a raven. Mortars of this general type were common to the whole Northwest Coast area.

44 BELOW

Tribe: Salish
Length: Approximately 10 in.
Location: Provincial Museum, Victoria, B.C.
Museum Number: 615

Collected by J. Levy at Victoria, B.C., in 1889.

Stone mortar carved in the shape of a bird. This Salish specimen is inferior in craftsmanship to the Haida mortar in plate 43.

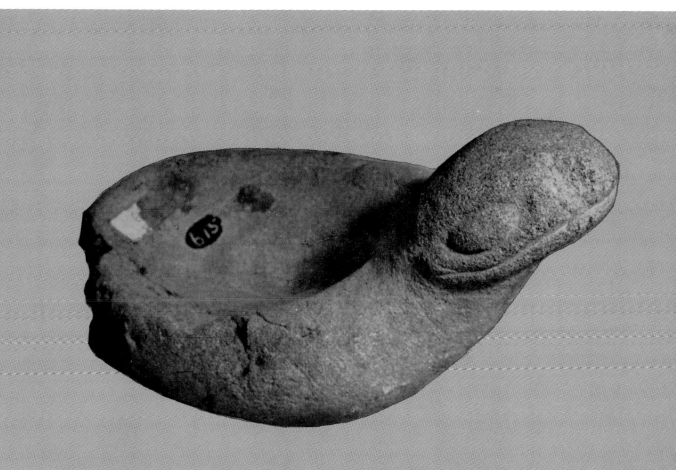

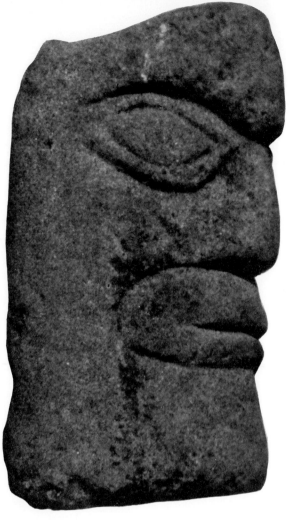

45 ABOVE AND RIGHT
Tribe: Salish
Height: 7½ in.
Width: 4½ in.
Thickness: 4½ in.
Location: Provincial Museum, Victoria, B.C.
Museum Number: 1138
Collected by J. E. Revsbeck at Yale, British
 Columbia, 1905.
A stone mortar carved as a human head; the
actual bowl is in the top of the head.

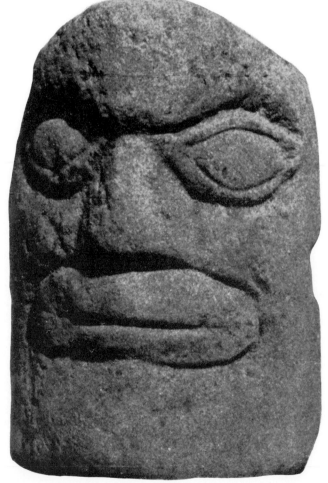

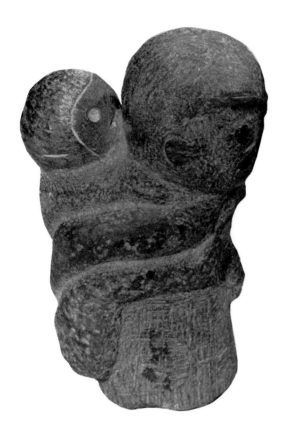

46 LEFT

Tribe: Kwakiutl · Location: Anthropological Museum, Univ. British Columbia, Vancouver, B.C.

Height: 5 in.

Width: 3¼ in.

Museum Number: A 1112

Photograph, Visual Education Service, University of British Columbia.

Collected at Bella Bella, British Columbia, and presented to the Museum by Dr. G. E. Darby.

Stone carving representing a mother and child.

47 BELOW

Tribe: Kwakiutl · Location: Anthropological Museum, Univ. British Columbia, Vancouver, B.C.

Height: 8¼ in.

Width: 13 in.

Museum Number: 1131

Photograph, Visual Education Service, University of British Columbia.

Collected at Bella Bella, British Columbia, and presented to the Museum by Dr. G. E. Darby.

Sandstone carving representing a killer whale with an eagle sitting on its back.

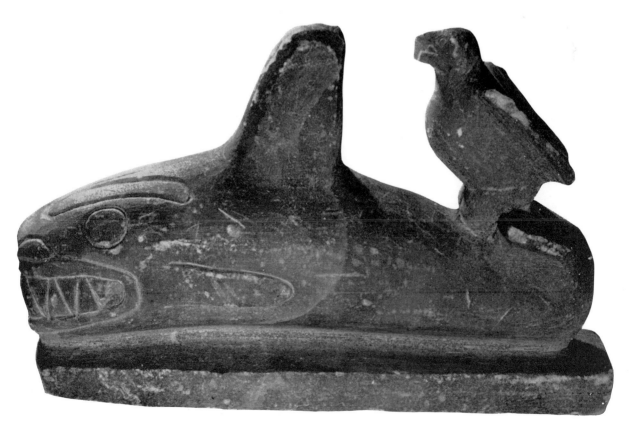

48
Tribe: Unknown
Height: 30 in.

Location: Anthropological Museum, Univ. British Columbia, Vancouver, B.C.
Museum Number : 1854

Photograph, Visual Education Service, University of British Columbia.
Presented to the Museum by A. L. White.
A prehistoric stone carving of a human head. This head is similar to the objects uncovered in the Fraser River midden.

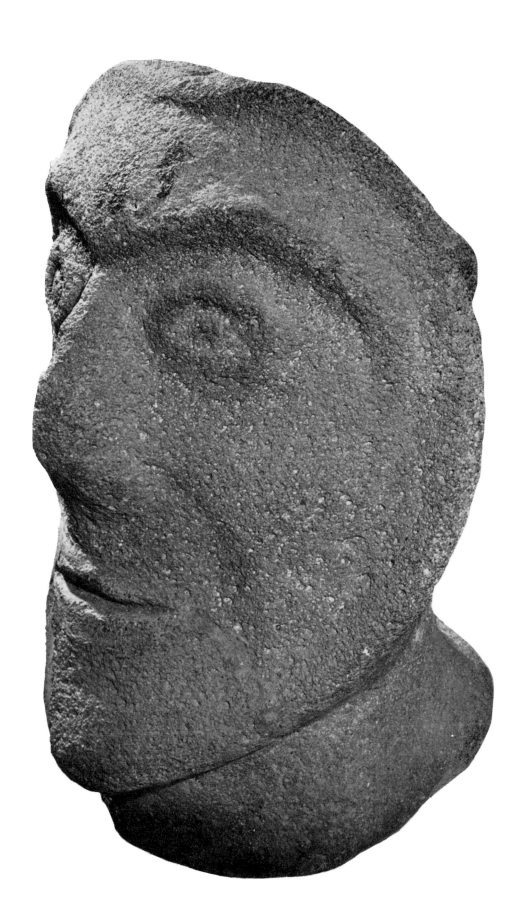

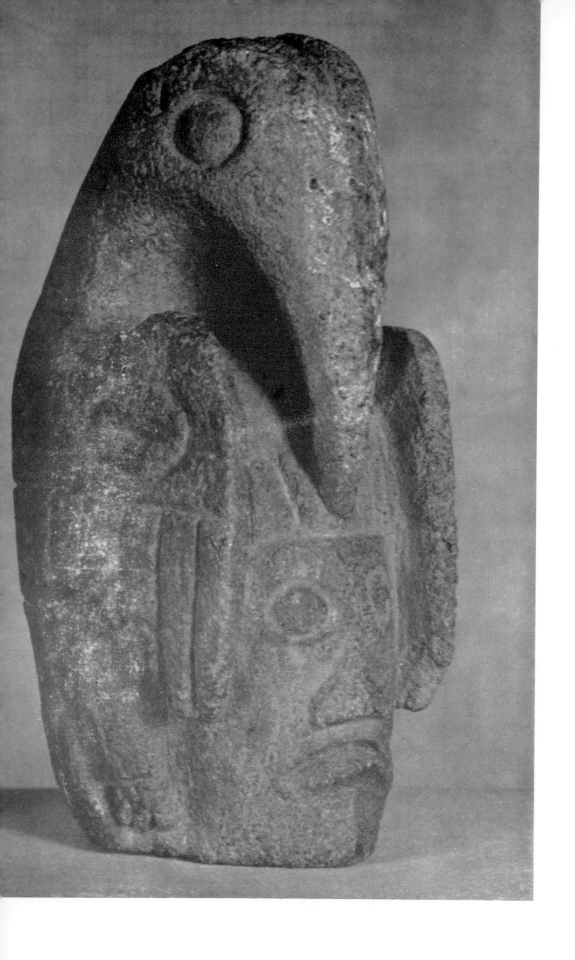

49 LEFT
Tribe: Tlingit
Height: 5 in.
Width: 2¾ in.
Depth: 2½ in.
Location: Washington State
Museum
Museum Number: 2225
Collected by G.T. Emmons at Sitka,
Alaska.

Stone carved in the shape of a seated raven with a human head at the base. The relationship of scale to size is so well conceived that the carving might be several feet high instead of merely five inches. A series of vertical curved lines are set up by the arch of the head and beak which is repeated in the wings. The downward sweep of the beak to a point is contrasted by the upward sweep formed by the wings. The eye of the raven is repeated on the side of the wings and in the eyes of the human head. The whole concept is monumental with interesting relationships between space and movement.

50 RIGHT
Tribe: Kwakiutl
Height: Approximately 6¾ in.
Location: Wolfgang Paalen Collection
Photograph by Manuel Alvarez Bravo.

Pecked stone figure; although found at Bella Bella, British Columbia, it is reminiscent of Salish stone figures.

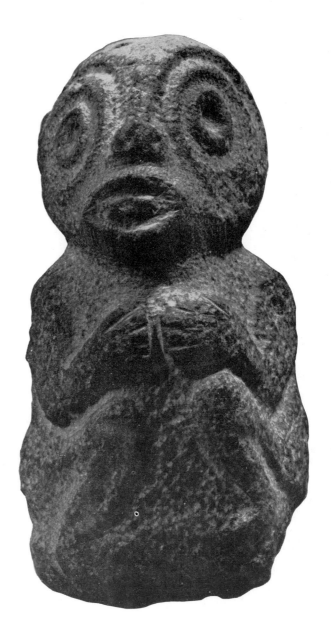

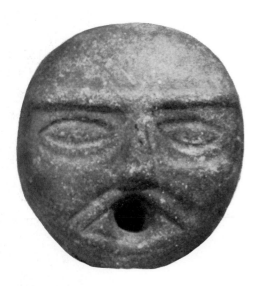

51 LEFT

Tribe: Kwakiutl

Diameter: 5 in.

Thickness: 2½ in.

Location: Provincial Museum, Victoria, B.C.

Museum Number: 2096

Collected by C. F. Newcombe at Alert Bay, British Columbia, 1912.

Stone head of a slave-killing club, carved to represent a human face. The haft fits into the hole in the mouth.

52 RIGHT

Tribe: Kwakiutl

Height: 15½ in.

Width: 9¾ in.

Thickness: Approx. 3½ in.

Location: Walter C. Arensberg Collection

Photograph by Brook Cuddy.

Pile driver made from pecked stone. Slots on the back receive the fingers of each hand while the thumbs grasp the front of the stone and fit into the grooves which form the eyes; a grip which gives the holder a firm grasp on the stone and enables him to use the lower edge as a pounding surface. The carving and concept are unique. The narrow ridge extending upward from the nose divides the space into halves. The round top, eye forms, and mouth shape all repeat one another in a series of curvilinear rhythms. The general shape of the stone is skillfully broken at the eye level to divide the space into two sections.

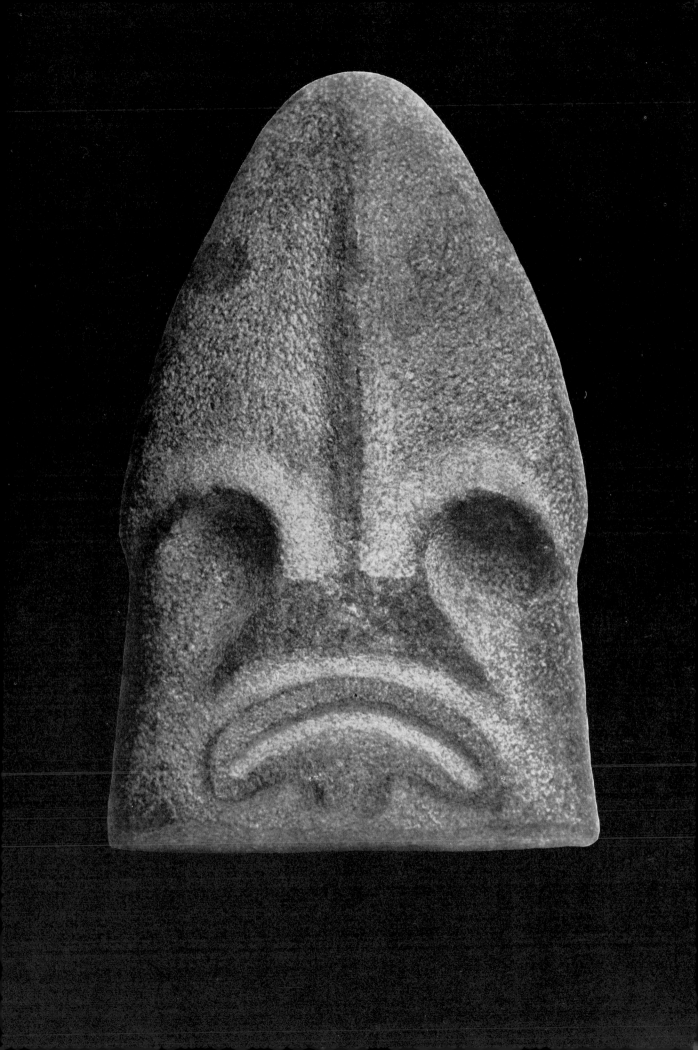

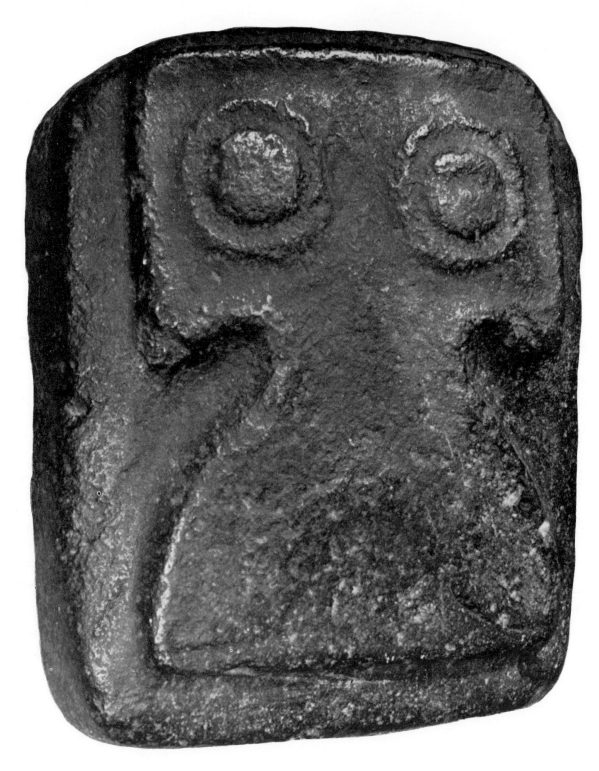

53

Tribe: Kwakiutl Location: Anthropological Museum, Univ. British Columbia, Van-
Height: 14 in. couver, B.C.
 Museum Number: A 1853, Raley Collection
Photograph, Visual Education Service, University of British Columbia.
Stone pile driver used for pounding stakes for fishing wiers and similar constructions.

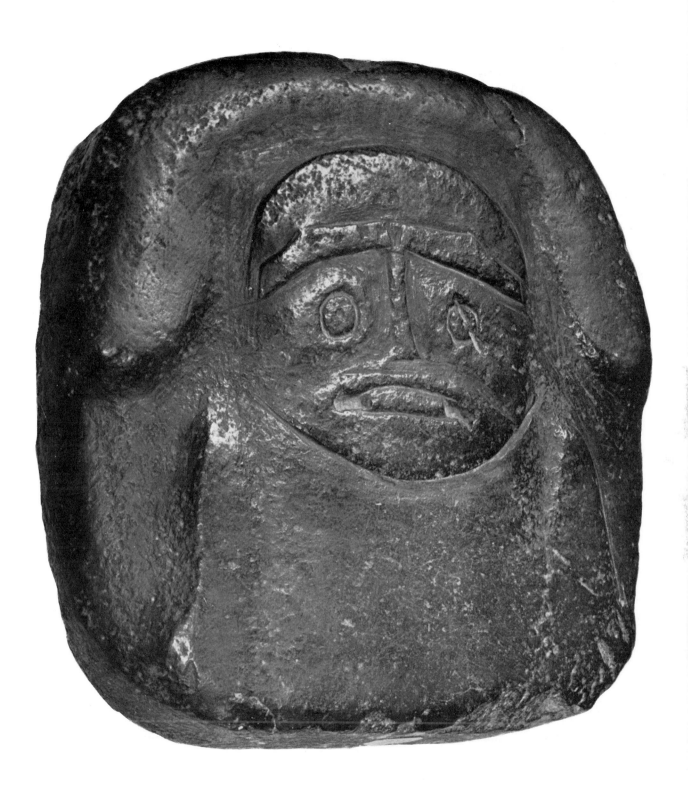

54

Tribe: Kwakiutl Location: Anthropological Museum, Univ. British Columbia, Van-
Height: 14 in. couver, B.C.

Museum Number: A1852, Raley Collection

Photograph, Visual Education Service, University of British Columbia.

Stone pile driver. Note the grooves for thumb and fingers.

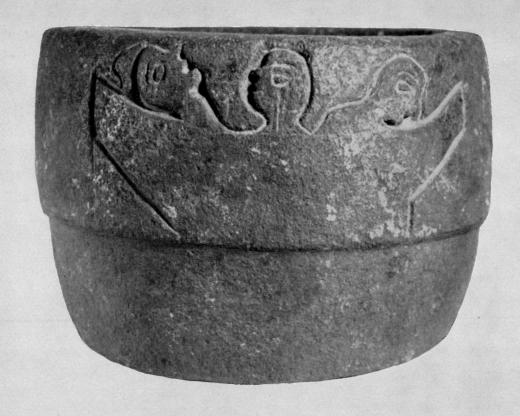

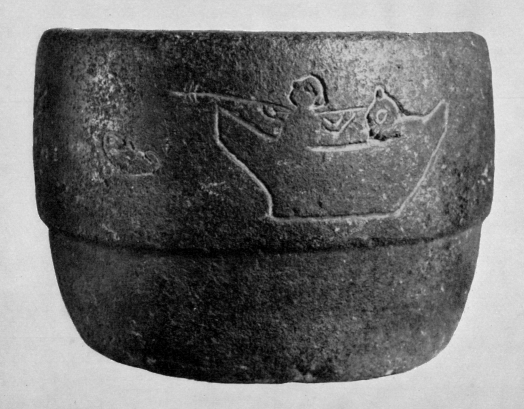

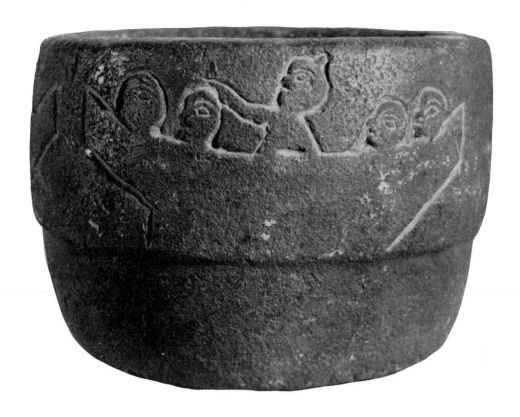

55 (THREE VIEWS)

Tribe: Kwakiutl Thickness: 1 in.
Diameter: 10 in. Location: Provincial Museum, Victoria, B.C.
Height: 6 in. Museum Number: 334
Collected by F. Jacobsen at Bella Bella, British Columbia, 1893.
Stone mortar with a seal hunt incised around the upper half. The simplicity of the
symmetrical designs, except for the canoe and harpooner, is due no doubt to the diffi-
culty of incising on stone. The size of the humans indicates the interest of the artist in
the characters displayed. The canoe is distorted, yet its essential characteristics are
preserved.

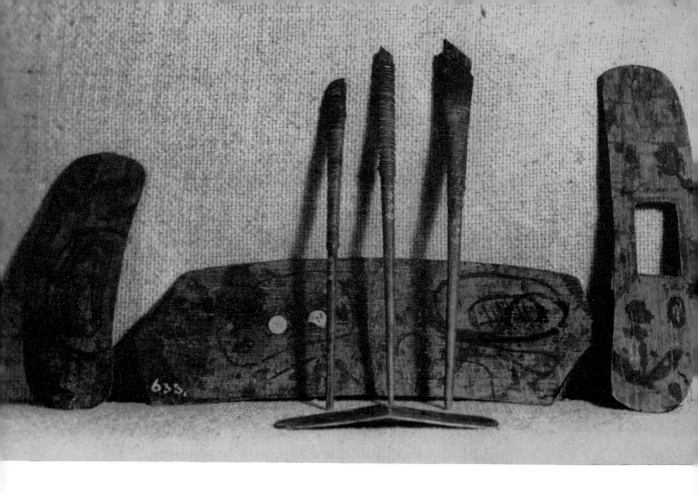

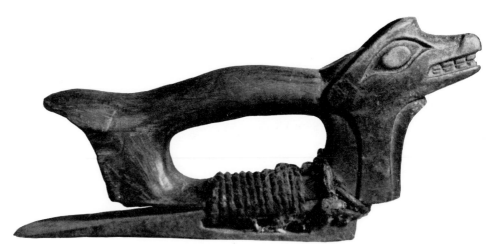

56 UPPER LEFT

Tribe: Kwakiutl
Lengths of Pattern Boards: 4½–10½ in.
Widths of Pattern Boards: 1½–3¼ in.
Length of Brushes: 7½–8¼ in.
Location: Provincial Museum, Victoria, B.C.
Museum Numbers: Pattern Boards, 641
 (10), 641 (15), 633, 636
 Brushes: 642, 643, 644
Collected by F. Jacobsen at Bella Bella, Brit-
 ish Columbia, 1893.

Pattern boards made of cedar, used to trace
ovular shapes on object to be painted. Use
of these boards assured regularity of shapes
when the pattern was used as the outline for
the eye design. Paint brushes have wooden
handles and the bristles are inserted. The
object in the foreground is a pattern which
has been folded and then cut so that both
halves would be the same. Plates showing
boxes and other material with two-dimen-
sional designs will show how the pattern
board was used.

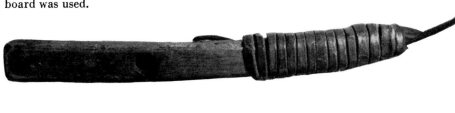

58 ABOVE

Tribe: Kwakiutl
Length: 10¾ in.
Width: 1 in.
Location: Provincial Museum, Victoria, B.C.
Museum Number: 490
Collected by F. Jacobsen at Bella Bella, Brit-
 ish Columbia, 1893.

Knife made from a piece of bent metal tied
with leather strips to a wooden handle; used
for carving small wooden objects.

57 LOWER LEFT

Tribe: Kwakiutl
Length: 10½ in.
Width: 1½ in.
Depth: 4½ in.
Location: Provincial Museum, Victoria, B.C.
Museum Number: 531
Collected by W. Haines in northern British
 Columbia, 1894.

Hand adze, the haft carved from wood and
a commercial metal ax blade lashed to the
underside. This tool is used in carving every-
thing from wooden masks to totem poles.

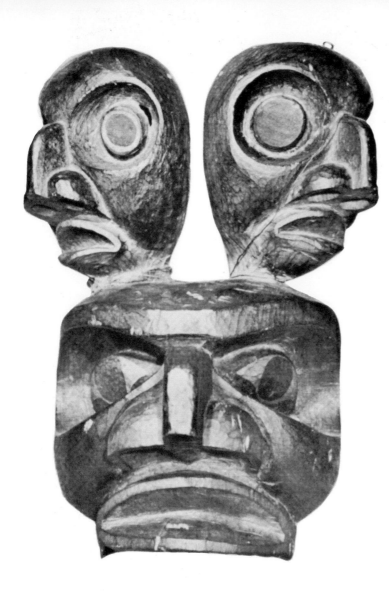

59 LEFT

Tribe: Tsimshian

Location: Anthropological Museum, Univ.
British Columbia, Vancouver, B.C.

Museum Number: 1784, Raley Collection

Photograph, Visual Education Service, University of British Columbia.

Collected near Kitlope, Gardner Channel,
British Columbia, 1897.

Wooden ceremonial mask found in the burial cave of a chief. Although found in Tsimshian territory this mask is typical of the "Cowichan type" of the Salish.

60 AND 61 RIGHT

Tribe: Salish

Height: Approx. 2 ft.

Width: Approx. 1½ in.

Location: Washington State Museum

Collected by Professor Erna Gunther and
the author at Lumni Island, Washington,
about 1940.

These cedar wood masks are painted in brilliant red, blue, and black. The traditional "Cowichan type" is apparent here in the use of bird heads projecting from the forehead and forming the nose. Note the projecting eyes.

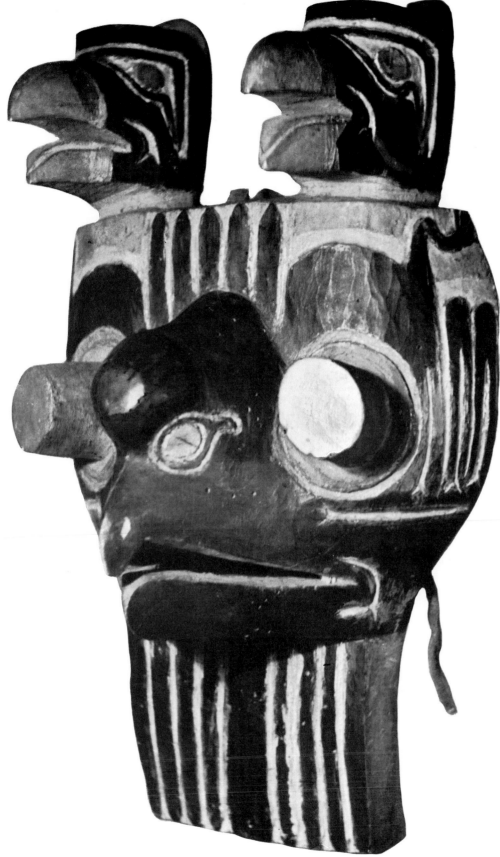

62

Tribe: Salish

Location: Provincial Museum, Victoria, B.C.

Museum Number: 2364

Collected by C. F. Newcombe at Cowichan, Vancouver Island, B.C., 1912.

Wooden dance mask painted red, black, and white. A traditional type produced by the Salish, particularly in the Cowichan district of Vancouver Island, often called "Cowichan type" mask. Typical features are the birds' heads rising above the forehead, the bird's head forming the nose, the protruding eyes, and the parallel lines of decoration.

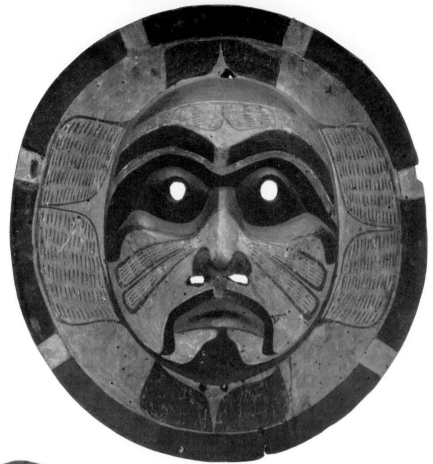

63 RIGHT
Tribe: Kwakiutl
Measurements: Unknown
Location: Museum of the American Indian
Museum Number: 8/1657
Photograph, Museum of the American Indian, Heye Foundation.
A carved mask, decorated with paint.

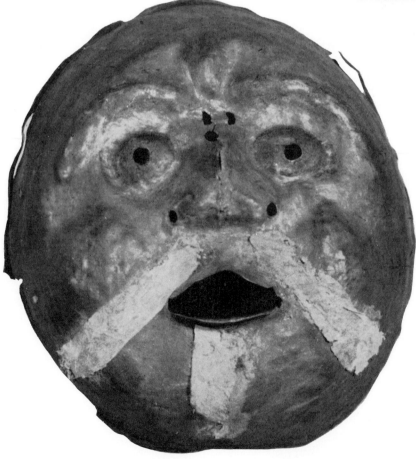

64 LEFT
Tribe: Tsimshian
Diameter: 8 in.
Depth: 2 in.
Location: Provincial Museum, Victoria, B.C.
Museum Number: 2900
Collected by G. T. Emmons at Kispiox on the Skeena River, British Columbia, 1916.
Mask hammered out of a sheet of copper; three paint lines on the face represent a mustache and a beard. The mask was used in winter ceremonials to represent a human face. If the collector was not so well known and the place of collection unknown it would be difficult to accept this mask as of Northwest Coast origin. Stylistically it has nothing in common with Northwest Coast art and, further, copper masks are rare in this area.

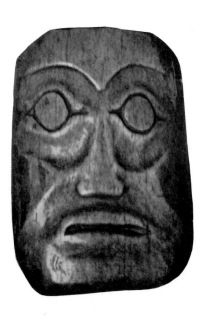

65 LEFT

Tribe: Tlingit

Height: 8 in.

Location: Washington State Museum

Museum Number: 1200

Collected by G. T. Emmons at Chichagof Island, Alaska, before 1900. Whalebone mask carved to represent a human face. Such masks were carried or worn on ceremonial occasions. Whalebone masks are uncommon.

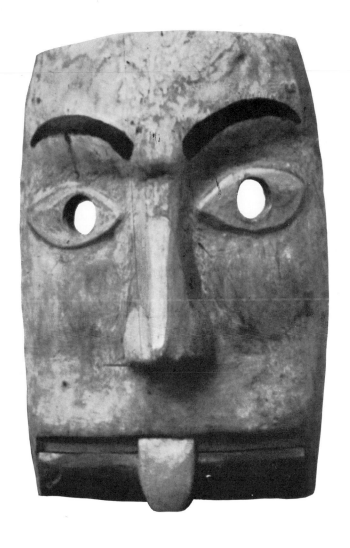

66 LEFT

Tribe: Nootka

Height: 3 ft. 4 in.

Width: 28 in.

Location: Provincial Museum, Victoria, B.C.

Museum Number: 5035

Collected by Captain Thompson on Vancouver Island, British Columbia, 1937.

Carved wooden mask painted green, red, and black.

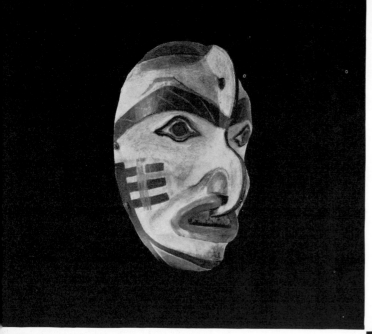

67 LEFT
Tribe: Tlingit
Height: 9¾ in.
Width: 7 in.
Depth: 5¾ in.
Location: Ralph Altman Collection
Collected before 1900.
Hawk mask carved in cedar and painted
blue-green, red, and black.

68 RIGHT
Tribe: Tsimshian
Height: 7½ in.
Width: 6 in.
Location: Provincial Museum, Victoria, B.C.
Museum Number: 1510
Collected by C. F. Newcombe, 1912.
Carved and painted red cedar potlatch mask,
used in the Man-Burned-in-the-Fire Dance.
The mask is intended to show the skin in
strips. The material tacked on the surface is
human skin, the teeth are of bone.

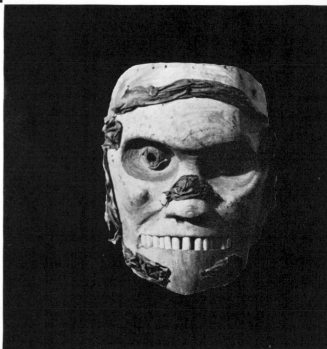

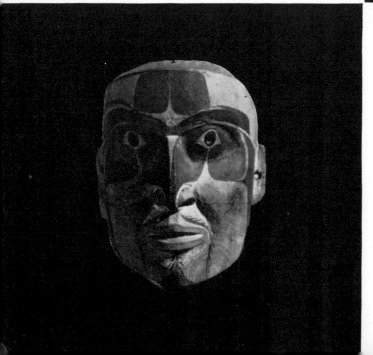

69 LEFT
Tribe: Kwakiutl
Height: 9 in.
Width: 7 in.
Location: Provincial Museum, Victoria, B.C.
Museum Number: 10
Collected by F. Jacobsen, 1893.
Carved wooden mask, called Tlaolacha, used
in Kwakiutl potlatchs; painted blue, red,
and black.

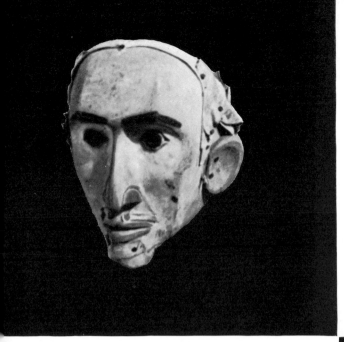

70 LEFT
Tribe: Tsimshian
Height: 8 in.
Width: 7 in.
Location: Provincial Museum, Victoria, B.C.
Museum Number: 1517
Collected by C. F. Newcombe, 1912.
Carved wooden potlatch mask. The face painted white with red lips, nostrils, and line on nose. Originally this mask had a mustache and goatee of animal hair, but today all that remains is the hide tacked into place. The mask represents a white man and, because of the unusual face, it must be a portrait mask. The long thin face, pointed chin, and type of nose give this mask a decided Semitic appearance.

71 RIGHT
Tribe: Kwakiutl
Height: 10 in.
Width: 9 in.
Location: Provincial Museum, Victoria, B.C.
Museum Number: 72
Collected by F. Jacobsen, 1893
Wooden mask carved and painted blue-green, with red lips, black nostrils, and eyebrows. In this mask a series of curves are repeated to good effect.

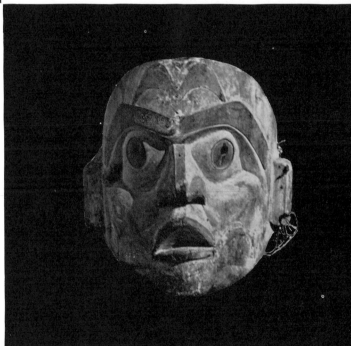

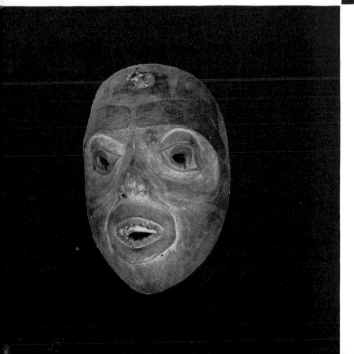

72 LEFT
Tribe: Tlingit
Height: 9½ in.
Width: 6½ in.
Depth: 4¾ in.
Location: Ralph Altman Collection
Collected before 1900.
Carved wooden mask painted in blue-green, red, and black.

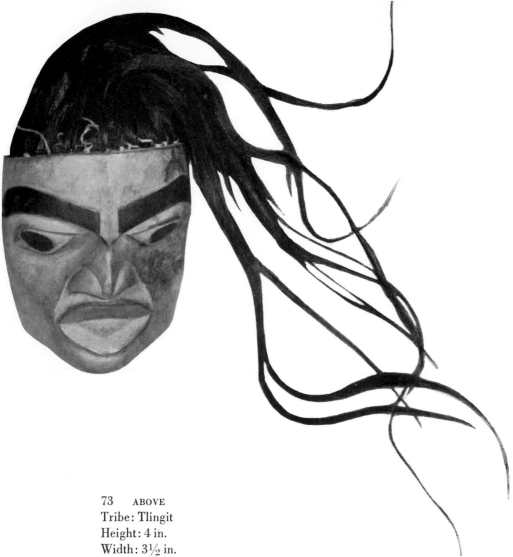

73 ABOVE
Tribe: Tlingit
Height: 4 in.
Width: 3½ in.
Location: Washington State Museum
Museum Number: 2264
Collected by G. T. Emmons at Kluckwan,
 Alaska.
Miniature mask carved in yellow cedar and
painted. This mask is attached to a head-
dress of eagle feathers and swansdown; used
by a shaman while exorcising evil spirits
from the sick or bewitched. The mask repre-
sents a spirit which the shaman controls and
impersonates. Human hair is inserted at the
top.

74 RIGHT
Tribe:
Height: 11 in.
Width: 9½ in.
Depth: 8 in.
Location: Ralph Altman Collection
Collected before 1900.
Carved wooden mask of a hawk, painted
red, black, and white. The angle of the eye,
the downward sweep of the nose, the upper
lip line, and the parted lips all give a defi-
nite expression to the mask.

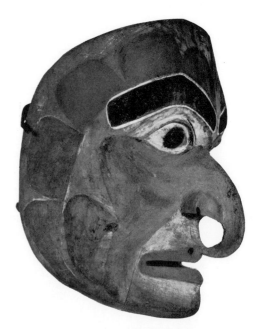

75 RIGHT

Tribe: Unknown

Height: 12 in.

Width: 10½ in.

Depth: 7 in.

Location: Formerly in the Julius Carlebach Collection; at present in the Denver Art Museum

Carved and painted wooden mask which obviously represents a white man, perhaps one of the early New England sea captains. Shows traces of white paint on face, lips painted red, hair and beard, black. Pitch on forehead and chin indicate where human hair was applied.

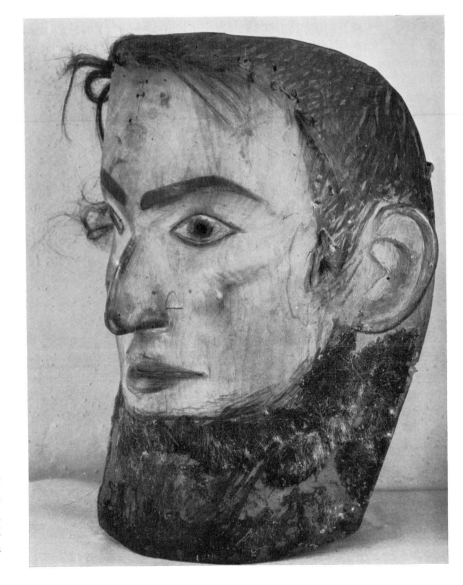

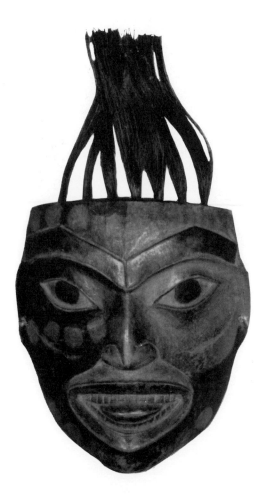

76 LEFT

Tribe: Tlingit Location: Washington State Museum
Height: 3¼ in. Museum Number: 1133
Width: 2¾ in.
Collected by G. T. Emmons at Sitka, Alaska.
Miniature mask representing a Tlingit face, carved in yellow cedar and painted red, blue, and black. Worn in general dances on the front of a headdress made of fur and feathers.

77 RIGHT

Tribe: Tlingit Location: Washington State Museum
Height: 7½ in. Museum Number: 2032
Width: 5¾ in.
Collected by G. T. Emmons near Yakutat Bay, Alaska.
Dance mask carved in yellow cedar and painted; represents a bear's face. Attached to the cheeks and chin are small carvings each with the head of a land otter and an octopus tentacle as the body. The circles of the eyes are repeated in the nostrils. The eyebrows have the usual stylized shape, but are here joined at the bridge of the nose.

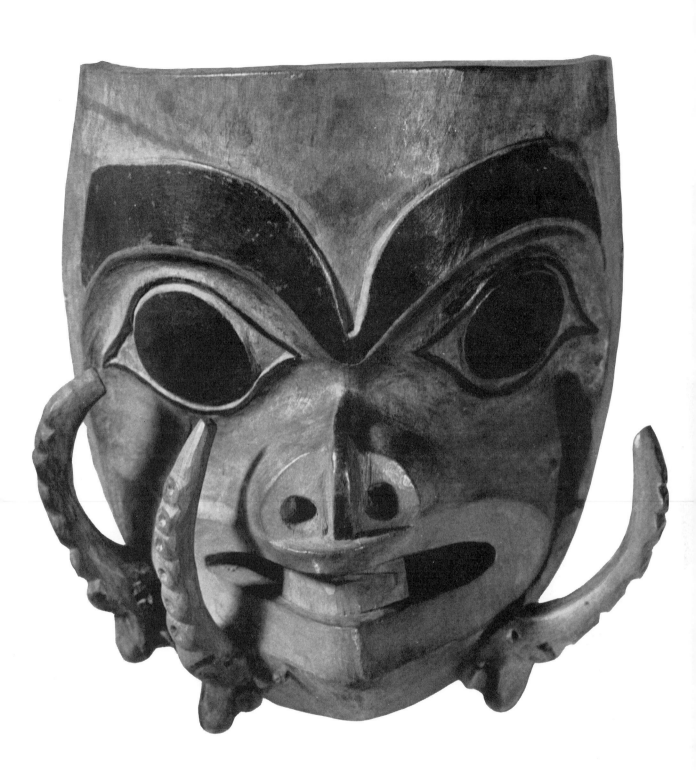

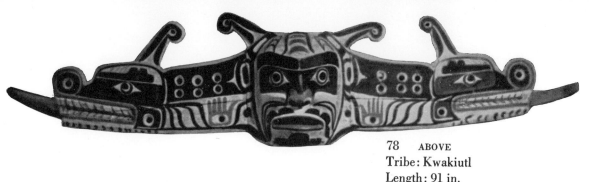

78 ABOVE
Tribe: Kwakiutl
Length: 91 in.
Height: 19 in.
Depth: 7 in.
Location: Provincial Museum, Victoria, B.C.
Museum Number: 1954
Collected by C. F. Newcombe at Fort Rupert, Vancouver Island, B.C., 1912.
Carved wooden masklike object painted black, green, white, and red. The figure represents the Sisiutl. See plate 14.

79 BELOW
Tribe: Unknown
Height: 9 in.
Width: 11 in.
Length: 15 in.
Location: Museum of Anthropology, Univ. California, Berkeley
Museum Number: 2-4771
Collected before 1904.
Carved wooden headdress representing a wolf, probably the crest of the owner, painted black, blue, and white. Although the actual tribe from which this headdress came is not known, it is similar in style to headdresses from the Tlingit area.

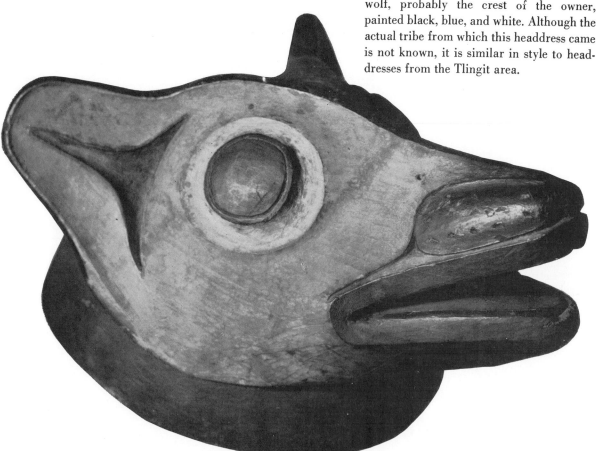

80
Tribe: Tlingit
Location: Washington State Museum
Museum Number: 2313
Collected by G. T. Emmons at Shakan,
 Prince of Wales Island, Alaska, before
 1900.
Headdress carved in wood, painted black,
ornamented with human hair. The design
represents a whale, the characteristic fin and
round eye are the obvious symbols.

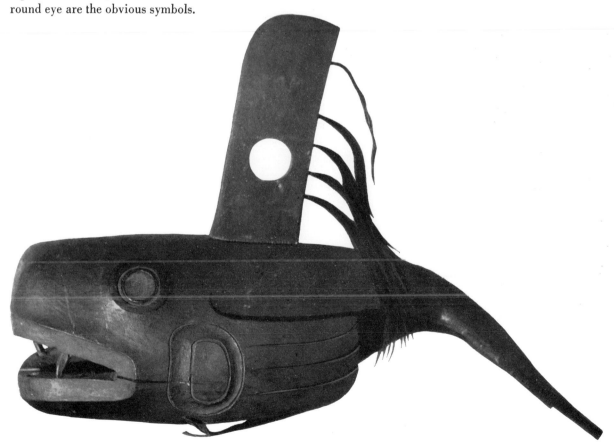

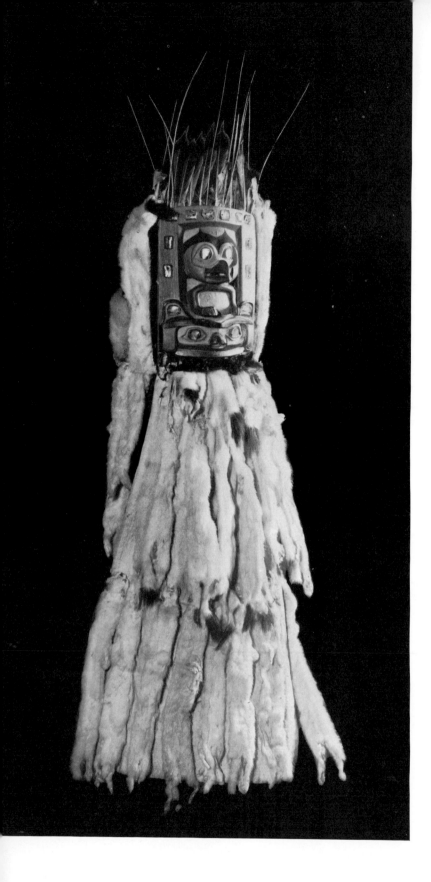

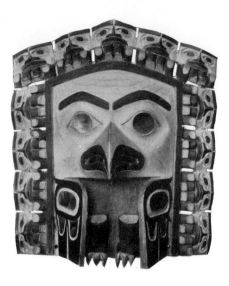

81 LEFT
Tribe: Tlingit
Over-all Height: 42 in.
Width: 9 in.
Location: Washington State Museum
Museum Number: 2312
Collected by G. T. Emmons.
Ceremonial headdress representing a raven, the owner's totemic emblem, carved in wood, painted blue-green, red, and black, and inlaid with abalone shell. Above the mask rise sea-lion bristles and flicker feathers; the remainder of the headdress is decorated with ermine skins.

82 ABOVE
Tribe: Tsimshian
Height: 7½ in.
Width: 6¼ in.
Location: American Museum of Natural History
Museum Number: 16/967
Photograph, American Museum of Natural History.
Collected by Franz Boas before 1895. Headdress carved in maple wood with eyes and other ornamentation inlaid abalone shell. The wood is painted black and red. The headdress represents the white owl and the surrounding figures are called "claw men." The small figures around the main face area are similar to those shown in plate 86.

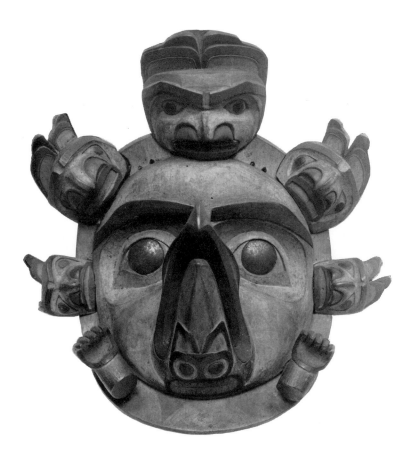

83 ABOVE
Tribe: Unknown
Height: 10½ in.
Location: British Museum
Museum Number: 6437
Copyright photograph, British Museum.
Carved and painted wooden headdress representing a raven.

84 RIGHT
Tribe: Kwakiutl
Location: Wolfgang Paalen Collection
Photograph by Manuel Alvarez Bravo.
Collected by Wolfgang Paalen on Vancouver Island, British Columbia.
A well-designed, carved, and painted headdress inlaid with abalone shell. This excellent carving was originally draped with ermine tails and surmounted with bristles. The design represents a myth of the whale and the raven and is in the general style of headdresses of this type. In many of the works of art from the Northwest Coast animals are represented as coming out of the mouths of humans or other animals.

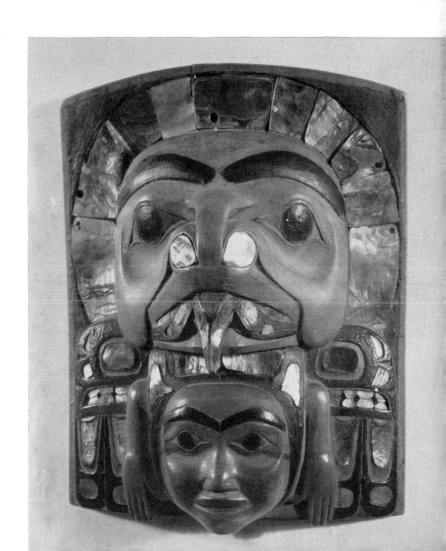

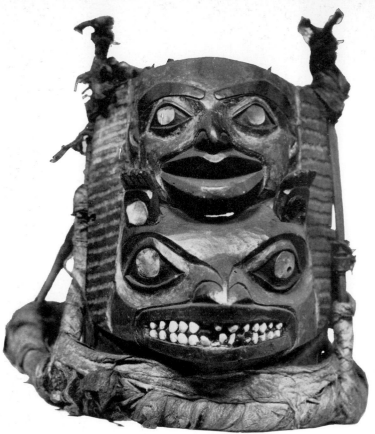

85 ABOVE
Tribe: Nootka Location: British Museum
Height: 5½ in. Museum Number: 1678
Copyright photograph, British Museum.
Carved wooden headdress inlaid with abalone shell and bone, probably contemporaneous
with the material collected by Captain Cook in 1778.

86 UPPER RIGHT
Tribe: Tsimshian Location: Provincial Museum, Victoria, B.C.
Height: 6½ in. Museum Number: 4118
Width: 7 in.
A chief's wooden headdress representing a human face surrounded by eleven small faces.
Painted red, black, and green. The outer ring, the eyes, and teeth are abalone shell. The
use of numerous small faces is found on other headdresses; here they serve to make a
border around the face which maintains interest, since it, too, is made up of faces. The
use of shell against the smooth wood texture provides color and eye variation. The prin-
cipal face is in the form of a rectangle with curved corners. This shape is accentuated by
the smooth bands of wood running around the face which is varied in angle so that it
receives different amounts of light and does not become monotonous. The firm manner
of indicating the line from the nostril to the edge of the mouth with a thin to swelling
line, such as is used in two-dimensional work, and the way the nose and the well-carved
mouth are held together as a unit is very remarkable.

87 LOWER RIGHT
Tribe: Kwakiutl Depth: 8 in.
Length: 6 ft. 2 in. Location: Provincial Museum, Victoria, B.C.
Height: 12 in. Museum Number: 1916
Collected by C. F. Newcombe, 1914.
Carved wooden mask painted black, white, and red, and trimmed with shredded bark of
red cedar dyed with alder juice. This mask represents the raven and the Cannibal of the
Mountains. It is a curious Janus-faced mask. The wearer, by pulling strings, causes the
lower jaws of the birds to clap with loud noises. This mask, as well as others of similar
type, was used in the winter secret society activities of the Kwakiutl.

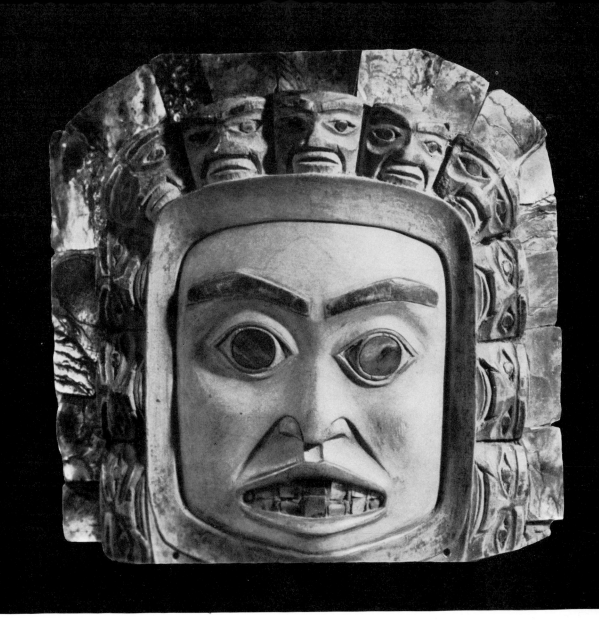

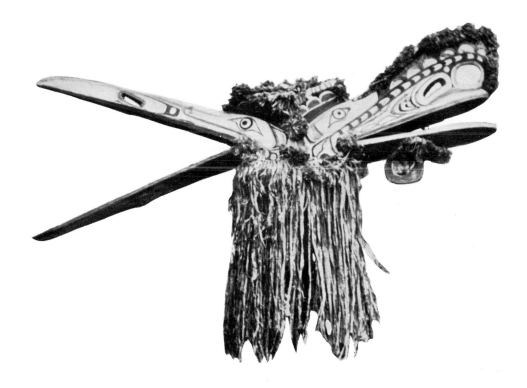

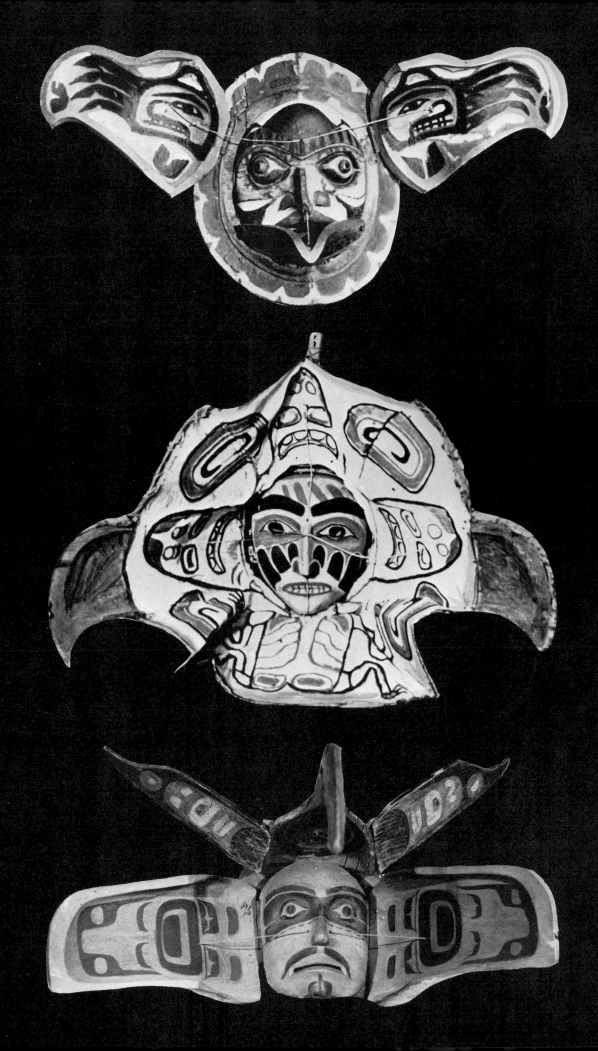

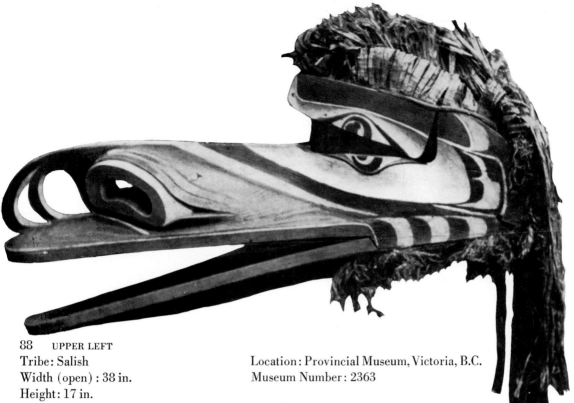

88 UPPER LEFT

Tribe: Salish Location: Provincial Museum, Victoria, B.C.
Width (open): 38 in. Museum Number: 2363
Height: 17 in.
Collected by C. F. Newcombe at Comox, British Columbia, 1912.
Carved wooden mask painted red, white, blue, black, and green. Although collected in
the Salish area and attributed to them, this mask actually came from the Kwakiutl by
intermarriage. The carving is unlike that of the Salish at Comox. This mask is shown
opened to reveal a human face, when closed it represents an eagle.

89 MIDDLE LEFT

Tribe: Haida Location: Provincial Museum, Victoria, B.C.
Width: Approx. 38 in. Museum Number: 1420
Height: 14 in.
Collected by C. F. Newcombe at Masset, British Columbia, 1911.
Carved alder wood mask painted red, black, and green, and fringed with down. When
closed the mask represents an eagle; when opened, it reveals a man's face. The body is
painted on cloth and surrounded by representations of three dogfish. Sometimes this
type of mask opens to reveal a third face.

91 UPPER RIGHT

Tribe: Kwakiutl Location: Provincial Museum, Victoria, B.C.
Length: 35 in. Museum Number: 1917
Height: 11 in.
Depth: 10 in.
Collected by C. F. Newcombe, 1914.
Carved wooden mask representing the Cannibal of the Mountains; painted black, white,
and red. Decorated with a fringe of shredded cedar bark dyed with alder juice. The jaw
is movable and makes a clapping sound; the forehead lifts to expose a copper band.
Generally masks are designed to be seen from the front, but many from the Northwest
Coast are designed also for profile view, as is the one in this plate.

90 LOWER LEFT AND LOWER RIGHT

Tribe: Unknown
Width: Approximately 2 feet
Height: Approximately 3 feet when open
Location: Max Ernst Collection
Carved and painted wooden mask. This is a double mask.
The outer mask represents an eagle which opens to reveal
a human face.

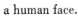

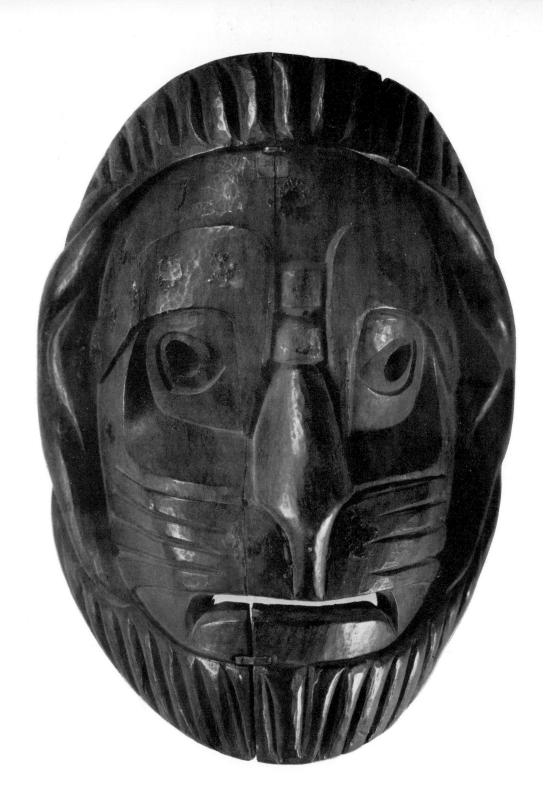

92

Tribe: Kwakiutl Location: Smithsonian Institution

Height: 11 in. Museum Number: 2659

Width: 8¼ in.

Photograph, Smithsonian Institution.

Collected by the United States Exploring Expedition under
 Captain Charles Wilkes, 1841.

This carved wooden mask represents the Nulmal or "fool
dancers." It is painted black except for the outer rim. The
members of this group of dancers are much concerned with
the nose and its mucus, which is the reason for the unusual
nose shape and the splayed and decorated upper lip.

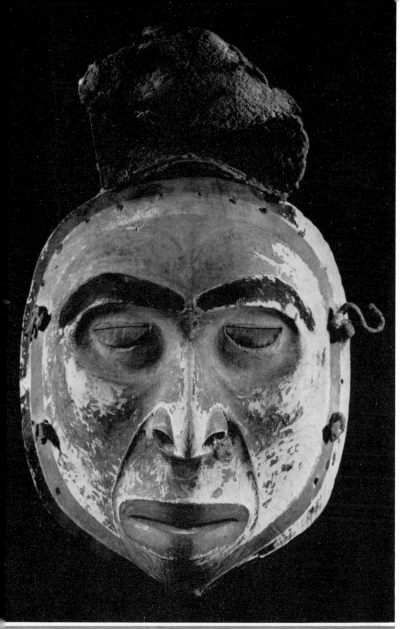

93 LEFT
Tribe: Tlingit
Location: Wolfgang Paalen Collection
Photograph by Manuel Alvarez Bravo.
Mask representing a dead man, found with
the charm shown in plate 166 and other
shaman's paraphernalia in an ancient box.
The mask is skillfully conceived and ex-
ecuted. The eyes indicate that it represents a
dead man.

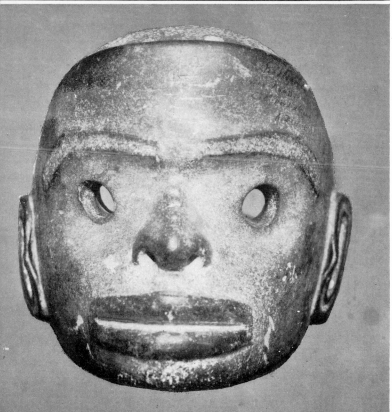

94 LEFT
Tribe: Tsimshian
Location: Musée de l'Homme, Paris
Museum Number: 81.22.1
Copyright photograph, Musée de l'Homme.
Collected on the Nass River, British Colum-
 bia by A. Pinert.
This mask, although carved in stone, follows
the traditional handling of wood sculpture.
The difficulty of working in stone no doubt
accounts for the simplicity of the design.
The mask resembles some of the stone sculp-
ture of Middle America.

95 RIGHT
Tribe: Haida Location: British Museum
Height: 8¼ in. Museum Number: 55.12-20.195
Copyright photograph, British Museum.
A fine example of a carved and painted wooden mask represent-
ing a woman wearing a labret.

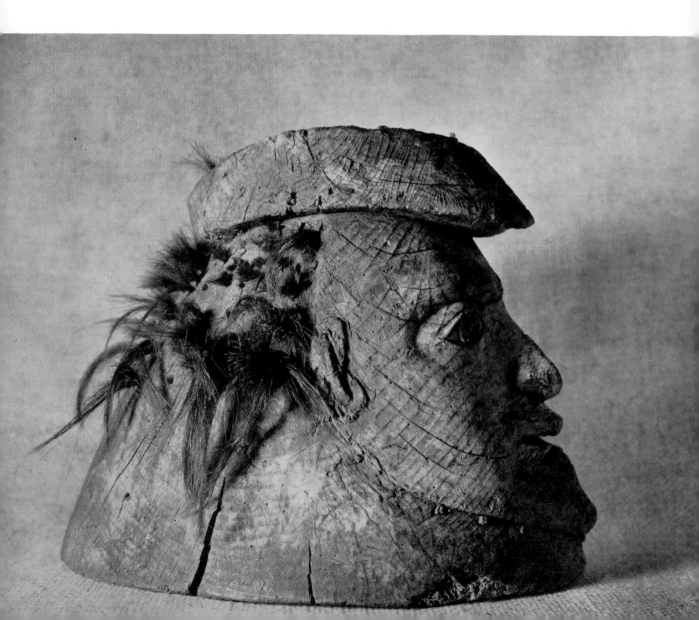

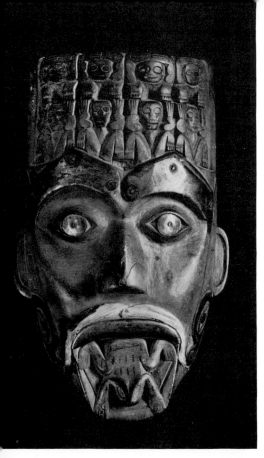

96 LOWER LEFT AND LOWER RIGHT

Tribe: Tlingit Location: Museum of Anthropol-
Height: 9 in. ogy, Univ. California, Berkeley
Width: 10 in. Museum Number: 2-4809
Depth: 11 in.
Collected before 1904.

Carved wooden helmet decorated with tufts of hair. Among the
Tlingit, helmets of this type were worn with a collar of wood
fitting underneath the helmet as a further protection to the head
and neck. Many of these helmets have some form of expression,
particularly around the mouth. This specimen and the one shown
in plate 98 have expressions usually described as facial paral-
ysis. However, I believe the carved expression was intended to
indicate emotion or to create it on the part of the beholder. In the
slate carving, plate 195, the same expression appears; it may well
be an attempt to indicate strain or, as in this specimen, to strike
fear into the enemy.

97 LEFT

Tribe: Tlingit
Location: Wolfgang Paalen Collection
Photograph by Manuel Alvarez Bravo.

Carved wooden mask, the eyes and eyebrows covered with cop-
per. In this carving the small figures used as a massed decorative
element are similar to those shown in plates 82 and 86. The
top figures have hands portrayed in an unusual position.

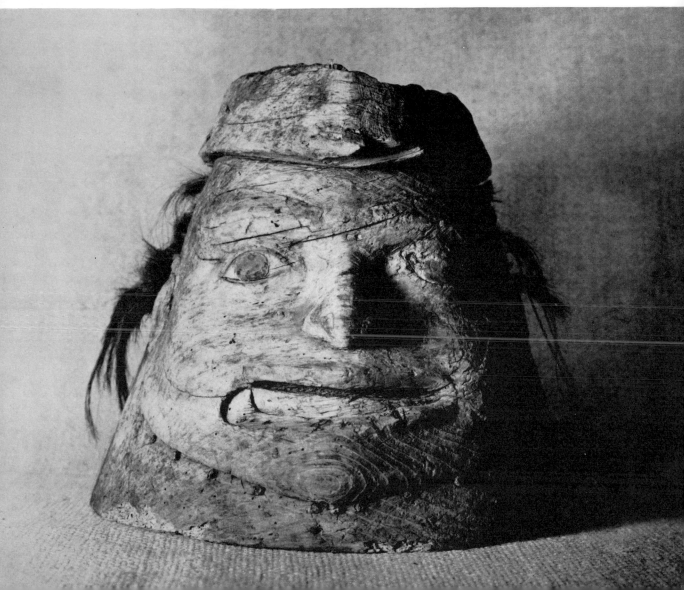

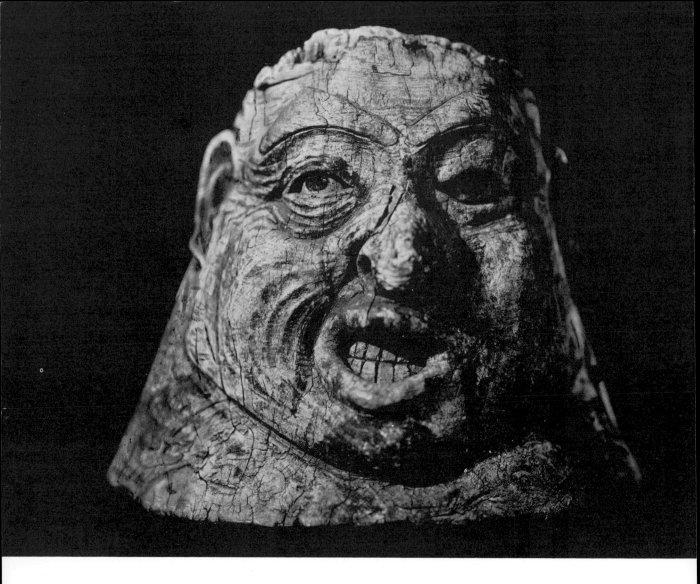

98
Tribe: Tlingit
Location: American Museum of Natural History
Museum Number: E/3453
Photograph, American Museum of Natural History.
This carved wooden helmet might well be a portrait because
of the realistic manner of the carving. Perhaps the expres-
sion is due to facial paralysis; but compare with plates 96
and 195. This helmet is the best known and most often
illustrated of those from the Northwest Coast. It is a superb
piece of sculpture and shows the ability of the Northwest
Coast artist to carve in a most realistic manner when the
occasion demanded.

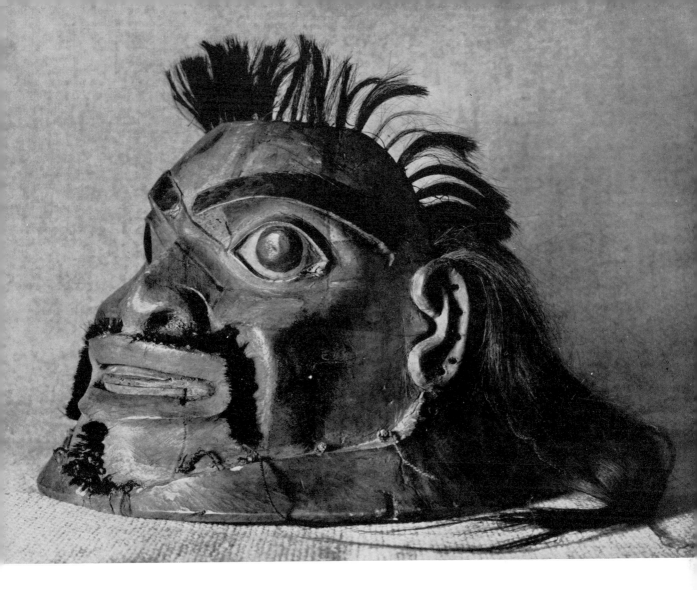

99

Tribe: Unknown

Height: 8 in.

Width: 11¼ in.

Depth: 11 in.

Location: Museum of Anthropology, Univ. California, Berkeley

Museum Number: 2-19081

Carved and painted wooden helmet, probably Tlingit, decorated with hair and similar to the specimens in plates 96 and 98.

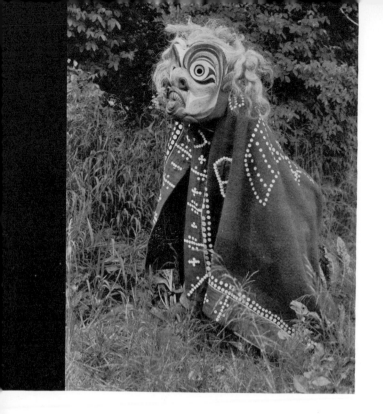

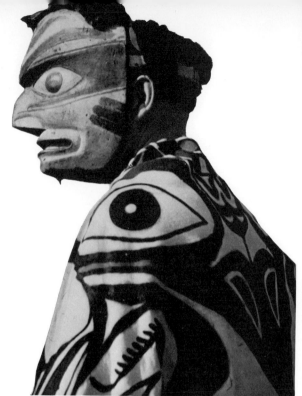

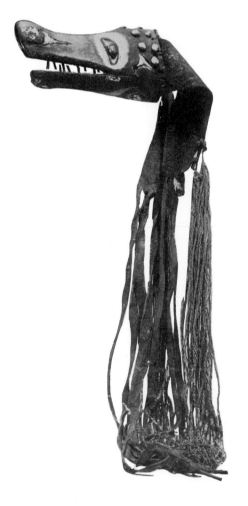

100 UPPER LEFT

Tribe: Salish Location: Property of Reuben Schooner, Bella Coola, British Columbia

Photograph, the Canadian Government.

Carved and painted wooden mask from Bella Coola, British Columbia. This mask is called the Echo mask or Setslantl; it is so carved that six different mouths may be attached.

101 UPPER RIGHT

Photo taken at Neah Bay, Washington, about 1938, of a native wearing a Makah mask. The mask has eyes that can be manipulated; when the strings are pulled the eyes roll upward leaving only the whites exposed.

102 LOWER RIGHT

Tribe: Kwakiutl Location: British Museum
Length of Mask: 8 in. Museum Number: N.W.C. 71

Copyright photograph, British Museum.

Collected by Captain James Cook in 1778.

Wooden mask carved to represent a wolf; inlaid with dentalia and decorated with leather and cedar bark. One of the earliest dated specimens; except for the crudity of the carving it shows little change in style from similar masks carved in recent years.

103 FACING PAGE

Photo taken about 1938 at Neah Bay, Washington, of Charley Swan, one of the finest dancers in the southern area. This type of headdress. made by the Makah. is common in the Nootka area.

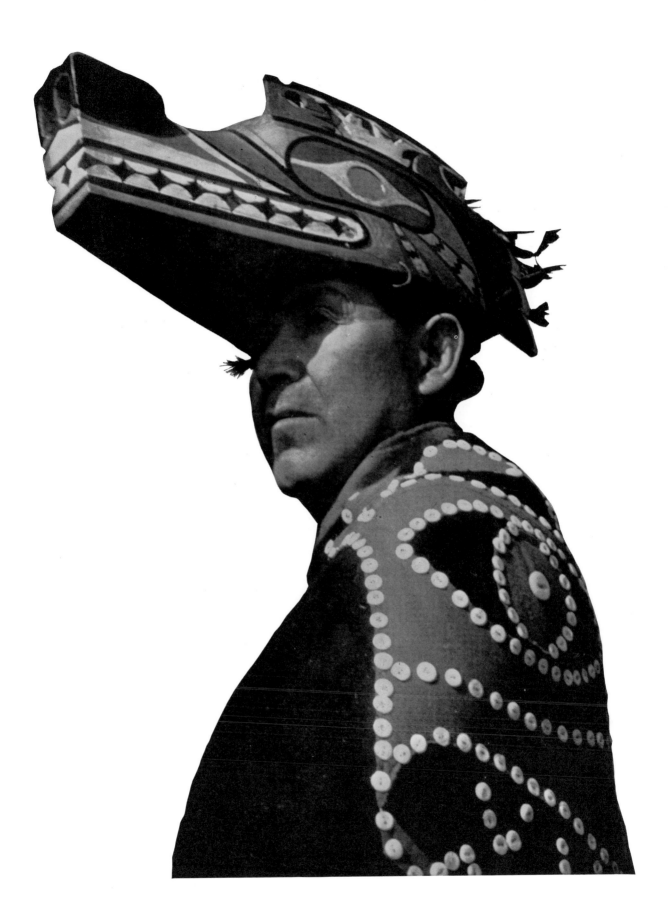

104
Tribe: Haida
Height: 48 in.
Location: Smithsonian Institution
Museum Number: 89038
Photograph, Smithsonian Institution.
Collected by J. G. Swan before 1884.
Figure carved from six pieces of wood at-
tached by means of animal skin; decorated
with black, white, and red paint. The object
was used as a headdress during the dances
of the Olala secret society and represents the
Olala, a mythical creature that ate men. The
head of the wearer was inserted at the point
where the legs are attached to the ribs. The
carving of the head is much superior to the
rest of the body. Often the design and carv-
ing of the head in the work of the Northwest
Coast carver is superior to that of the other
parts of the body, as if the carver was inter-
ested principally in the head, the rest of the
body receiving cursory attention.

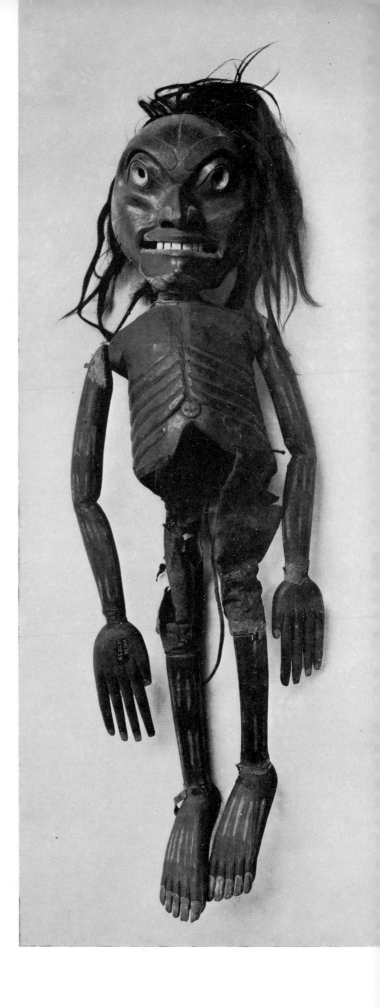

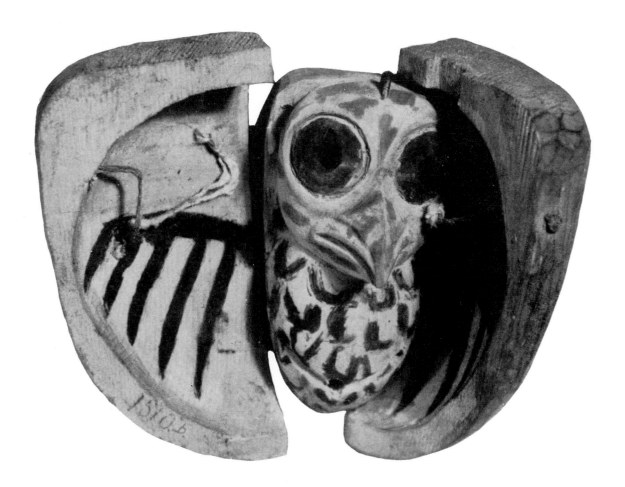

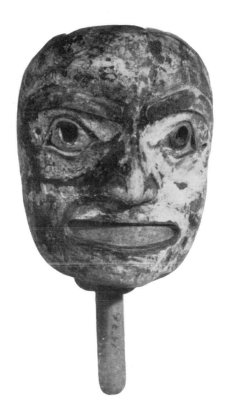

105 ABOVE

Tribe: Tsimshian

Height: 5½ in.

Width (open): 7½ in.

Depth: 2½ in.

Location: Provincial Museum, Victoria, B.C.

Museum Number: 1510-b

Collected by C. F. Newcombe at Grenville, British Columbia, 1912.

This heart-shaped charm is carved in wood and painted; when opened it reveals an owl.

106 LEFT

Tribe: Tsimshian

Height: 8 in.

Width: 4¼ in.

Location: Provincial Museum, Victoria, B.C.

Museum Number: 1536

Collected by C. F. Newcombe at Grenville, British Columbia, 1912.

The head of a potlatch figure which was held up to guests at potlatchs while songs of welcome were sung. The host at a potlatch wore a headdress into which a head such as this one fitted

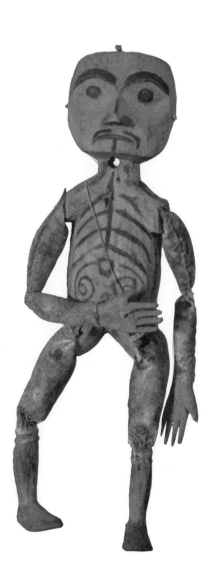

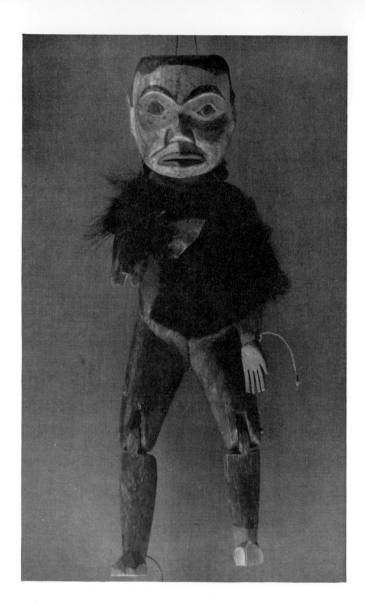

107 ABOVE
Tribe: Tsimshian Location: Wolfgang Paalen Collection
Height: 19 in.
Photograph by Manuel Alvarez Bravo.
Collected by Wolfgang Paalen, 1939.
Carved puppet painted red and white and decorated with fur.
This puppet is similar to those used by the Kwakiutl in their
winter ceremonies.

108 LEFT
Tribe: Unknown Depth: 3¼ in.
Length: 15 in. Location: Ralph Altman Collection
Width: 6 in.
Carved wooden puppet painted red and black.

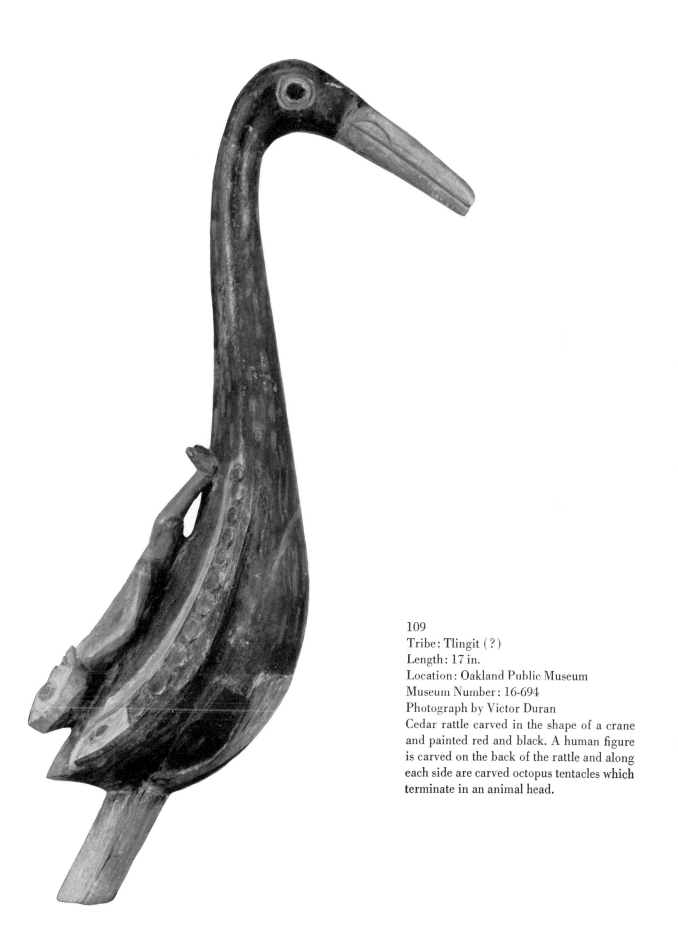

109
Tribe: Tlingit (?)
Length: 17 in.
Location: Oakland Public Museum
Museum Number: 16-694
Photograph by Victor Duran
Cedar rattle carved in the shape of a crane
and painted red and black. A human figure
is carved on the back of the rattle and along
each side are carved octopus tentacles which
terminate in an animal head.

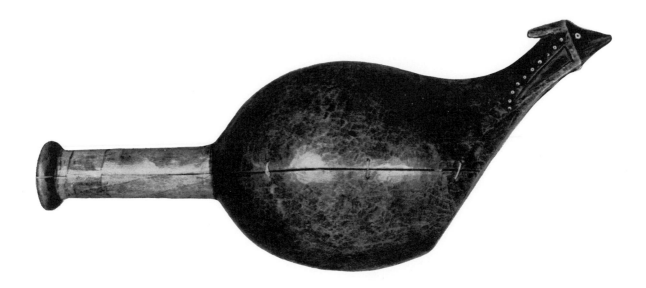

110 ABOVE

Tribe: Nootka Depth: 6½ in.
Length: 13 in. Location: Washington State Museum
Width: 4 in. Museum Number: 4857

Wooden rattle representing a grouse, made in two pieces and sewn together; bead inlay.

111, 112, AND 113 FACING PAGE

Tribe: Nootka Location: British Museum
Length (top): 20½ in. Museum Numbers (top): N.W.C. 27
 (middle): 17 in. (middle): N.W.C. 29
 (bottom): 19½ in. (bottom): N.W.C. 28

Copyright photograph, British Museum.

The middle, unpainted rattle was collected by Captain Cook in 1778 from the Nootka.
The other two rattles are probably from the same area and time; the top one represents
a cormorant. The designs painted on the top and bottom rattles show an unusual motif of
dots.

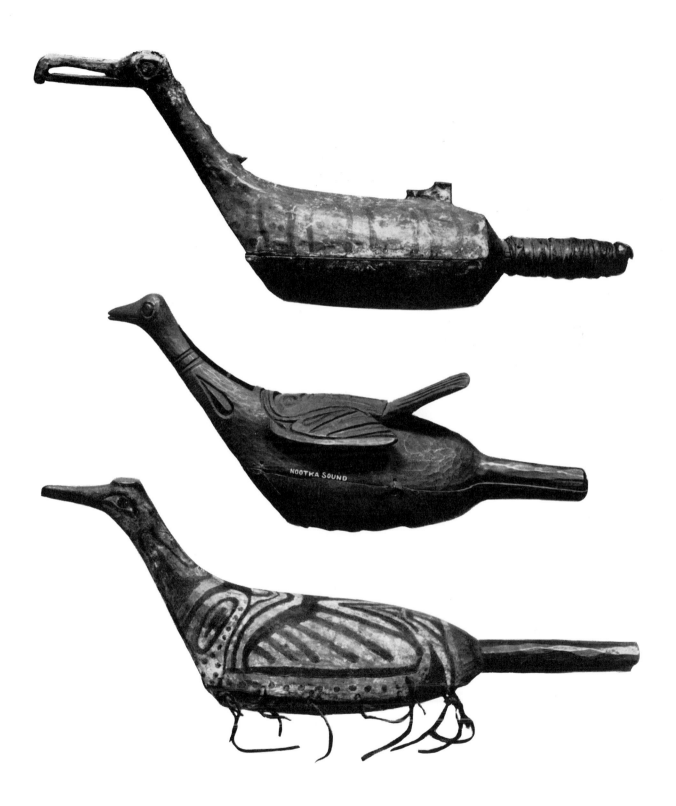

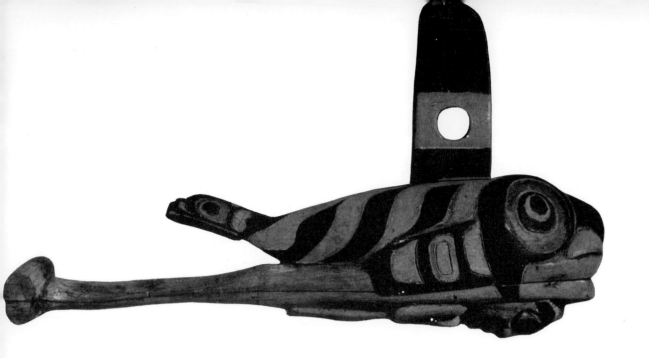

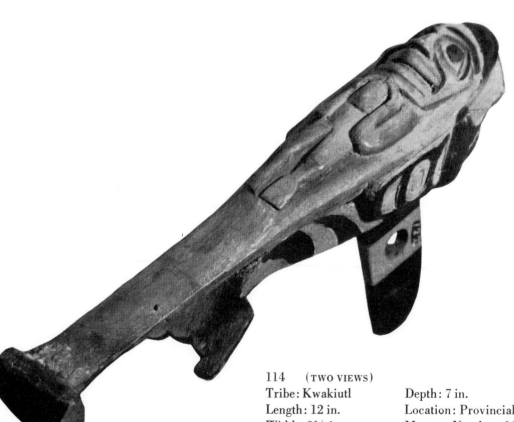

114 (TWO VIEWS)

Tribe: Kwakiutl Depth: 7 in.
Length: 12 in. Location: Provincial Museum, Victoria, B.C.
Width: 2½ in. Museum Number: 122

Collected by F. Jacobsen in Bella Bella, British Columbia, 1893.

Hand clapper carved in wood to represent a killer whale with a figure of a man on the bottom; painted red and black. Here again is a repetition of motifs which set up a rhythm of shape variances. The eye of the whale, the hole in the fin, and the circle of the tail form a triangle of circles which repeat the general shape of the rattle. The fin shape is repeated in the flipper and, instead of a circle as a decorative motif, has an oblong. Along the back of the whale a flowing line produces a pattern which is in contrast to the more abrupt pattern of the flipper. The round eye turned upward, the blunt nose, and large lips give the whale a decidedly humorous expression.

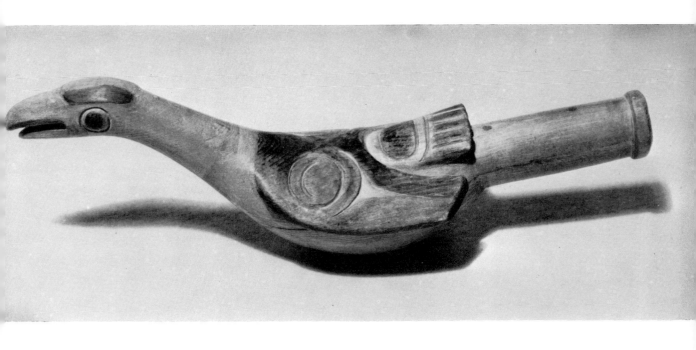

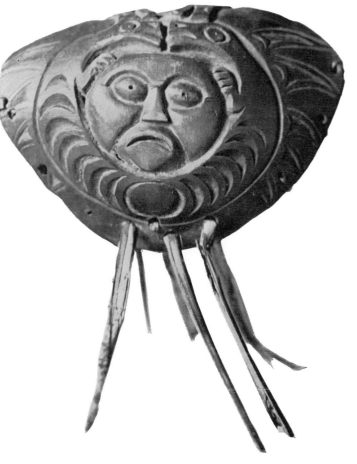

115 ABOVE
Tribe: Unknown
Length: 12 in.
Width: 3 in.
Location: Washington State Museum
Museum Number: 1-393
Photograph by Robert Donaldson.
Wooden rattle carved and painted to repre-
sent a bird. The exact bird represented is
difficult to determine, but it seems to be a
raven's head with the tail of a kingfisher. The
streamlined effect of a bird's body is well
conceived.

116 RIGHT
Tribe: Unknown
Height: 4 in.
Width: 6½ in.
Location: Frank Smith Collection
Rattle carved from mountain-goat horn. The
original handle is missing. The design repre-
sents two otters or seals joined at the tail.

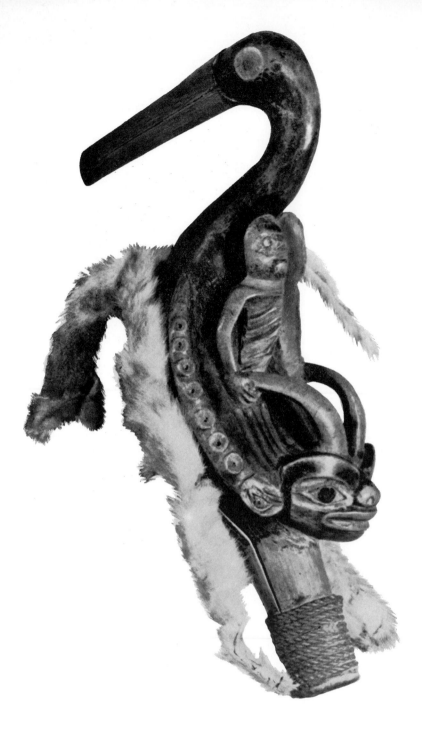

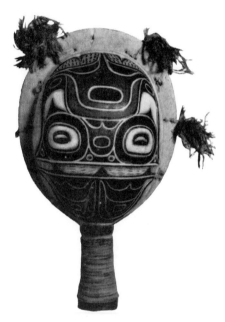

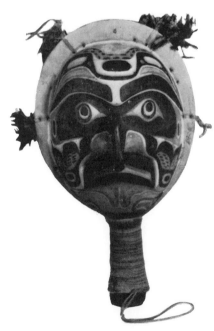

118 BELOW (TWO VIEWS)
Tribe: Kwakiutl
Length: 12 in.
Width: 7 in.
Thickness: 6½ in.
Location: Provincial Museum,
 Victoria, B.C.
Museum Number: 1924
Collected by C. F. Newcombe at Blunden
 Harbor, British Columbia, 1914.
Alder wood rattle representing a hawk,
formed from two pieces of wood and
sewn together; painted red, black,
green and white, with frayed cedar dyed
cerulean blue.

117 ABOVE
Tribe: Tlingit Depth: 5¼ in.
Length: 9¾ in. Location: Washington State Museum
Width: 4 in. Museum Number: 2067
Collected by G. T. Emmons near Yakutat Bay, Alaska.
Rattle carved in wood, painted, and trimmed in fur. The
main body and bird head represent the crane. The figure on
the crane's back is a spirit shaman split in two halves. The
horns of a mountain goat form the shaman's legs and the
head of the mountain goat faces the handle of the rattle. On
each side of the rattle are two animals each having as its
body an octopus tentacle. The breast of the rattle is carved
as a hawk's head.

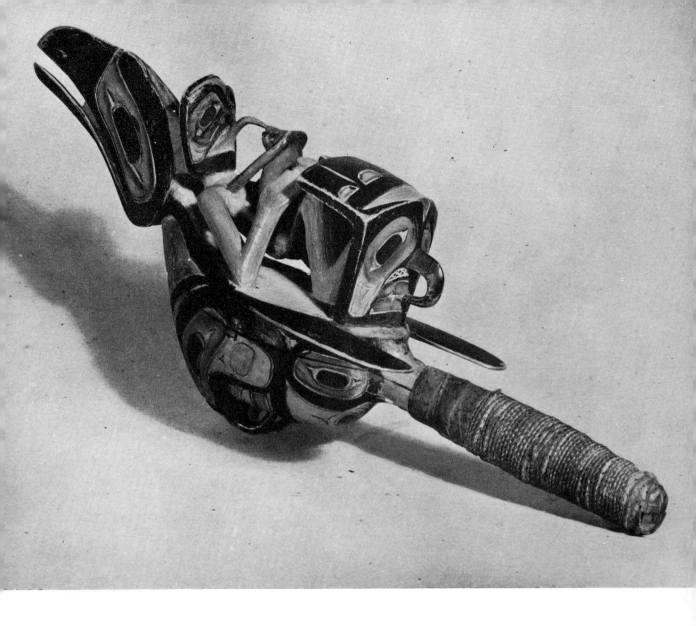

119
Tribe: Tlingit
Length: 14 in.
Width: 4¼ in.

Depth: 5 in.
Location: Washington State Museum
Museum Number: 952

Collected by G. T. Emmons at Wrangell, Alaska.

Rattle carved from wood and painted red, green, and black. The principal figure represents a raven with the head of a hawk on its breast. On the back of the central figure is a human figure with its tongue protruding into the mouth of a frog. The frog was believed to possess a poison which, when sucked out, was useful to shamans. Vertically arranged near the handle, and forming the tail of the raven, is a hawk's head. This type of rattle seems to have originated among the Tsimshian, but was adopted by the Tlingit for ceremonial use and later spread over a wide area. The use of the "S" curve forms the basic line of the rattle.

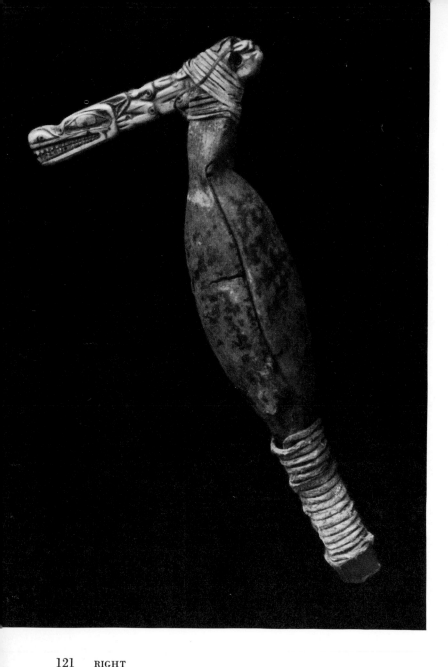

120 LEFT
Tribe: Tlingit
Height: 9½ in.
Location: Wolfgang Paalen Collection
Photograph by Manuel Alvarez Bravo.
Rattle made of copper with a carved piece
of ivory bound on. This rattle is very unusual
in concept. The design and carving of the
ivory are excellent.

121 RIGHT
Tribe: Unknown Location: Anthropological Museum,
Height (body) : 4 in. Univ. British Columbia, Vancou-
Length (handle) : 3 in. ver, B.C.
 Museum Number: A1776
Photograph, Visual Education Service, University of British Columbia.
Presented to the Museum by B. Robson.
A copper rattle with a wooden handle.

122 FACING PAGE
Tribe: Tlingit Thickness: 4 in.
Length: 11½ in. Location: Washington State Museum
Width: 5½ in. Museum Number: 955
Collected by G. T. Emmons at Wrangell, Alaska.
Rattle made from two pieces of yellow cedar sewn together; carved and
painted black and red. The rattle formerly belonged to the family of
the famous Chief Shakes. The design represents the foot of a bear
ornamented with a human face. The form of the bear's foot was the
first concern of the artist, then the face. This is a very fine example of a
rattle which does not follow the more common bird-shape design of
the Northwest Coast.

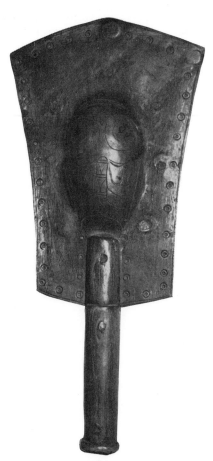

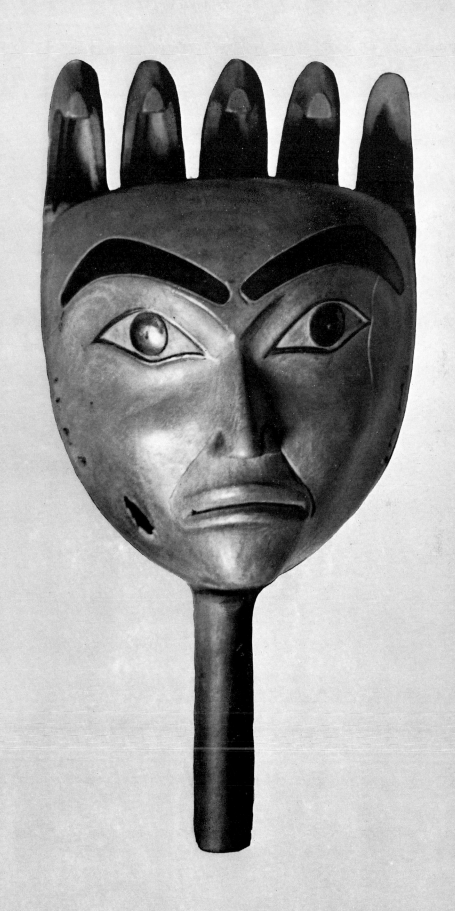

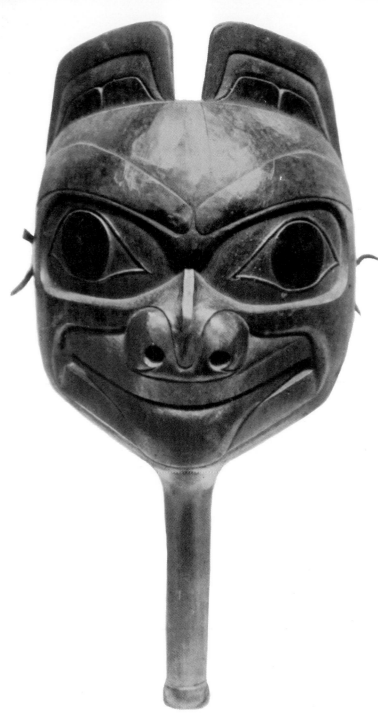

123 ABOVE
Tribe: Haida Location: British Museum
Height: 9 in.
Copyright photograph, British Museum.
A beautifully carved wooden rattle representing a bear. Note the very
fine quality of the carving and the beauty of the design.

124 RIGHT
Tribe: Tsimshian Depth: 4¾ in.
Height: 11 in. Location: Provincial Museum, Victoria, B.C.
Width: 5¾ in. Museum Number: 1561
Collected by C. F. Newcombe on the Nass River, British Columbia,
1913.
Rattle carved from two pieces of alder and painted red and black. One
side has two faces which in themselves form eyes for a third design,
the whole comprising a face.

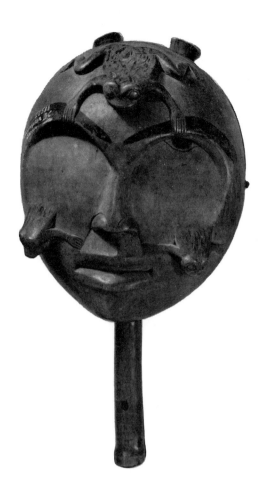

125 LEFT
Tribe: Haida
Height: 12 in.
Width: 6½ in.
Location: Smithsonian Institution
Museum Number: 20,583
Photograph, Smithsonian Institution.
Collected by J. G. Swan before 1876.
Rattle used in the secret society dances. The
design on this rattle represents a legend
which tells how frogs and toads come with
the rain. The modeling of the frogs which
spring from the cheeks is especially note-
worthy. The lips of the face and the frogs'
legs are painted red; the eyebrows and eyes,
black; streaks of black paint on the backs of
the frogs.

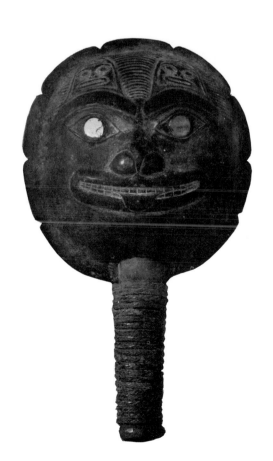

126 LEFT
Tribe: Tlingit
Height 9½ in.
Diameter 5⅝ in.
Location: Southwest Museum
Museum Number: 980-9-131
Rattle made from two pieces of copper
riveted together, inlaid with abalone shell
eyes. The wooden handle is bound with
braided leather.

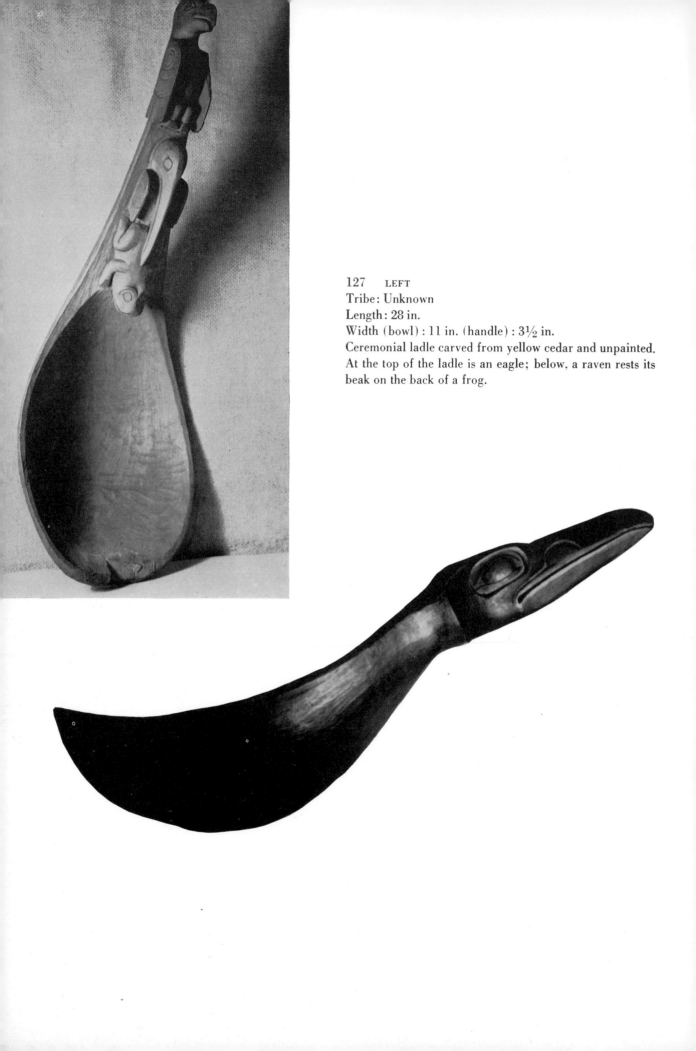

127 LEFT
Tribe: Unknown
Length: 28 in.
Width (bowl): 11 in. (handle): 3½ in.
Ceremonial ladle carved from yellow cedar and unpainted.
At the top of the ladle is an eagle; below, a raven rests its
beak on the back of a frog.

128 LOWER LEFT
Tribe: Haida
Length: 38 ½ in.
Depth of Bowl: 7½ in.
Location: Provincial Museum, Victoria, B.C.
Museum Number: 440
Collected by C. F. Newcombe at Skidegate, Queen Charlotte Islands, B.C., 1907.
Red cedar ceremonial ladle handle carved in the form of a raven.

129 BELOW
Tribe: Tlingit
Length: 31¼ in.
Height: 9 in.
Width: 9½ in.
Location: Washington State Museum
Museum Number: 1343
Photograph by Robert Donaldson.
Collected by G. T. Emmons at Angoon, Alaska.
Carved wooden feast ladle painted red and black. The exterior of the bowl is carved and painted with symbols representing the brown bear, a totemic animal of the Ta-Quay-tu clan living at Angoon. On the bottom of the bowl is carved a sun and around the upper sides are incised outlines of salmon. An old witch with a pack on her back and ornamented with human hair is carved on the handle. Ladles of this type were used on ceremonial occasions, filled with oil, and handed to the honored guests to drink from. They were also used to skim oil off the water when fish were being processed.

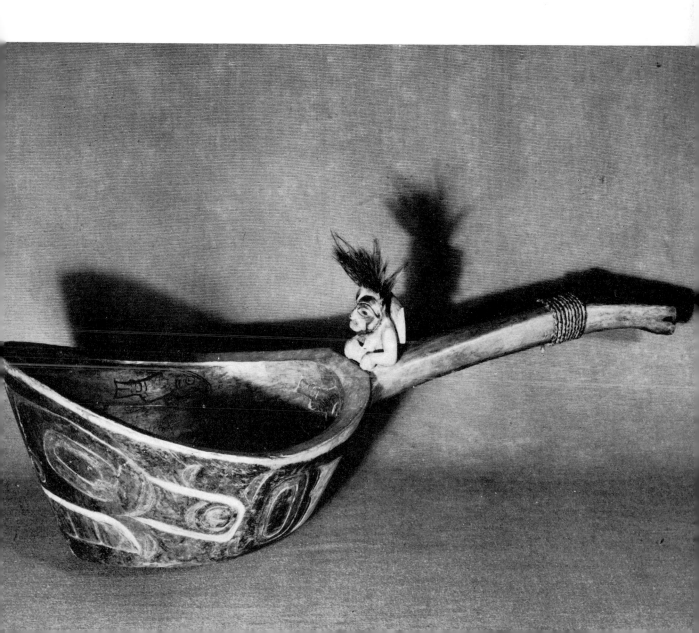

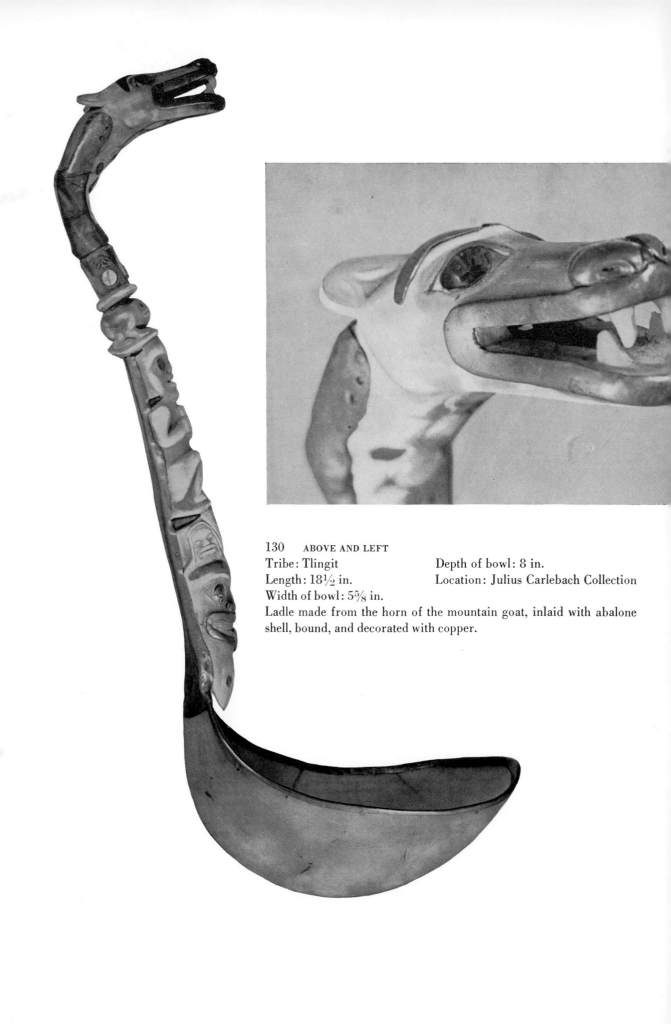

130 **ABOVE AND LEFT**

Tribe: Tlingit Depth of bowl: 8 in.

Length: 18½ in. Location: Julius Carlebach Collection

Width of bowl: 5⅝ in.

Ladle made from the horn of the mountain goat, inlaid with abalone shell, bound, and decorated with copper.

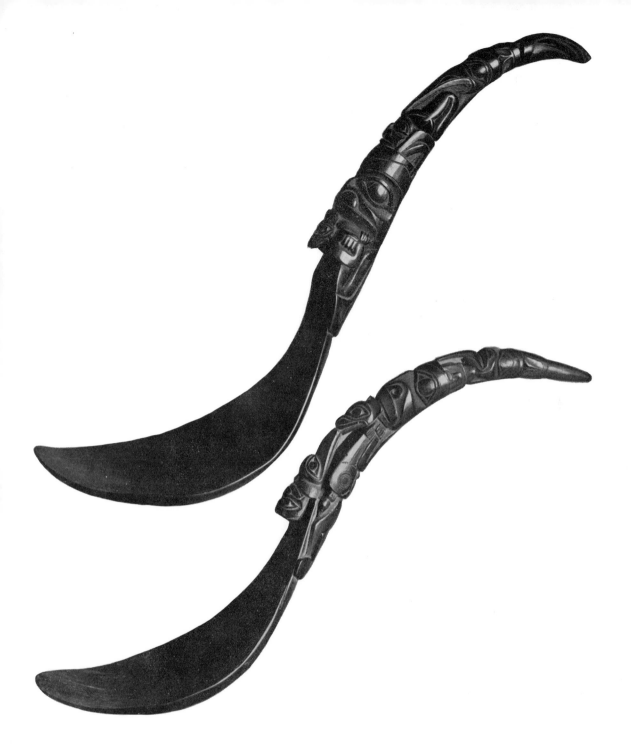

131 UPPER
Tribe: Haida Location: R. B. Inverarity Collection
Length: 9¾ in.
Width of bowl: 2⅜ in.
Spoon made of two pieces of mountain-goat horn riveted
together with copper. Spoons of this type show great deli-
cacy in carving, yet the interlaced work and the strength of
design are associated with totem poles.

132 LOWER
Tribe: Haida Location: Julius Carlebach Collection
Length: 10½ in.
Width of bowl: 2⅝ in.
Spoon made of two pieces of mountain-goat horn riveted
together with copper.

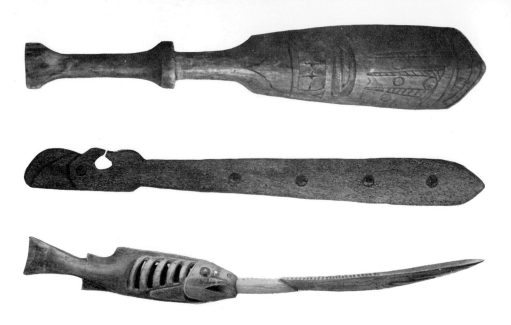

133 LEFT
Tribe: Tlingit
Length: 39½ in. Location: Washington State Museum
Width: 3½ in. Museum Number: 1000
Photograph by Robert Donaldson.
Collected by G. T. Emmons at Angoon, Alaska.
Wooden stick carved in the shape of a land otter. The land otter was intimately connected
with the practices of, and sacred to, the shaman. When the shaman was called upon to
exorcize spirits which had entered the body of a sick person, he would often be ac-
companied by members of his family. These people would beat on the stick in time to the
spirit songs of the shaman.

134 UPPER
Tribe: Kwakiutl
Length: 16¼ in. Thickness: 1¼ in.
Width: 3 in. Location: Provincial Museum, Victoria, B.C.
 Museum Number: 2071
Collected by C. F. Newcombe at Fort Rupert, British Columbia, 1914.
Carved yellow cedar club with longitudinal ribs on reverse side. This club was used for
beating nettle fiber.

135 MIDDLE
Tribe: Nootka
Length: 25½ in. Location: R. B. Inverarity Collection
Width: 2⅜ in.
A war club carved from whalebone.

136 LOWER
Tribe: Tlingit
Location: Museum of Anthropology,
 Univ. California, Berkeley
Museum Number: 2-19096
Collected by George Davidson at Chilkat, Alaska, 1869.
Carved wooden spoon. The handle, carved in the shape of a fish, is also a rattle, for the
artist has carved a small human figure inside the body of the fish.

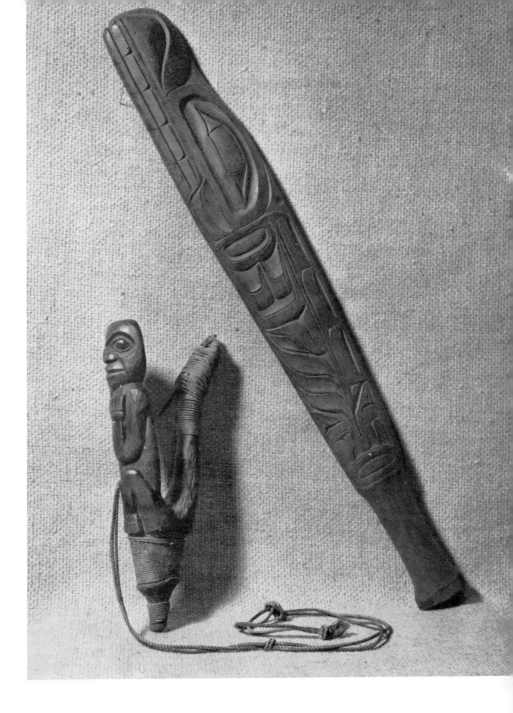

137 LOWER RIGHT

Tribe: Tlingit
Length: 9½ in.
Width: 2 in.

Depth: 4½ in.
Location: Washington State Museum
Museum Number: 4259

Collected by L. S. Robe before 1909.

Halibut hook carved in yellow cedar with a nail for a barb, bound to the hook with fishline.

138 UPPER RIGHT

Tribe: Tlingit
Length: 22 in.
Width: 3¾ in.

Thickness: 2½ in.
Location: Washington State Museum
Museum Number: 1402

Collected by G. T. Emmons at Wrangell, Alaska.

Carved, unpainted fish club made of yellow cedar. These clubs were used to kill seal, sea otter, or any large fish before hauling them into the canoe. The design represents a whale, admirably conceived and beautifully executed. The small blow hole is placed directly behind the large eye.

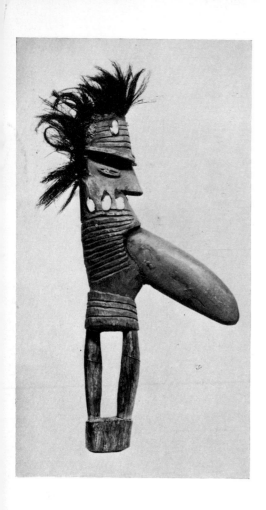

139 LEFT

Tribe: Unknown
Length: 16½ in.
Location: British Museum
Museum Number: N.W.C. 97
Copyright photograph, British Museum.
Collected by Captain James Cook in 1778.
Carved wooden handle with projecting stone celt, commonly called a slave killer. Such weapons were used when a chief killed his slaves to shame a rival chief or when a chief died and his slaves were killed.

140 BELOW

Tribe: Nootka
Length: 20¾ in.
Location: British Museum
Museum Number: N.W.C. 100
Copyright photograph, British Museum.
Collected by Captain James Cook in 1778.
Carved wooden war club inlaid with abalone shell and bone and decorated with tufts of human hair. The specimens collected by Captain Cook prove the continuance of a consistent art style at least from the time of the arrival of the white man in the area—a period of approximately one hundred and seventy years.

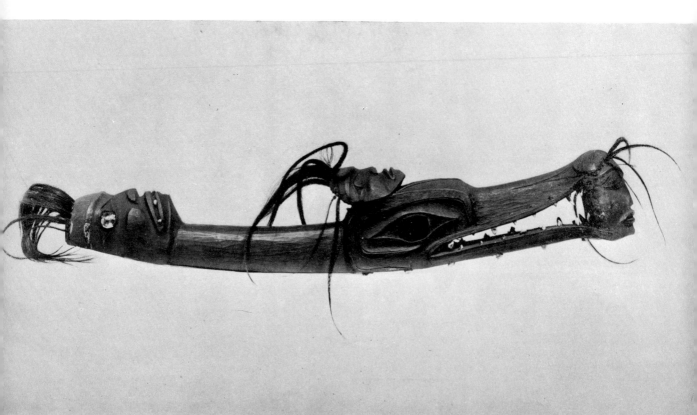

141, 142, 143, AND 144 RIGHT

Tribe: Nootka Location: British Museum

Length: Approximately 18 in. to 22 in.

Copyright photograph, British Museum.

Clubs of whalebone and one of wood all stylistically the same except for the specimen on the left, which has a human head on the hilt instead of the conventionalized eagle wearing a headdress. The third specimen from the left was collected by Captain Cook, which indicates the early origin of this form of war club and which seems to be peculiar to the Nootka.

145 MIDDLE

Tribe: Kwakiutl

Length: 22 in.

Width: 3 in.

Height (including dorsal fin): 10 in.

Location: Provincial Museum, Victoria, B.C.

Museum Number: 105

Collected by F. Jacobsen at Bella Bella, British Columbia, 1893.

This club is carved and painted wood with a stone piercing the main shaft and held in place by friction. The club was used for breaking coppers at potlatchs. The main body of the club represents the killer whale. Note how successfully the stone was been incorporated into the design as the dorsal fin of the whale. The whale's flukes have been turned upward and back to lie flat along the top surface of the club. The handle is carved to represent a hawk.

146 LOWER

Tribe: Nootka

Length: 19 in.

Width: 2¾ in.

Thickness: ⅝ in.

Location: Provincial Museum, Victoria, B.C.

Museum Number: 268

Collected by C. F. Newcombe at Clayoquot, British Columbia, 1898.

This war club of whalebone is, in general, like the typical Nootka club. However, it is a more unusual and complex conception, indicating, perhaps, its more recent origin. The bird represented is the thunderbird. The half figure in front of the thunderbird is a wolf. In front of the wolf is half a killer whale with the unusual feature of arms and hands. The hands hold a man whose feet disappear in the whale's mouth.

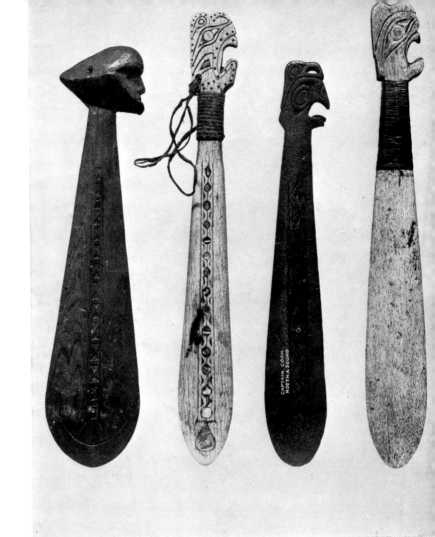

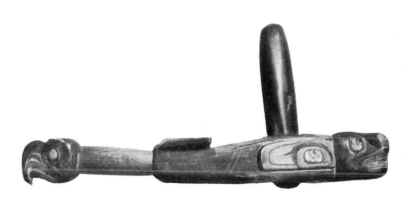

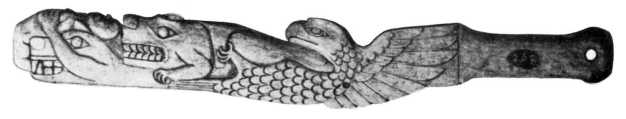

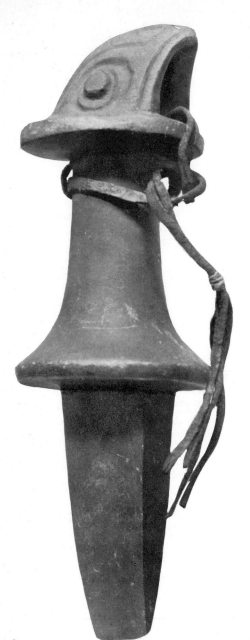

147 UPPER LEFT
Tribe: Unknown Location: British Museum
Length: 13¾ in. Museum Number: N.W.C. 94
Copyright photograph, British Museum.
Collected by Captain James Cook in 1778.
A stone slave killer.

148 BELOW
Tribe: Unknown Thickness: ¾ in.
Length: 16¾ in. Location: Southwest Museum
Width: 2 in.
Dagger carved in whalebone.

149 BOTTOM OF PAGE
Tribe: Tlingit Location: Southwest Museum
Length: 18¼ in. Museum Number: 9/980-9-132
Width: 2⅛ in. of blade
Copper dagger with the hilt engraved with a bird's head design and inlaid with shell and a red bead eye.

150 FACING PAGE
Tribe: Tsimshian Location: Provincial Museum, Victoria, B.C.
Height: 4¾ in. Museum Number: 254
Width: 2¼ in.
Collected by W. B. Anderson at Metlakahtla, Alaska.
Carved bone dagger handle; a superb example of Northwest Coast art. The large head is that of a bear and crouched between the bear's ears is the figure of a man. The technical excellence of the carving and the clever handling of the space in the design make this carving wholly admirable. The delicately drawn rectangle of the eyeball is set within the curves of the eye socket and this, in turn, is set in a smooth recessed curvilinear shape; the whole arrangement thus gives contrast and repetition to the work. The head of the small crouching figure, the body of the figure, and the ear of the bear show an interesting progression of size of similar shapes across the top of the object. The man's head is balanced with the ear by a similar sized shape but at variance in direction with the man's head. The overlapping hand of the man ties the two areas together skillfully and helps create the feeling of plastic depth in a very shallowly carved object.

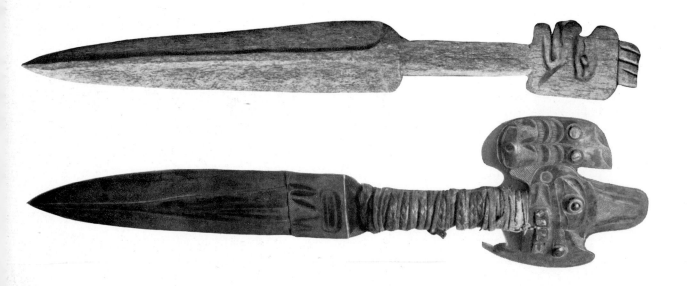

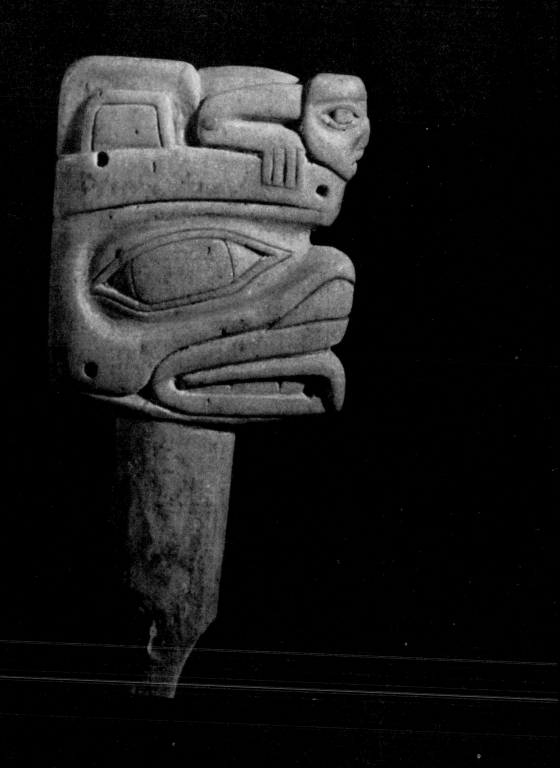

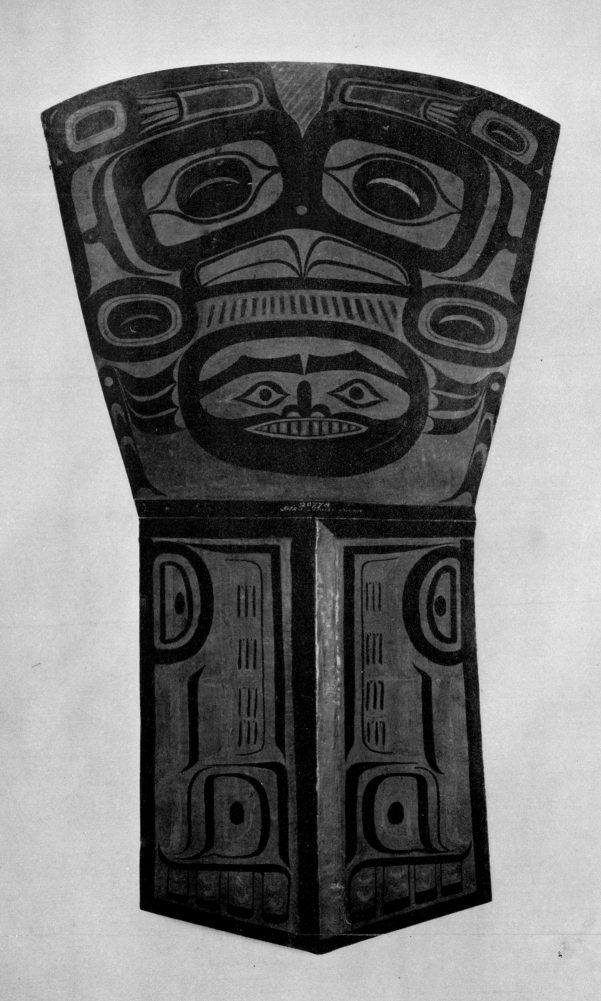

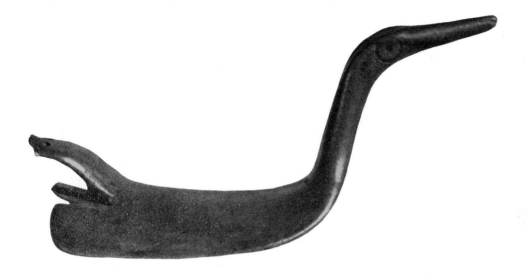

151 FACING PAGE
Tribe: Tlingit Location: Smithsonian Institution
Height: 37 in. Museum Number: 20,778
Width: 22¼ in.
Thickness: 1/16 in.
Photograph, Smithsonian Institution.
Collected by J. G. Swan before 1876.
Copper, with heraldic designs painted in red, black, and green.

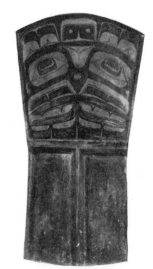

152 ABOVE
Tribe: Haida Location: Provincial Museum, Victoria, B.C.
Length: 3 in. Museum Number: 5068
Width: 1½ in.
Height: 1½ in.
Collected by H. Carmichael at Cumshewa, British Columbia, 1905.
Blanket fastener in the form of a cormorant, made from native copper. Blankets were worn over the shoulder and fastened with this kind of pin. The delicate head of the bird is nicely balanced by the weight of the body and the upturned tail.

153 UPPER RIGHT
Tribe: Tsimshian Location: British Museum
Height: 30 in.
Copyright photograph, British Museum.
Copper, painted with a totemic design.

154 LOWER RIGHT
Tribe: Kwakiutl Location: Provincial Museum, Victoria, B.C.
Height: 19 in. Museum Number: 1329
Width: 10 in.
Copper, with a representation of a head on the upper half; on the lower, ribs are painted.

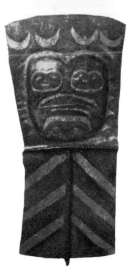

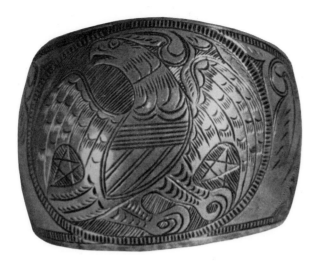

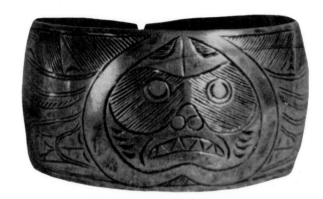

155
Tribe: Kwakiutl Location: Provincial Museum,
Width: 1⅝ in. Victoria, B.C.
 Museum Number: 5080
Collected by Dr. Hall at Alert Bay, British Columbia, 1884.
Silver bracelet engraved with the design of an eagle, apparently copied from an American silver dollar. The making of these bracelets, by hammering out silver dollars into blanks which were then formed and engraved, was a popular activity for tourist and trade sale. Today a few pieces are still made but not with the craftsmanship or skill of design shown in the earlier pieces.

156
Tribe: Kwakiutl Location: Provincial Museum,
Width: 1½ in. Victoria, B.C.
 Museum Number: 5079
Collected by Dr. Hall at Alert Bay, British Columbia, 1884.
One of these bracelets is European in design influence; the other is clearly native in influence.

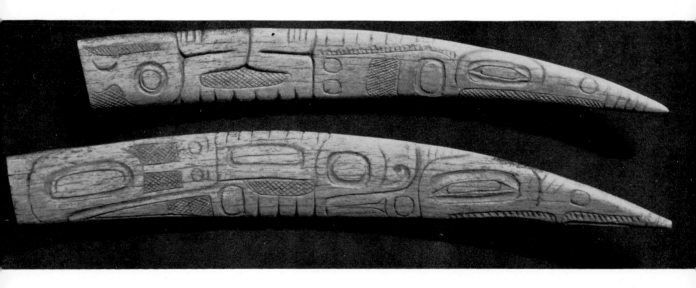

157 AND 158
Tribe: Unknown Location: Southwest Museum
Length: 15 in. (longest item) Museum Numbers: 348-9-5; 348-9-6
Two pieces of marine ivory carved with totemic designs. The use of these objects is not known.

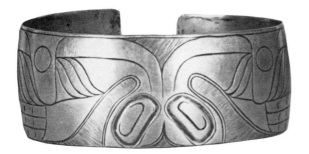

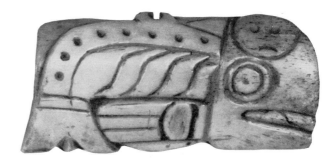

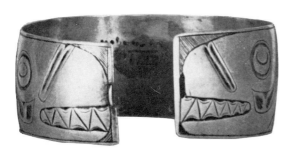

160
Tribe: Tlingit
Length: 4 in.
Depth: 1⅞ in.
Location: Washington State Museum
Museum Number: 1204
Collected by G. T. Emmons at Wrangell, Alaska.
Bone amulet worn around the neck as a charm or fastened to a shaman's robe. The design of the whale's body is fitted successfully into the shape of the bone.

159 (TWO VIEWS)
 Tribe: Tlingit
 Width of metal: 1⅛ in.
 Location: Washington State Museum
 Museum Number: 2179
 Collected by G. T. Emmons at Wrangell, Alaska.
 Silver bracelet beaten from a silver dollar and engraved to represent a killer whale.

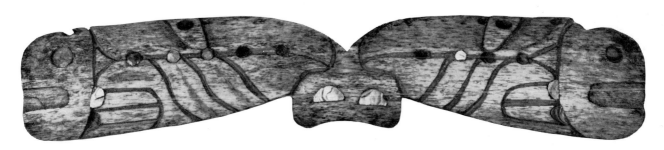

161
Tribe: Tlingit Thickness: ¼ in.
Length: 11 in. Location: Washington State Museum
Depth: 2⅛ in. Museum Number: 1522
Collected by G. T. Emmons at Wrangell, Alaska.
Bone amulet inlaid with abalone shell, worn as a charm or attached to a shaman's robe.
The carving represents two killer whales. The two profiles have a common tail instead
of a common head.

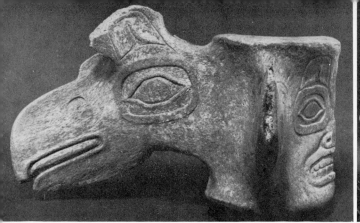
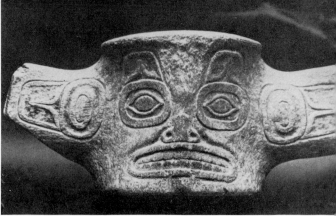

162 (THREE VIEWS)
Tribe: Haida
Location: Musée de l'Homme
Museum Number: 38.175.1
Copyright photograph, Musée de l'Homme.
Carved whale vertebrae in which the artist has skillfully adapted his design to the unusual shape of the bone. The design represents a human face and the head of a raven. This piece was probably used as a tobacco mortar.

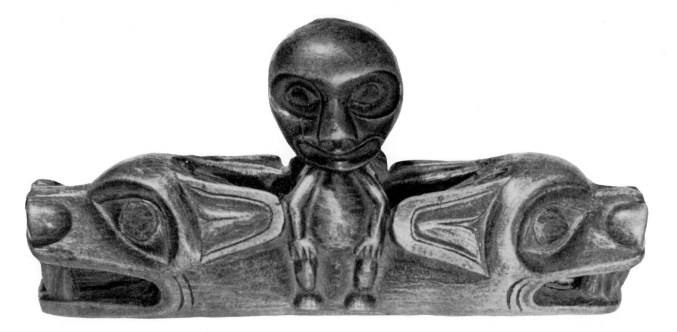

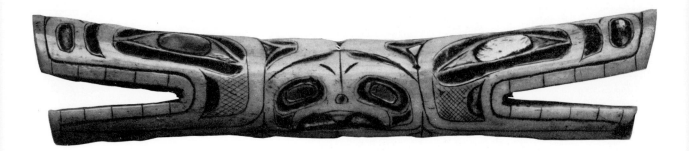

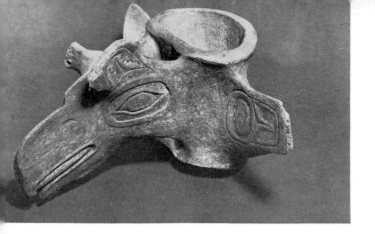

163　MIDDLE LEFT
Tribe: Kwakiutl
Length: 5 in.

Location: Anthropological Museum,
　Univ. British Columbia, Vancouver,
　B.C.
Museum Number: 1744, Raley Collection

Photograph, Visual Education Service, University of British Columbia.
Collected among the Kitlope of Gardner Channel, British Columbia.
This carved object is a "soul catcher" used by a shaman. When the shaman was successful in recapturing the wandering soul of a patient he would remove the head of this "soul catcher" and place the soul in the small opening plugged in by the head.

164　LOWER LEFT
Tribe: Haida (?)
Length: 7¾ in.

Location: British Museum

Copyright photograph, British Museum.
Bone object carved and inlaid with abalone shell. These spirit catchers or soul cases were used by shamans to trap and hold spirits or souls. This specimen is probably from the Haida area.

165　BELOW
Tribe: Unknown
Length: 5 in.
Height: 2½ in.

Location: Southwest Museum
Museum Number: 980-9-136

Shaman's charm in the form of a killer whale carved from an antler. Here the artist has seen in the shape of the antler the totemic design of the killer whale.

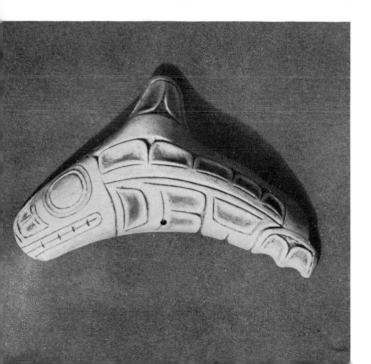

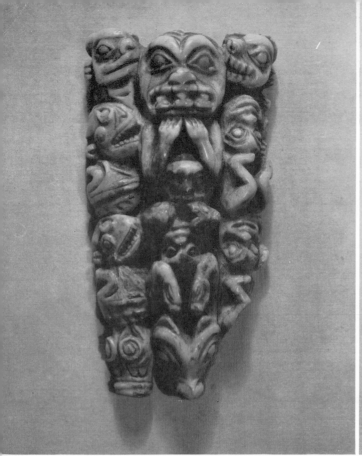

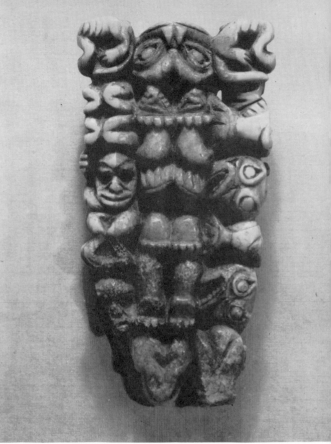

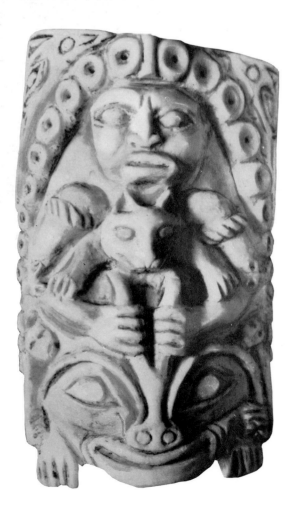

166 UPPER LEFT AND RIGHT
Tribe: Tlingit
Height: Approximately 3¾ in.
Location: Wolfgang Paalen Collection
Photograph by Manuel Alvarez Bravo.
A small carving in marine ivory, probably a shaman's charm. The central figure in the front view has three bears issuing from its mouth.

167 LEFT
Tribe: Tlingit Location: Museum of Anthropology,
Height: 4½ in. Univ. California, Berkeley
Width: 2 in. Museum Number: 2-19101
Collected in 1891.
This small ivory charm is reported to have come from the Chilkat group of the Tlingit. In the upper corners are the heads of two animals, probably otters. Below these, and framing the carving of a man, are octopus tentacles. The man represents a culture hero tearing apart a sea lion. The small figure below the man has a somewhat feline appearance but is probably meant to represent a wolf.

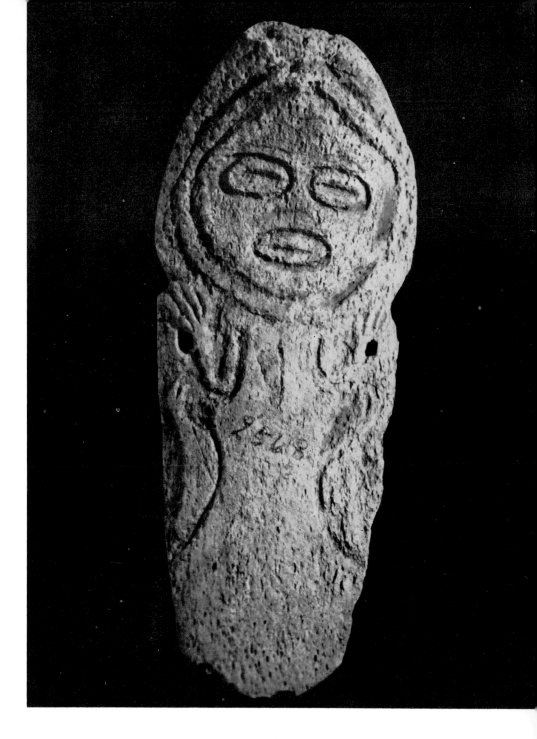

168

Tribe: Haida

Length: 8½ in.

Width: 3¼ in.

Thickness: ⅛ in.

Location: Provincial Museum,
Victoria, B.C.

Museum Number: 2568

Collected by C. F. Newcombe from excavation at Ogden
Point, Victoria, B.C., 1914.

This object is carved from bone and represents a head
with arms. The two holes were for lashing the carving to
some other object. Although excavated at Victoria, the
carving is attributed to the Haida.

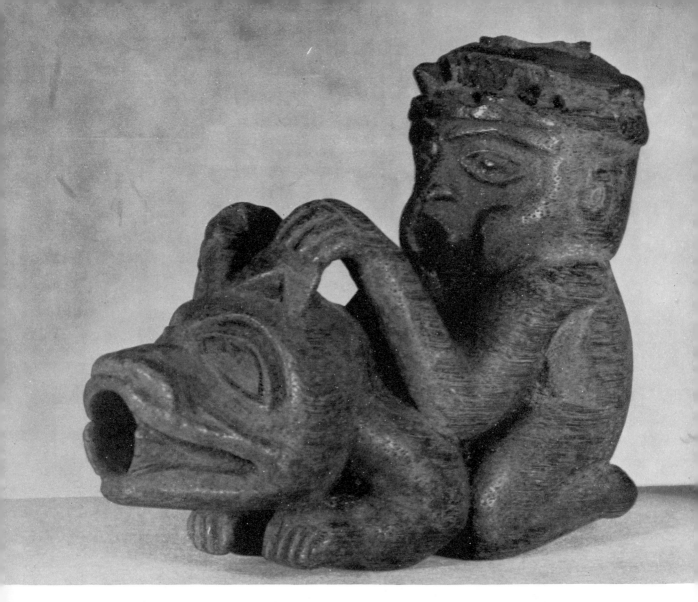

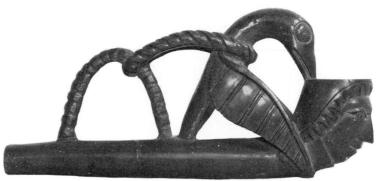

169 UPPER
Tribe: Unknown Thickness: 1⅝ in.
Length: 4 in. Location: Washington State Museum
Height: 3¼ in. Museum Number: 1-198
A wooden pipe; the stem in the form of an animal; the bowl, the figure of a man.

170 LOWER
Tribe: Haida Thickness: 1 in.
Length: 6 in. Location: R. B. Inverarity Collection
Height: 2¾ in.
Photograph by Lamont Bench.
Slate pipe with bowl in the form of a white man's head and a bird, perhaps a raven, carved above the stem.

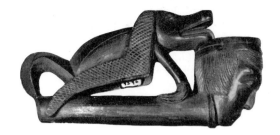

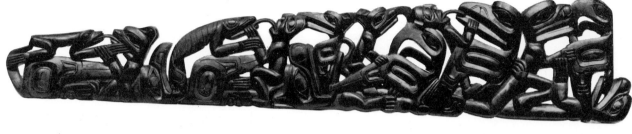

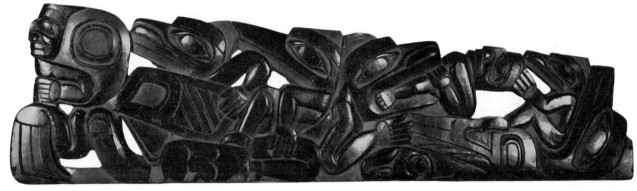

171 UPPER RIGHT

Tribe: Haida
Length: 4½ in.
Height: 2⅛ in.

Thickness: ⅞ in.
Location: Washington State Museum
Museum Number: 4396

Collected by James T. White in the Queen Charlotte Islands, B.C., 1894.

Pipe made of a carbonaceous shale. There are few places in the world where this peculiar slate formation is found; in the Northwest Coast area it is quarried near Skidegate. When quarried it may be cut and carved, but after being exposed to the air it hardens. The Northwest Coast Indians polished their slate carvings with shark fins and then rubbed them with oil to darken the slate. This material was not quarried in large pieces. Pieces of slate were joined together to form boxes and other objects. Most slate carvings were made for tourists or for trading purposes. The pipe shown here is an imitation of a European pipe. I have never seen a slate pipe that had been used for smoking. The bowl of this pipe represents the head of a white man and the stem represents a dog. The exaggerated ears and typical Northwest Coast type of foot are interesting details.

172 MIDDLE RIGHT

Tribe: Haida
Length: Approximately 18½ in.

Location: British Museum

Copyright photograph, British Museum.

A slate pipe that illustrates the complexity of design attained in slate carvings.

173 LOWER RIGHT

Tribe: Haida
Length: 13½ in.
Height: 3¾ in.

Thickness: ½ in.
Location: Julius Carlebach Collection

Slate pipes made in imitation of European pipes eventually became so complex in design that the pipe became unrecognizable as such. The mouthpiece is at the right bottom edge and the bowl is in the top of the second head from the left.

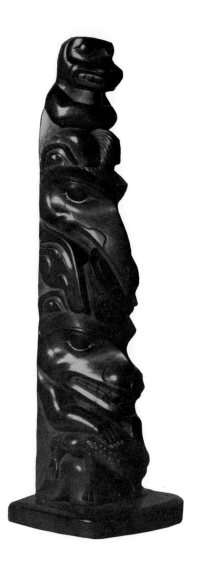

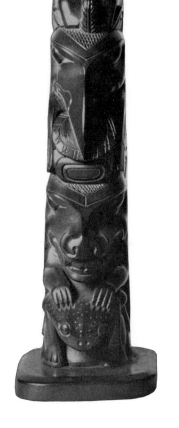

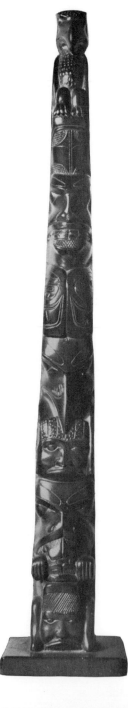

174 UPPER (TWO VIEWS)
175 LOWER (TWO VIEWS)
Tribe: Haida
Height: 9¼ in.
Width: 1¾ in.
Depth: 2 in.
Location: Frank Smith Collection
Model slate totem poles showing a raven with the sun in its beak. The space-filling and interlocking designs are pleasing as is the well-conceived repetition of the downward sloping line. These pieces are admirably executed.

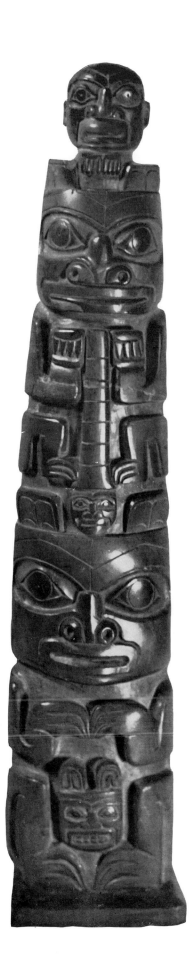

176 LEFT

Tribe: Haida Depth: 1¾ in.
Height: 20½ in. Location: Washington State Museum
Width: 4 in. Museum Number: 6901

Collected by Mrs. J. C. Haines in the Queen Charlotte Islands, B.C.

Model slate totem pole showing a human head at the top and a bear with interesting feet; below the bear is a third design representing a head with a potlatch hat. Below the bear is another figure which has the body of a bear with a small head between the legs; the head of this last figure is not readable. The splitting of the design is clearly apparent in this front view.

177 LOWER

Tribe: Haida Location: Frank Smith Collection
Height (of section shown): 6 in.
Width (of section shown): 3½ in.

Detail of a model slate totem pole showing the fineness of surface quality. The way in which the small figure of the man is related and interwoven with the bear is skillful and pleasing. The whole concept is monumental.

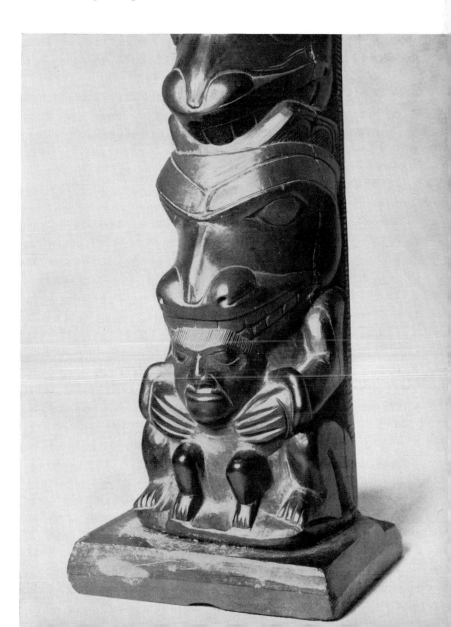

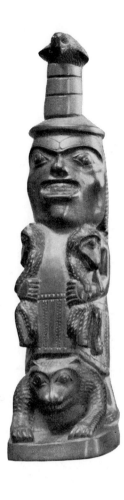

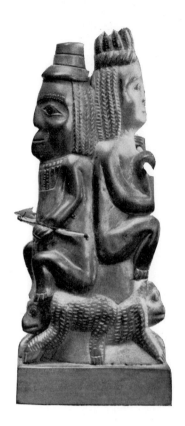

178 UPPER LEFT
179 UPPER RIGHT
Tribe: Haida
Measurements: Unknown
Location: Unknown
Two old Haida slate carvings. These pieces were photographed in the early 1900's.

180 FACING PAGE (TWO VIEWS)
Tribe: Haida Depth: 2¼ in.
Height: 9¾ in. Location: R. B. Inverarity Collection
Width: 3¾ in.
Photograph by Lamont Bench.
A fine carving of a chief wearing a blanket of unusual design, a rope of cedar bark over one shoulder, and a small headdress. The monumental character of the carving is obvious.

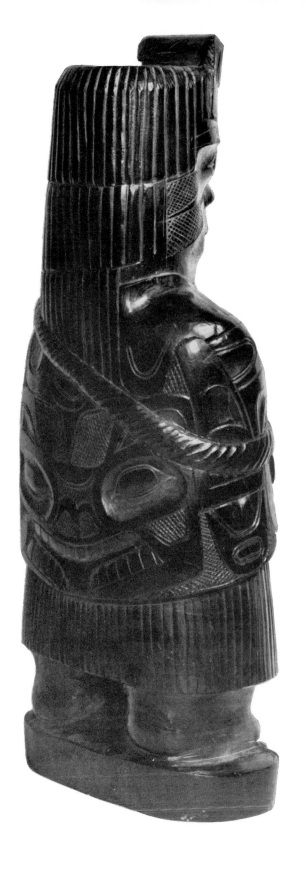
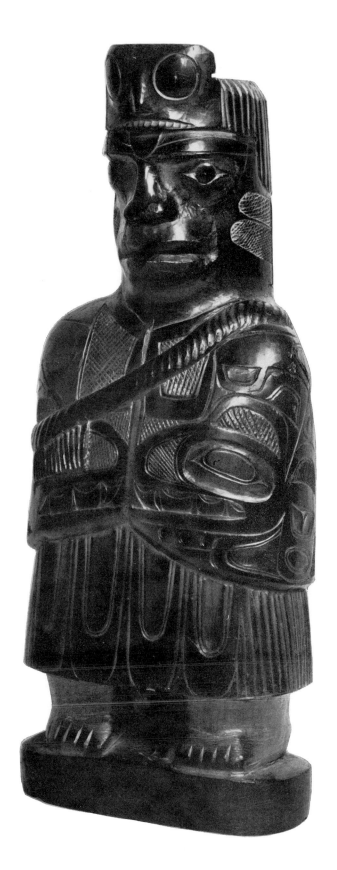

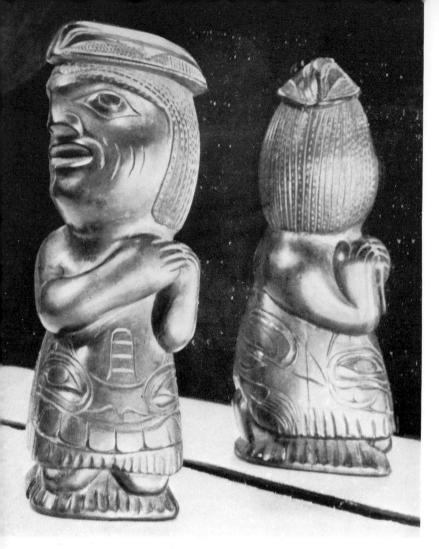

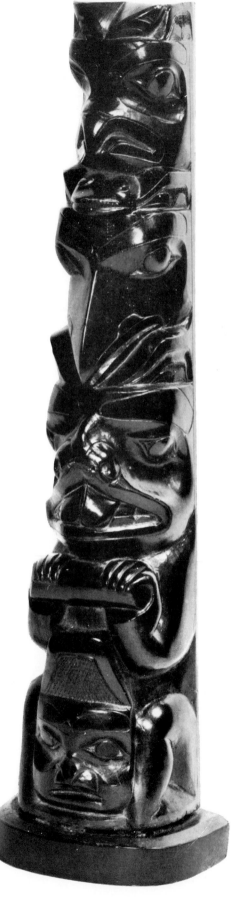

181 ABOVE
Tribe: Haida Base: 1¾ in.
Height: 5½ in. Location: Viola Garfield Collection
Carved slate figure wearing a boat-shaped hat and a dance apron. This
carving is probably an old example of slate carvings because of the
boat-shaped hat, which is an old style, and the treatment of the hair,
and also the attempt to give expression to the face by the lines on the
cheeks. The position of the arms and hands is uncommon.

182 RIGHT
Tribe: Haida Depth: 1¾ in.
Height: 10¾ in. Location: R. B. Inverarity Collection
Width: 2¼ in.
Photograph by Lamont Bench.
Model totem pole carved in slate. The front view shows the symmetrical
quality of the design; however, when the veiwpoint is changed slightly
to one side, the symmetry is gone and a dynamic series of moving
forms appears.

183 UPPER LEFT
Tribe: Haida Location: Southwest Mu-
Height: 6¾ in. seum
 Museum Number:
 980-9-141
Carved bone figure of a white sea captain seated in a wooden chair.
This figure has the typical Northwest Coast eyes.

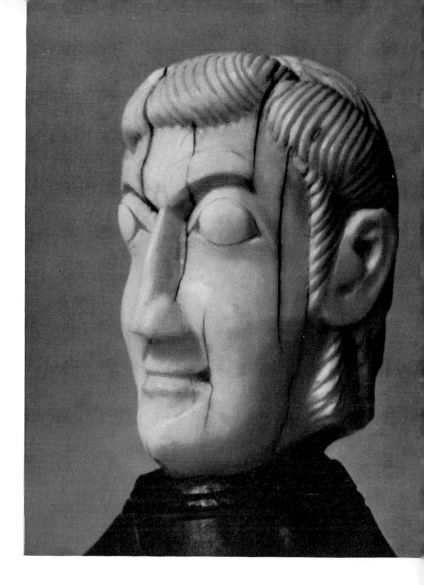

184 UPPER RIGHT
Tribe: Haida
Height: 7¾ in.
Width: 2½ in.

Location: Southwest Museum
Museum Number:
980-9-142

Slate carving representing a white woman. The use of ivory to indicate the whiteness of the European is not uncommon. The details of the dress are well observed and rendered.

185 RIGHT
Tribe: Haida
Height: 6¼ in.

Location: Southwest Museum
Museum Number:
980-9-140

Figure of a white woman carved in horn, the head is ivory.

186 FAR RIGHT
Height: 6½ in.
Width: 2½ in.

Location: Southwest Museum
Museum Number:
980-9-139

Bone carving representing a white woman but which retains most of the Indian stylization.

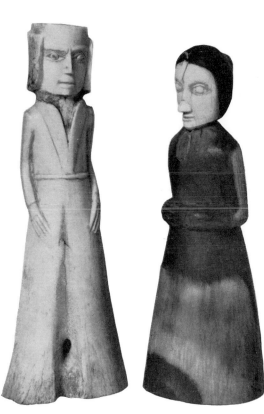

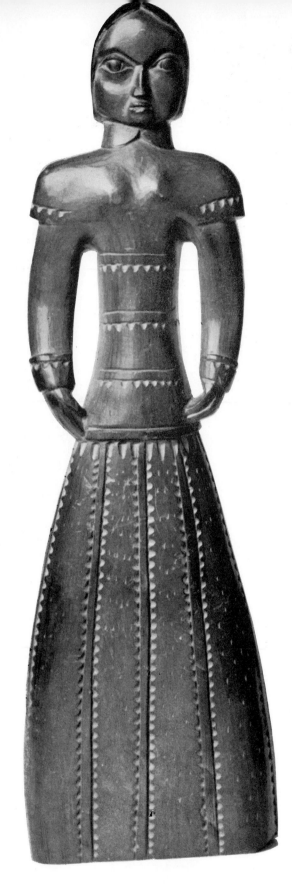

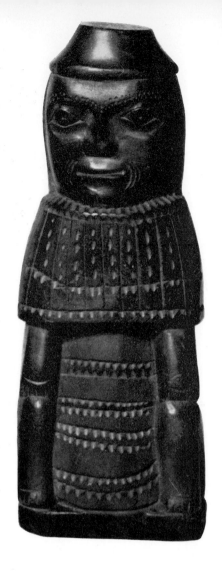

187　UPPER LEFT
Tribe: Haida　　　　　Location: Southwest Mu-
Height: 9⅞ in.　　　　　　seum
Width: 3 in.　　　　　　Museum Number:
　　　　　　　　　　　980-9-143(B)
Slate carving of a white woman. The salient features
of the dress are well observed and recorded as simply
as possible, although the surface decoration is mo-
notonous in the spacing. The artist has very ably por-
trayed the primness of the subject.

188　UPPER RIGHT
Tribe: Haida　　　　　Location: Southwest Mu-
Height: 4⅞ in.　　　　　　seum
Width: 1¾ in.　　　　　　Museum Number:
　　　　　　　　　　　980-9-143(A)
Slate carving in an older style than plate 187.

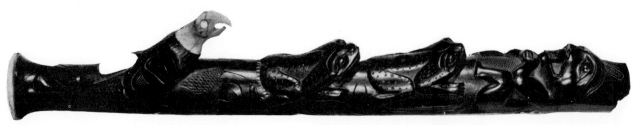

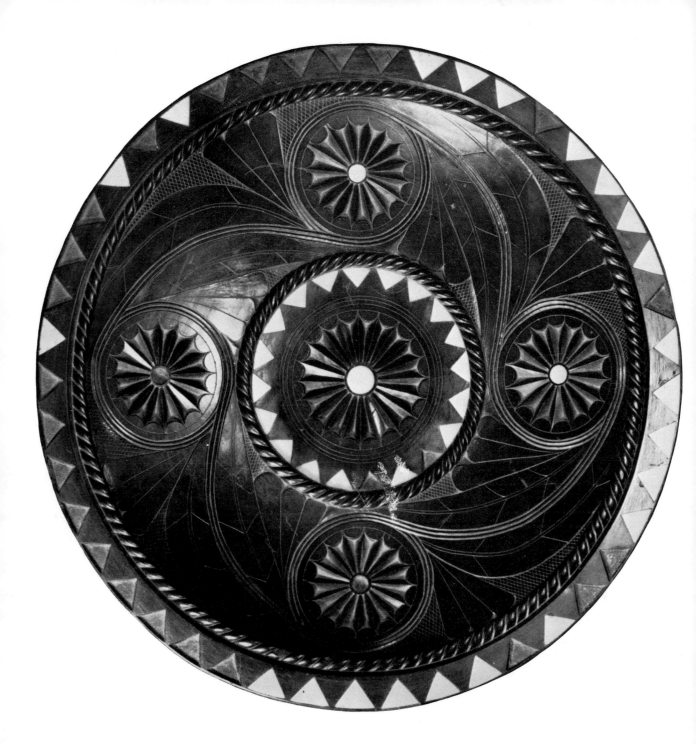

189 LEFT
Tribe: Unknown
Length: 22 in.
Location: Anthropological Museum, Univ. British Columbia, Vancouver, B.C.
Museum Number: A250, Burnett Collection
Photograph, Visual Education Service, University of British Columbia.
Flute carved from slate. The mouthpiece and the head and tail of the eagle are ivory;
the inlaid eye is abalone shell.

190 ABOVE
Tribe: Haida Thickness: 2¾ in.
Diameter: 17 in. Location: R. B. Inverarity Collection
Photograph by Lamont Bench.
Slate plate engraved and inlaid with bone. The design is clearly derived from European
influences. The circular elements are similar to Russian designs; it may be that this was
the source for the design of the plate.

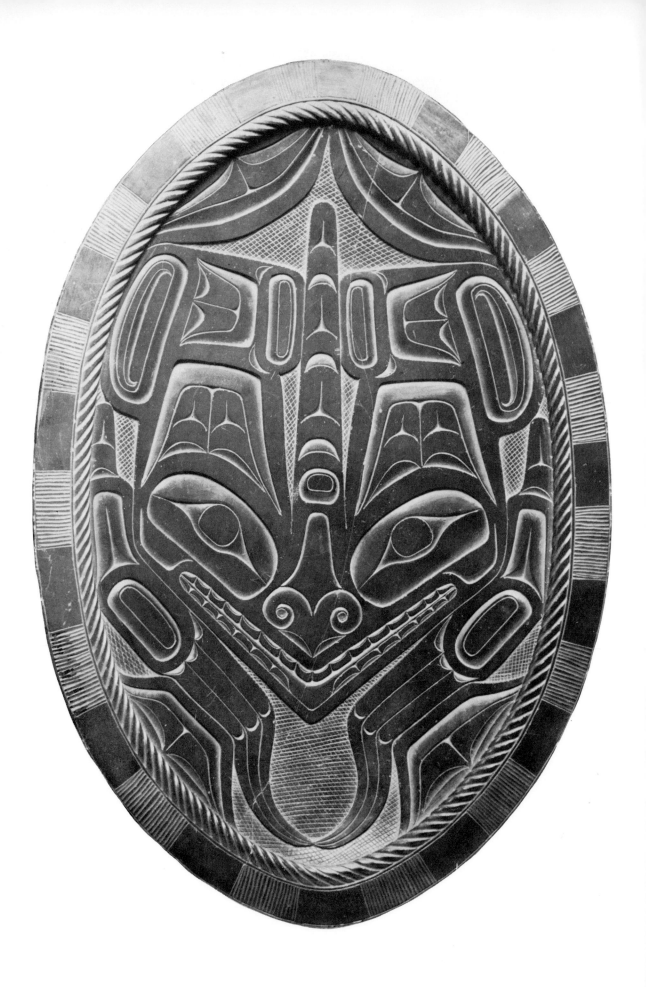

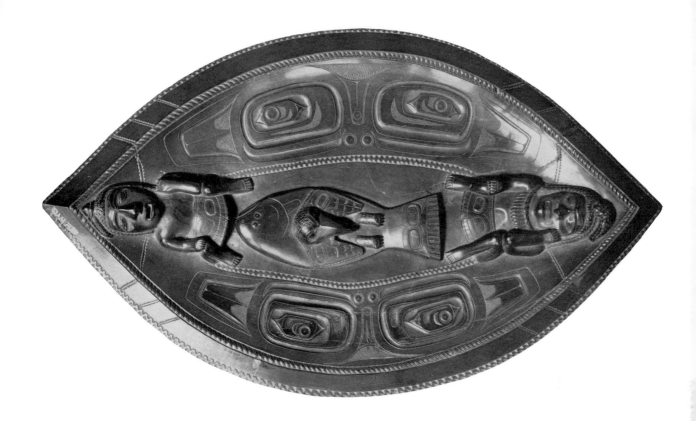

191 FACING PAGE
Tribe: Haida Width: 10 in.
Length: 14 in. Location: Frank Smith Collection
Slate plate engraved with the design of a dragonfly. The adaptation of the design to the
shape of the plate is extremely well done. The use of straight lines on the border and
hatching in the center of the plate produces, in contrast to the plain slate surface, a
variety of textures which enhance the beautiful design. Note the spiral line of the nos-
trils. The long delicate and sweeping fingers are pleasing; throughout the design similar
forms are repeated.

192 ABOVE
Tribe: Haida Location: Southwest Museum
Length: 23½ in. Museum Number: 638-9-1
Width: 13⅞ in.
Carved slate plate; an older shape than the one shown in plate 190. Low and high relief
carving have been employed here. In the center a raven is depicted partly emerging from
a halibut. The two figures at the ends represent shamans. Totemic designs are incised
along the sides of the plate. The two shamans are carved in a more realistic manner than
is customary, particularly is this true of the free and natural position of the arms and
legs. Note the incised lines about the mouths of the shamans which give expression to the
face.

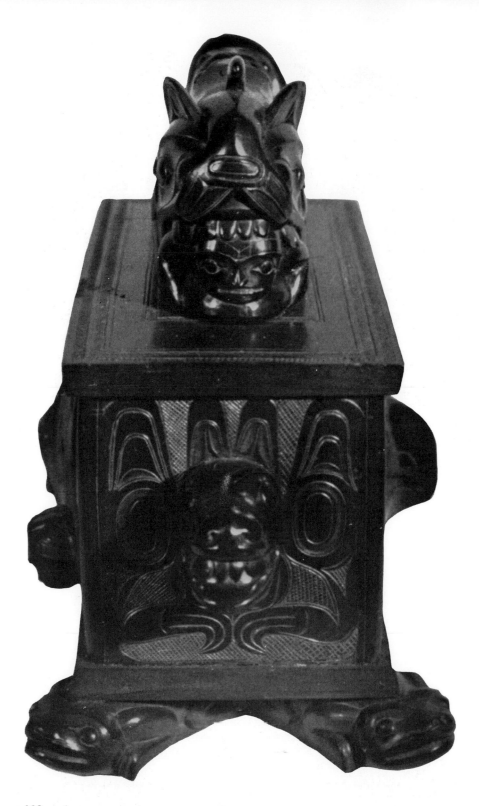

193 (THREE VIEWS)

Tribe: Haida

Height: 5½ in.

Length: 5½ in.

Width: 2½ in.

Collected by G. H. Cunningham.

Location: Provincial Museum, Victoria, B.C.

Museum Number: On loan

An elaborately designed, carved slate box. The top of the box shows a mythical animal with a man in its mouth and a porpoise over its head and another one held by the tail. One side of the box is carved with a beaver's head with two smaller heads projecting from its cheeks. The other side portrays an eagle. On the ends of the box animal heads jut out; the four corners of the box are supported by frogs.

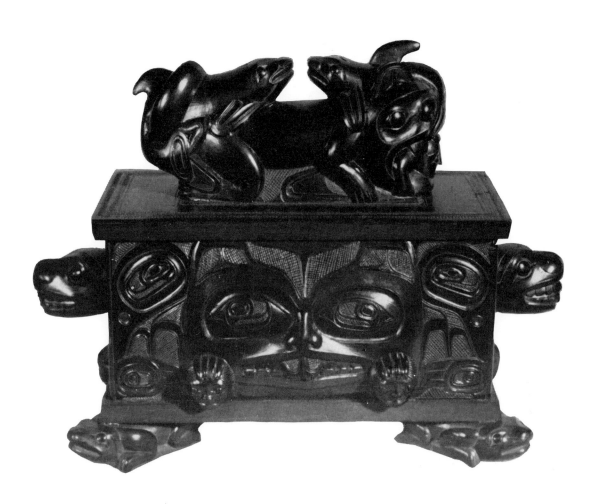

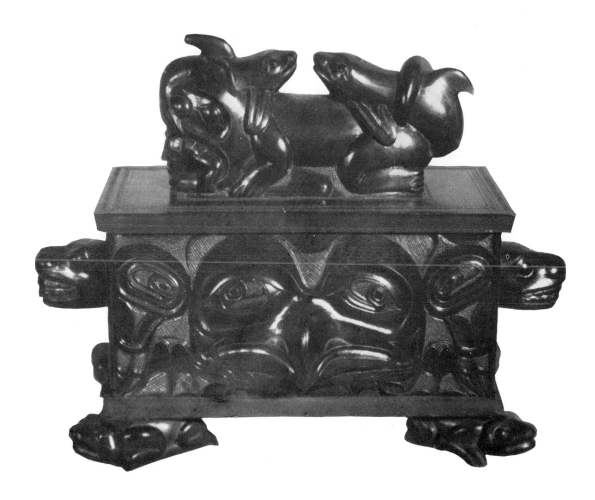

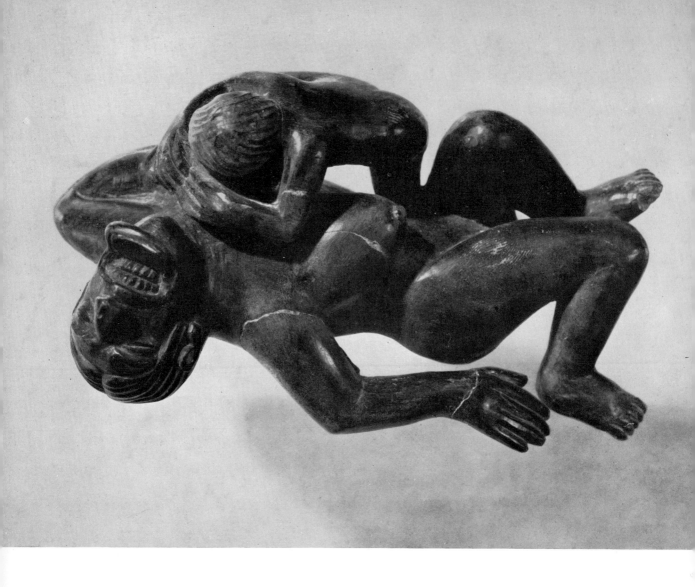

194

Tribe: Haida

Location: Smithsonian Institution

Length: 5¾ in.

Museum Number: 73, 117

Photograph, Smithsonian Institution.

Collected by J. G. Swan at Skidegate, Queen Charlotte Islands, B.C., 1883.

The "Bear Mother" carved in black slate by Skaowskeay of Skidegate. The carving illustrates a well-known legend about a group of Haida women who were out gathering berries and one of the women, daughter of a chief, ridiculed bears. The bears heard and attacked, killing all but the chief's daughter whom the king of the bears took for his wife. The woman bore a child, half human and half bear. The slate carving represents the mother's pain in suckling this child in human form but with the instincts of a bear. A group of Indian hunters found the woman, according to the tale, and returned her to her home where she became the progenitrix of all Indians belonging to the bear totem. Members of this totem believe that bears are turned into men for the time being.

This carving is one of the most famous of all slate carvings, largely because it presents an emotional quality seldom found in Northwest Coast art.

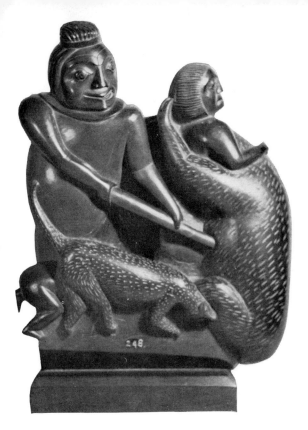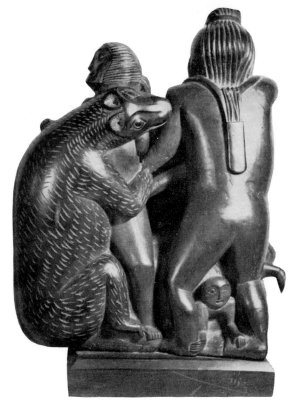

195 ABOVE (TWO VIEWS)

Tribe: Haida Location: Provincial Museum, Victoria, B.C.

Height: 13 in. Museum Number: 248

Collected by J. Deans at Skidegate, Queen Charlotte Islands, B.C., 1889.

Slate carving representing a hunter, child, and dog rescuing a woman from a bear. This carving is one of the finest because of the concept, craftsmanship, sculpture, motif, and size. Such literal interpretations are rare, and it is a fine example of the attempt to portray facial expression. The bulging eyes and the shape of the hunter's mouth create a tense expression. The mouth shape is found occasionally on other objects from this area; it is usually referred to as facial paralysis. Some helmets presenting a twisted mouth may indeed depict facial paralysis (see pls. 96, 98). However, I am inclined to think that these contorted mouths represent an attempt to create an expression of tension or strain. The portrayal of the hair and the use of surface textures are points to be noted in this carving. The simplicity of the body and the feeling of fullness and mass are apparent in this sculpture.

In the front view all the main lines have been subordinated to the spear in the side of the bear. The dog's tail repeats in form and direction the bear's arm and both areas have the same textural pattern. All the lines radiate to the bear and the wound in its side. Note how the body of the bear has bulged to accentuate the thrust of the spear, yet the figure of the man is passive in gesture. All of the figures, except the dog and the boy, seem to be static, although the carving and arrangement of forms and line movement present to the eye the illusion of action. If closely examined, the position of the hips of the man indicates that he was withdrawing the spear rather than forcing it forward, yet the bulge in the bear's body indicates that the spear is being forced upward. The way in which the lines flow into one another is noteworthy. The bear's arm flows into the woman's head; the man's right arm carries on into the spear; the movement of the dog's head is carried into the bear's hips; the dog's tail takes the same curve as the man's torso; all lines lead into others. The general effect is, then, one of radiation to the bear's wound and the added sag of the bear's body. The size of the bear's body is balanced by that of the man, and the sag is in the opposite direction.

The reverse side of the carving is an excellent example of how these artists simplified the figure by diminishing the size of the parts thus permitting one mass to flow into another. The boy's wink is an anomaly considering the motif of the sculpture. Except in the rendering of the eyes, eyebrows, and textural patterns, this carving bears little relation to the art styles of the Northwest Coast Indians. It is one of the great pieces of sculpture from the area.

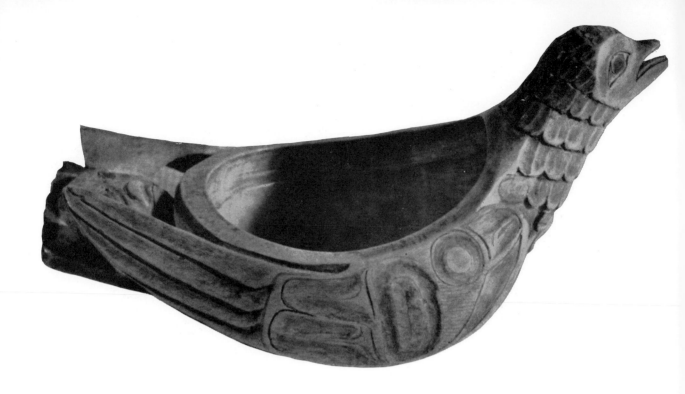

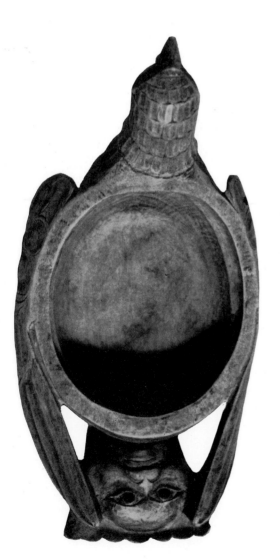

196 ABOVE AND LEFT
Tribe: Tsimshian
Location: Provincial Museum, Victoria, B.C.
Museum Number: 4108
Wooden dish carved in the shape of a bird with a human figure
on its breast and a human face on its tail. Note the careful and
unusual treatment of the neck feathers. The adaptation of a
bird shape to a dish is comparable to the more common adapta-
tion of a seal. Birds of this type, which are not part of totemic
conventionalization, are unusual in the art.

197 LOWER
Tribe: Haida Location: British Museum
Length: 10 in. Museum Number: N.W.C. 25
Copyright photograph, British Museum.
Collected by Captain George Dixon in 1785–1787.
Wooden bowl, one of the earliest known dated pieces from the
area. It is clear from this specimen that the style has not greatly
changed from the days of the earliest contacts with Europeans
to recent times. The design and carving are very fine.

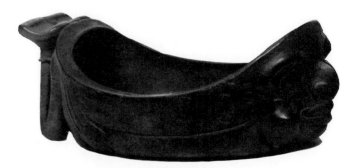

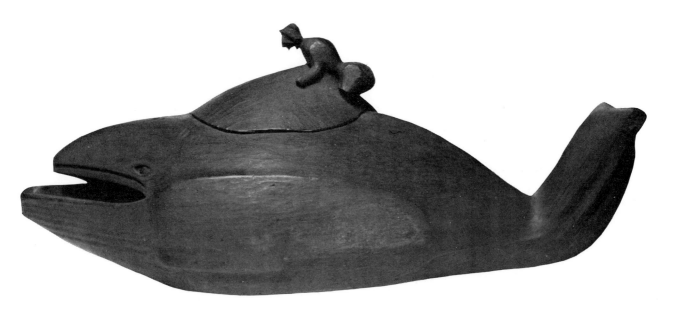

198
Tribe: Kwakiutl
Length: 28 in.
Width: 11 in.
Height: 13 in.
Location: Vancouver Historical Museum,
Public Library, Vancouver, B.C.
Collected by D. J. Sweeny at Nootka, Vancouver Island, B.C., 1929.
Ceremonial wooden food receptacle, stained black. The artist has made the receptacle in
the form of a whale, instead of adapting the animal form to fit the object he was carving.

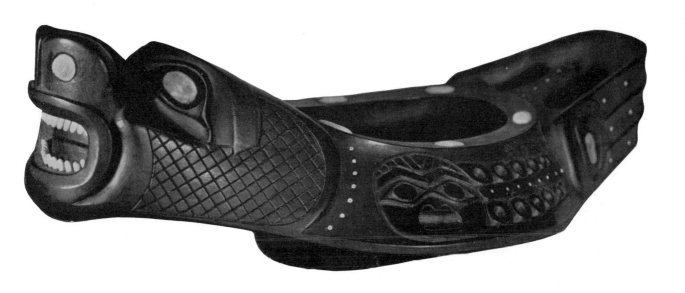

199
Tribe: Unknown
Length: 15 in.
Width: 7½ in.
Depth: 5 in.
Location: Museum of Anthropology, Univ. California,
Berkeley
Museum Number: 2-13166
Collected by W. M. Tompkins.
Wooden food dish carved to represent a species of seal commonly found on the North-
west Coast; painted black; decorated with abalone shell, bone, and beads. The incised
carving on the side represent the octopus. Certain pieces of this type were reproduced
by the Japanese and sold on the Northwest Coast as genuine Indian articles.

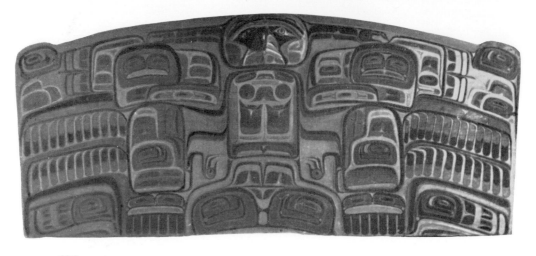

200 ABOVE

Tribe: Kwakiutl

Height: 22 in.

Length: 36 in.

Collected by C. F. Newcombe, 1911.

Location: Provincial Museum, Victoria, B.C.

Museum Number: 1856

Chief's seat carved in yellow cedar (view of back of seat). Painted black, red, and blue. The back of the seat represents an eagle and a thunderbird; the sides (not shown), a whale.

201 BELOW

Tribe: Unknown

Length: 24 in.

Location: Anthropological Museum, Univ. British Columbia, Vancouver, B.C.

Museum Number: 1785

Photograph, Visual Education Service, University of British Columbia.

Ceremonial feast dish adzed out of cedar, carved in one piece. This dish and that shown on the facing page were made to commemorate the deeds of a famous Nootka whale hunter, Kula. Traces of the original red paint are still visible around the eyes, mouth, and other parts.

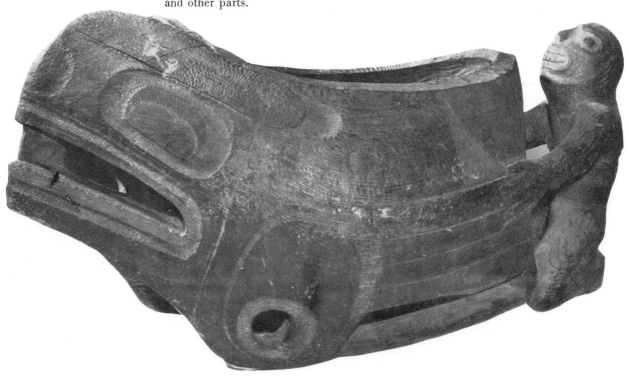

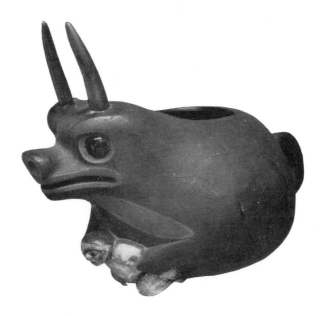

202 ABOVE
Location: De Young Museum
Photograph by Victor Duran.
Wooden feast dish carved in the shape of a bear holding a human figure with its front paws. The horns are, to say the least, unusual. The eyes are made of glass. The dish comes from the Kwakiutl area.

203 BELOW
Tribe: Unknown
Length: 24 in.

Location: Anthropological Museum,
 Univ. British Columbia, Vancou-
 ver, B.C.
Museum Number: 1786

Photograph, Visual Education Service, University of British Columbia.
Ceremonial feast dish of cedar. This dish—made to fit with that shown in plate 201—represents the tail of a whale and commemorates the Nootka whale hunter, Kula.

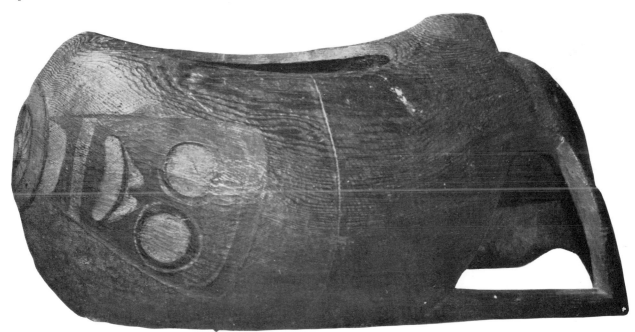

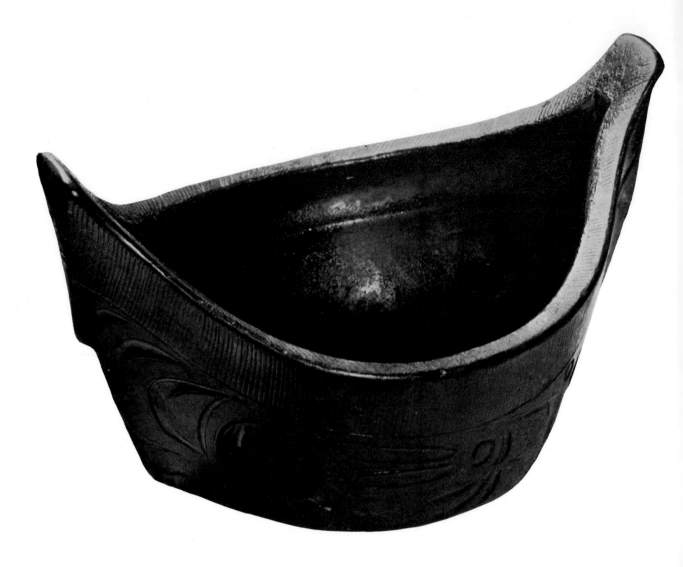

204
Tribe: Kwakiutl Location: Anthropological Museum, Univ. British Columbia, Van-
Length: 12 in. couver, B.C.
 Museum Number: A1798, Raley Collection
Photograph, Visual Education Service, University of British Columbia.
Carved wooden dish made to hold fish oil.

205
Tribe: Unknown Location: Museum of Anthropology,
Length: 12⅝ in. Univ. California, Berkeley
Depth: 6½ in. Museum Number: 2-4634
Photograph by Victor Duran.
Alder wood dish carved in the shape of a boat or canoe.
Dishes of this kind, which were used to hold fish oil, are
often so permeated with oil that they still exude it after
half a century. This dish was collected before 1904. The
flowing shape of the dish is a delight to the eye.

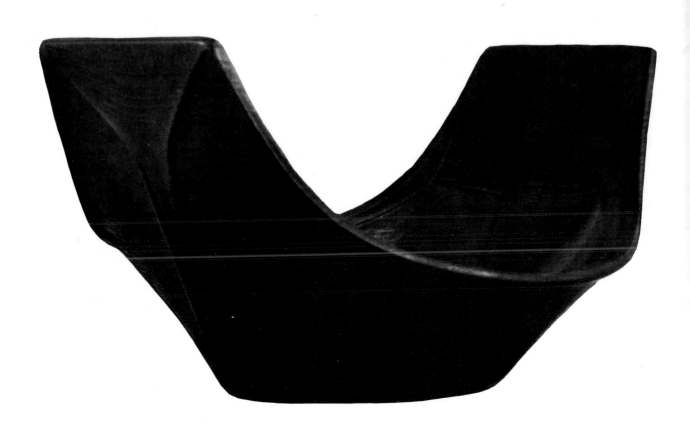

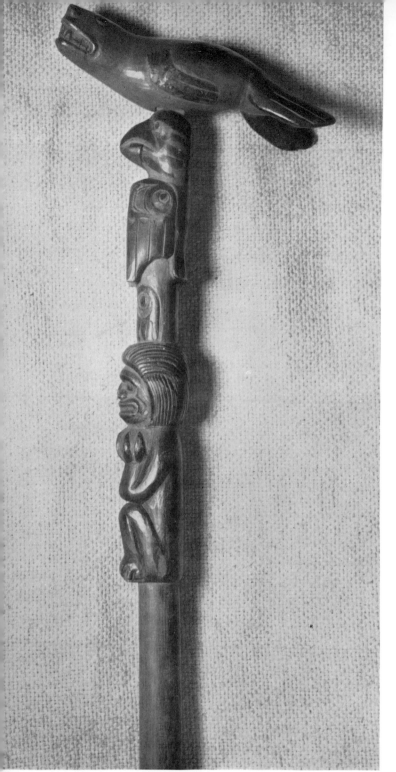

206 LEFT
Tribe: Unknown
Length: 14½ in.
Location: Frank Smith Collection
Painted wooden baton carved with a realistic seal at the top, an eagle below. and the figure of a man. Between the eagle and the man is a small design representing a foot.

207 BELOW
Tribe: Kwakiutl
Length of spear: 3 ft. 10 in.
Location: Provincial Museum, Victoria. B.C.
Museum Number: 103
Collected by F. Jacobsen, 1893.
Wooden spearhead representing the Sisiutl.

208 RIGHT
Tribe: Unknown
Length: 68 in.
Length of hand: 20 in.
Width of hand: 8½ in.
Location: Frank Smith Collection
Carved and painted wooden baton decorated with tufts and strands of hair. The natural crook of the wood has been used to form an elbow. The palm of the hand is painted with the figure of a man with unusual eyebrow shapes; the back of the hand shows a carved face.

209 LOWER RIGHT
Tribe: Haida
Length: 4 ft.
Width: 2½ in.
Location: Frank Smith Collection
Carved and unpainted wooden baton. The main body of the baton forms an octopus tentacle with a double row of suckers. At the top, surrounded with a fringe of hair, is the actual "beak" of the octopus. Above the fringe of hair the beak is circled with a series of small faces.

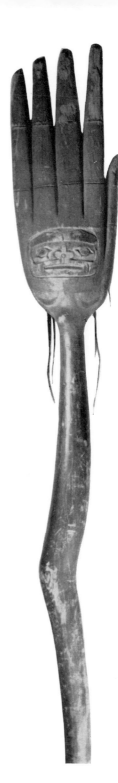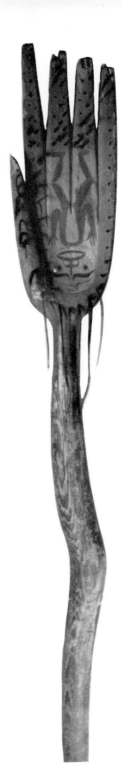

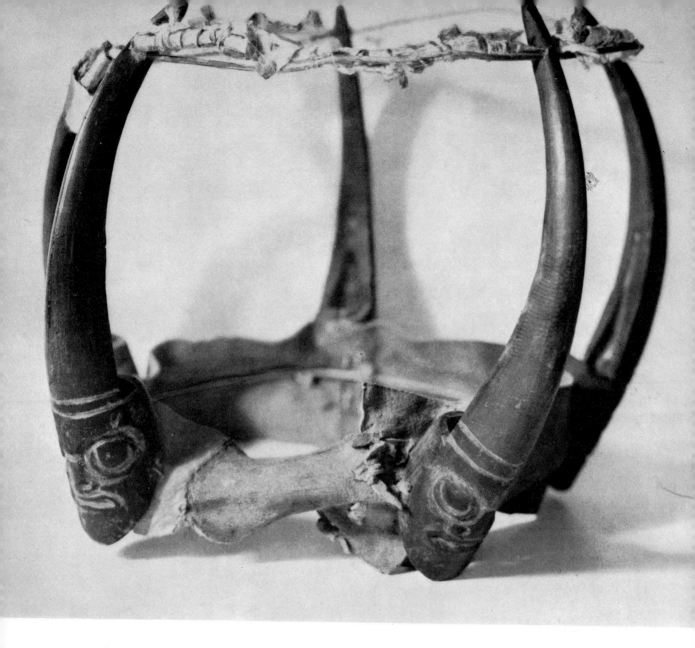

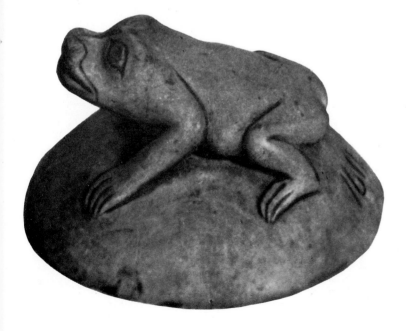

210 ABOVE
Tribe: Tlingit
Height: 7⅛ in.
Circumference: 10 in.
Location: Southwest Museum
Museum Number: 781-G-16
Shaman's headdress made from horns of the
mountain goat and of leather. There is a piece
of wire in the crown and at the top, probably
added at a later date.

211 LEFT
Tribe: Tsimshian
Diameter: 2 7/16 in.
Location: Provincial Museum, Victoria, B.C.
Museum Number: 1611
Collected by C. F. Newcombe at Angidah, Brit-
 ish Columbia, 1913:
Half of a clapper carved in maple to represent
a frog.

212 LEFT

Tribe: Kwakiutl
Length: 13¼ in.
Width: 2½ in.
Depth: 2 in.
Location: Provincial Museum, Victoria, B.C.
Museum Number: 1926
Collected by C. F. Newcombe at Blunden Harbour, British Columbia, 1914.

Whistle carved from two pieces of cedar joined together with pitch and bound with fishline. The carving represents a human figure with a frog on the stomach. The whistle emits one note which, humorously enough, comes out of the gaping mouth.

213 BELOW (TWO VIEWS)

Tribe: Tsimshian
Length: 4 in.
Width: 2½ in.
Thickness: ⅛ in.
Location: Provincial Museum, Victoria, B.C.
Museum Number: 181
Collected by W. B. Anderson at Port Simpson, British Columbia, 1891.

Wooden comb with the head of a hawk carved on the handle.

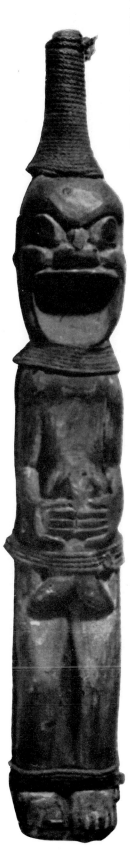

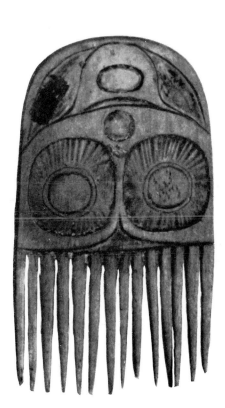

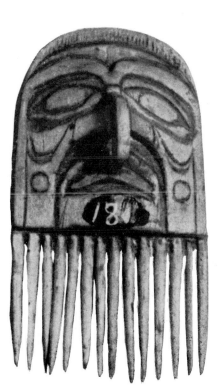

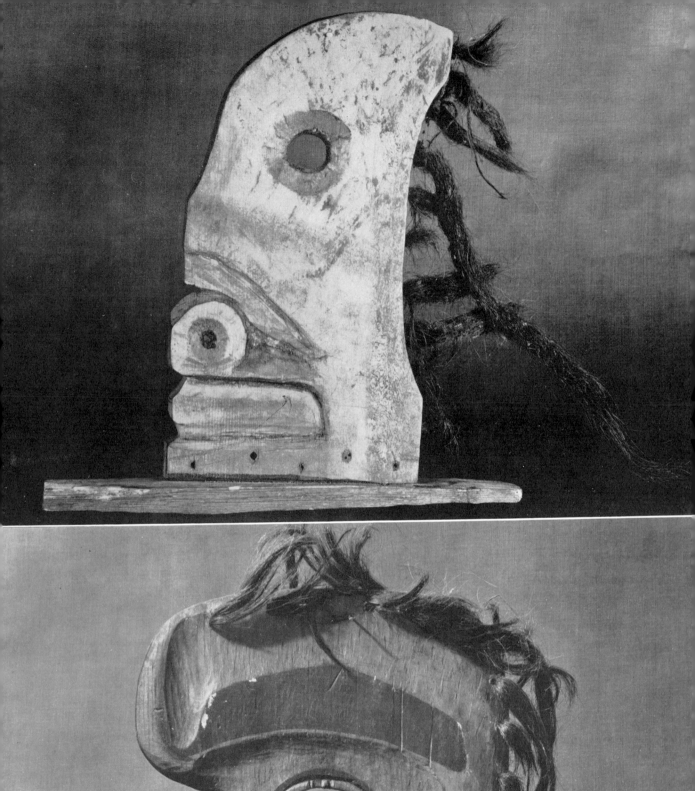
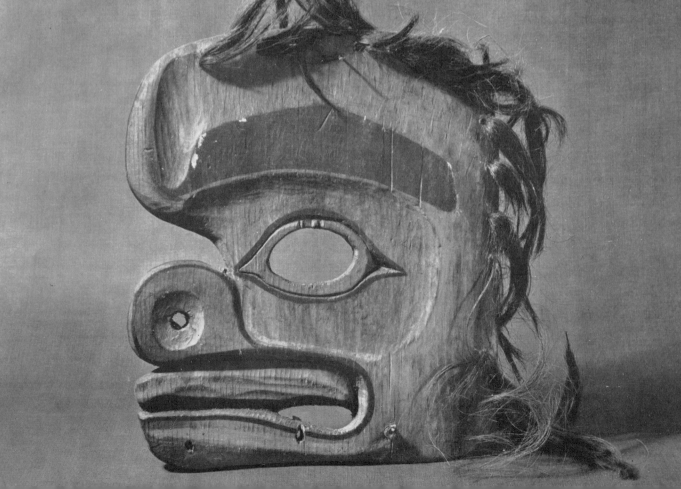

216 RIGHT

Tribe: Unknown
Height: 7 in.
Width: 4½ in.
Location: Washington State Museum
Museum Number: 2043
Photograph by Robert Donaldson.
Collected by G. T. Emmons.
Carved wooden ornament attached
by thongs to a headdress; decorated
with tufts of human hair and painted
green. Carved to represent the dorsal
fin of a killer whale. Compare the de-
sign with a similar ornament shown
in plate 214.

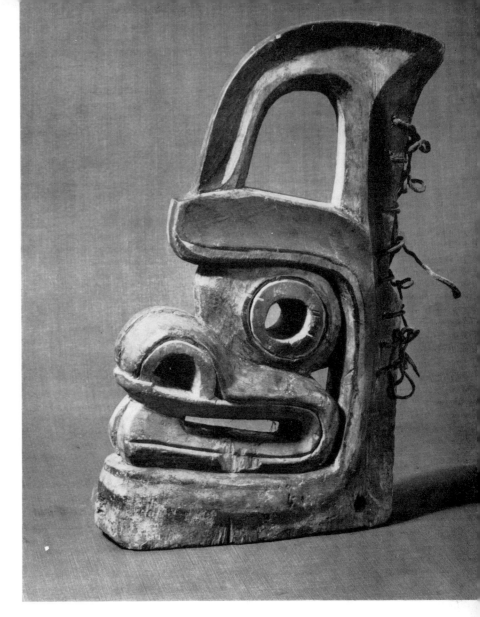

214 UPPER LEFT

Tribe: Unknown
Height: 8 in.
Width: 7 in.
Thickness: ¾ in.
Photograph by Robert Donaldson.
Collected by G. T. Emmons.

Location: Washington State Museum
Museum Number: 2042

Carved wooden headdress ornament decorated with tufts of human hair and painted red
and black. The design represents the dorsal fin of the killer whale. Compare the design
and execution with the specimen shown in plate 216.

215 LOWER LEFT

Tribe: Unknown
Height: 6½ in.
Width: 6 in.
Thickness: ½ in.
Photograph by Robert Donaldson.
Collected by G. T. Emmons.

Location: Washington State Museum
Museum Number: 2041

Carved headdress ornament representing a bear's head; decorated with tufts of human
hair and painted red and black.

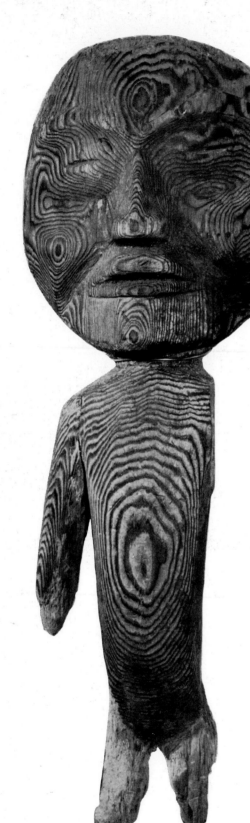

217 LEFT

Tribe: Kwakiutl Location: Anthropological Museum,
Height: 24 in. Univ. British Columbia, Vancouver,
 B.C.
 Museum Number: A1799, Raley Collec-
 tion

Photograph, Visual Education Service, University of British
 Columbia.

Carved wooden grave figure from a deserted village near Kiti-
mat, Douglas Channel, British Columbia.

218 FACING PAGE

Tribe: Tlingit Location: Wolfgang Paalen Collection
Height: 12 in.

Photograph by A. Caillet.

Wood carving painted green, yellow, red, and black with the
figure in flesh tone. On the back of the carving is a penciled note:
"Sitka 1810"; which may or may not be an indication of the
carving's age. The figure represents a sea monster carrying a
woman on its back. The nude figure of the woman is not a com-
mon subject in this art. Although the head of the sea monster
is rendered in the usual fashion, the rest of the monster's body is
unusual. It appears to be composed of three sets of flukes, the
lower one has circular elements which repeat the forms of the
eyes and breasts. The carving of the head of the woman is superb,
the body, as is usual, is crude in comparison. Note the interesting
indentation where the upper and forearm meet.

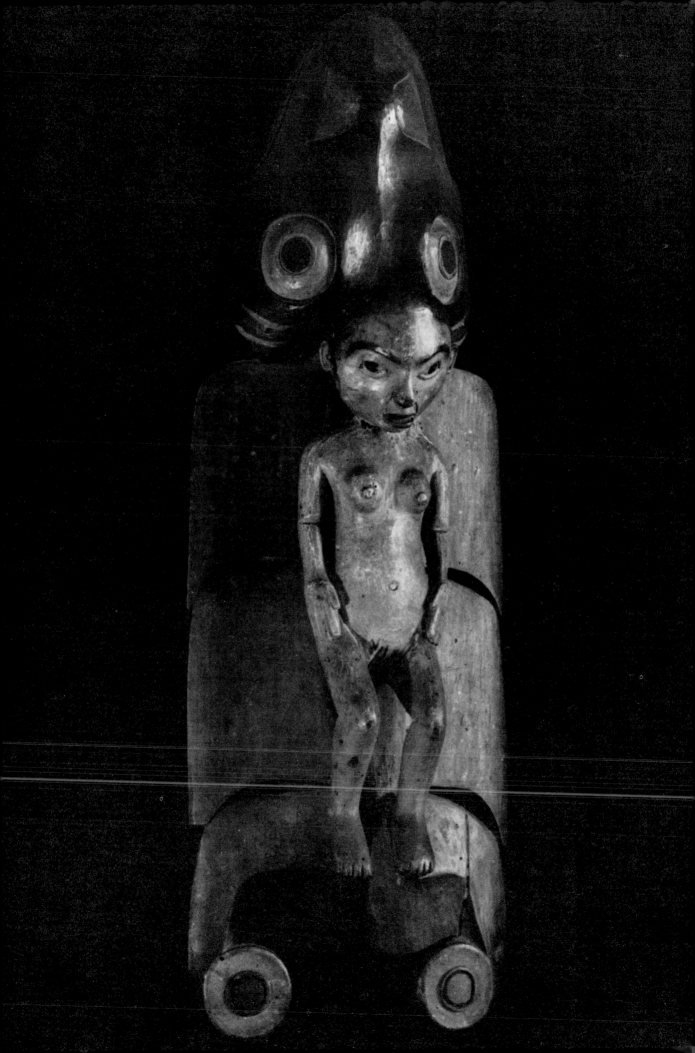

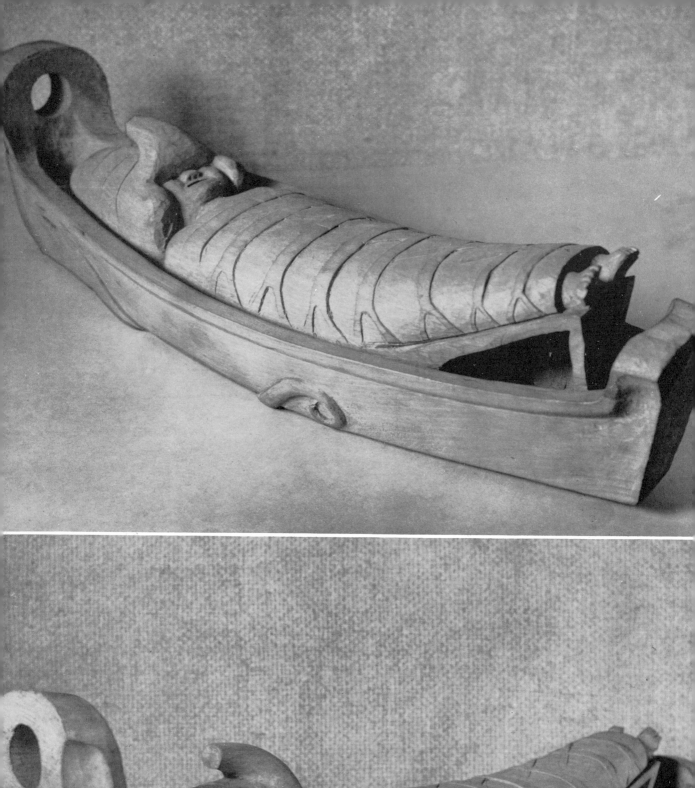
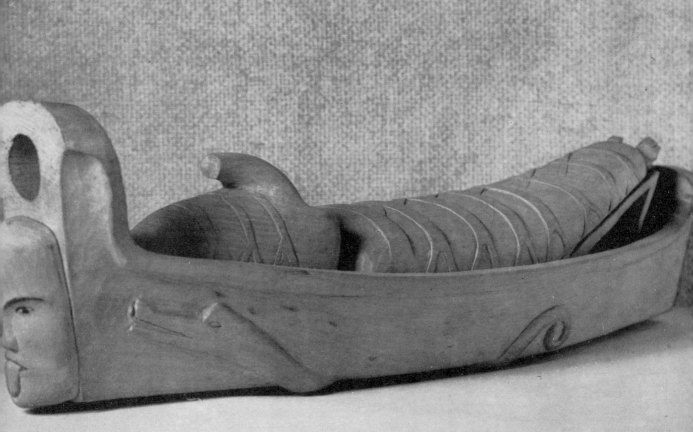

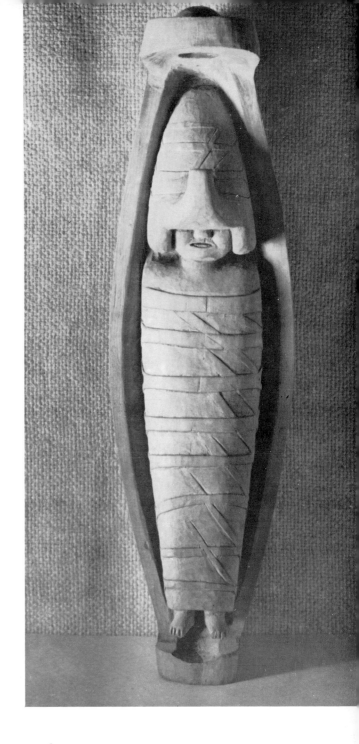

219 (THREE VIEWS)
Tribe: Kwakiutl(?) Depth: 5 in.
Length: 17 in. Location: Frank Smith Collection
Width: 5¼ in.
Collected at Quatsino Sound, Vancouver Island, B.C., in Kwakiutl territory.
Wood cradle carved in yellow cedar. The binding of the head and the wrapping of the
body are reminiscent of ancient practices. The artist may have been either Nootka or
Kwakiutl.

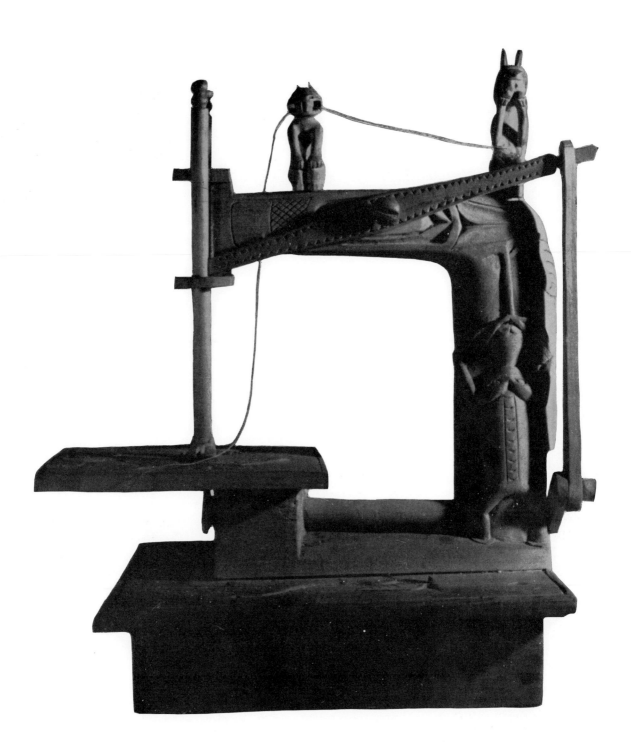

220
Tribe: Tlingit Width: 7½ in.
Height: 11¼ in. Location: Provincial Museum, Victoria, B.C.
Length: 10 in. Museum Number: S 56
Wooden model of a sewing machine decorated with totemic designs. It is included here
because it shows that even when copying European objects the Indian felt a necessity
to make it his own.

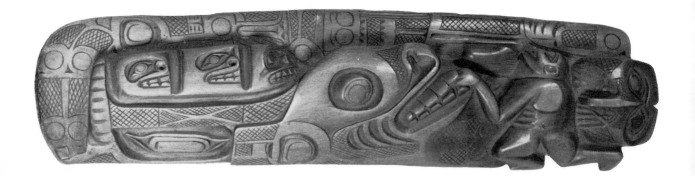

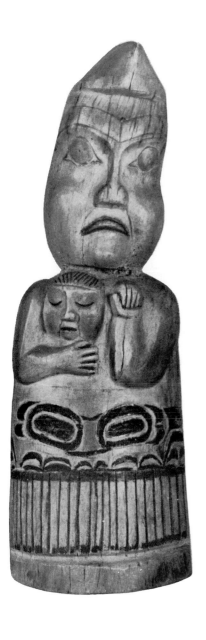

221 ABOVE

Tribe: Tlingit Thickness: 1¼ in.
Length: 16¾ in. Location: Washington State Museum
Width: 4 in. Museum Number: 2288
Collected by G. T. Emmons at Pyramid Harbour, British Colum-
 bia, 1885.
This carving in maple wood represents a man caught by a sea
spirit; at one end is a hawk's head. The object's use is not known.
Decorated objects were ordinarily made for some specific use,
unless they were made merely for trading purposes. It may be
this carving falls in that category. The carving was the work of a
master craftsman for it shows great technical skill as well as
artistic ability.

222 LEFT

Tribe: Unknown Depth: 2½ in.
Height: 10½ in. Location: Julius Carlebach Collection
Width: 3¾ in.
Figure carved in marine ivory; painted red and black.

223

Tribe: Unknown Depth: 3½ in.
Height: 14¾ in. Location: R. B. Inverarity Collection
Width: 3⅝ in.

Carved wooden figure painted red and black with tufts of
hair inserted. The figure is divided into three sections of
almost equal length. The large head forms one section, the
torso the second, and the legs the third. The large head is
repeated, essentially, in the head of the small figure;
similarly, the body of the large figure is repeated in the
small figure. The large head is the center of attraction to
the eye of the observer, but the whole carving illustrates the
downward flow of the form. The flat knee caps are promi-
nent features on both figures. The spaces between the arms
and legs are similarly rounded on both figures. The surface
painting is a complement to the flowing form of the whole
carving.

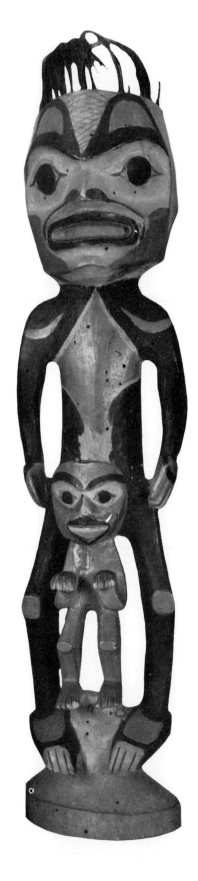

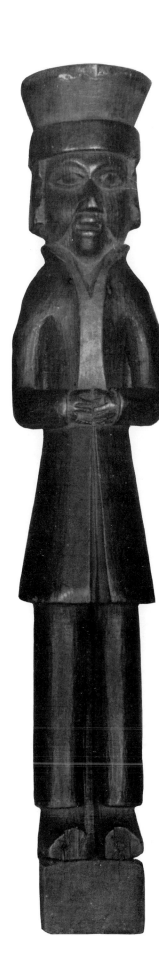

224

Tribe: Tlingit Depth: 2½ in.
Length: 16 in. Location: Washington State Museum
Width: 3 in. Museum Number: 2216
Collected by G. T. Emmons at Sitka, Alaska.

Figure carved in red cedar and painted. This carving seems almost a portrait of a nineteenth-century Russian missionary. The carver has skillfully, with a minimum of detail, simplified the figure, emphasizing only the features needed to give the spirit of the dress. Although divided lengthwise nearly into fourths, the subtle flaring lines eliminate any monotony which might have arisen from such an arrangement. The parts of the figure as well as the whole are cylindrical. The hat is very round; the face generally so, but broken up by the features; the arms, body, and legs are all cylindrical, yet each is different. This treatment gives a relationship of the parts to the whole and yet produces a pleasing variety.

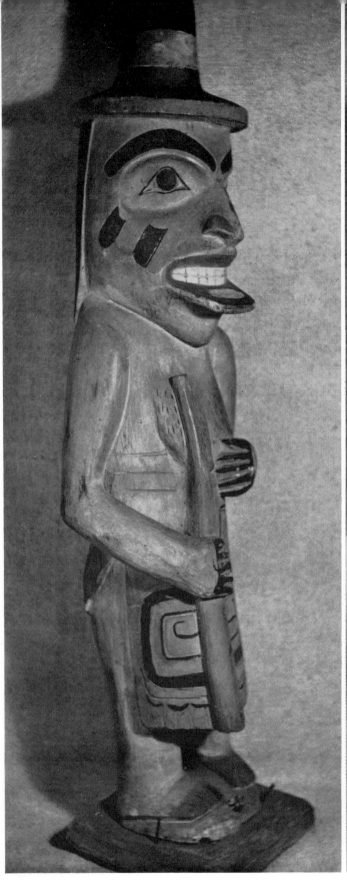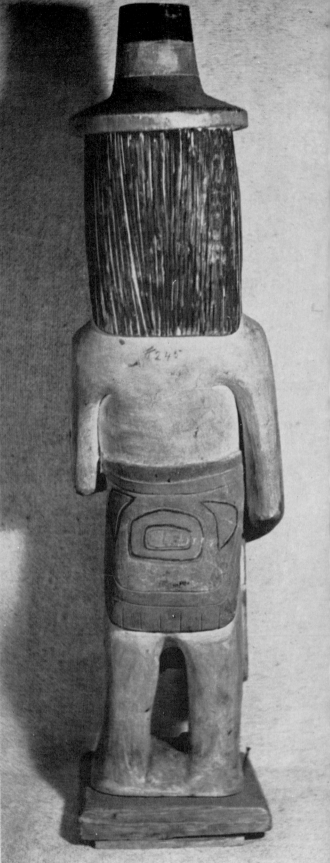

225 (TWO VIEWS)

Tribe: Haida

Height: 27 in.

Width: 6 in.

Depth: 5½ in.

Location: Provincial Museum, Victoria, B.C.

Museum Number: 245

Collected by J. Deans in the Queen Charlotte Islands, B.C., 1892.

Carved and painted representation of the spirit of death in the form of a woman with a labret. Painted red, black, and blue.

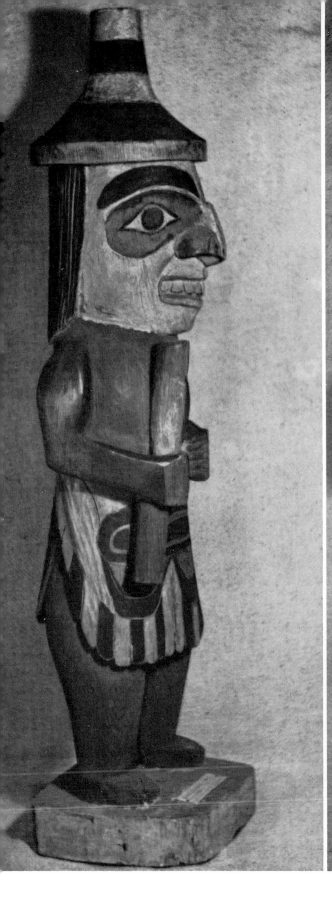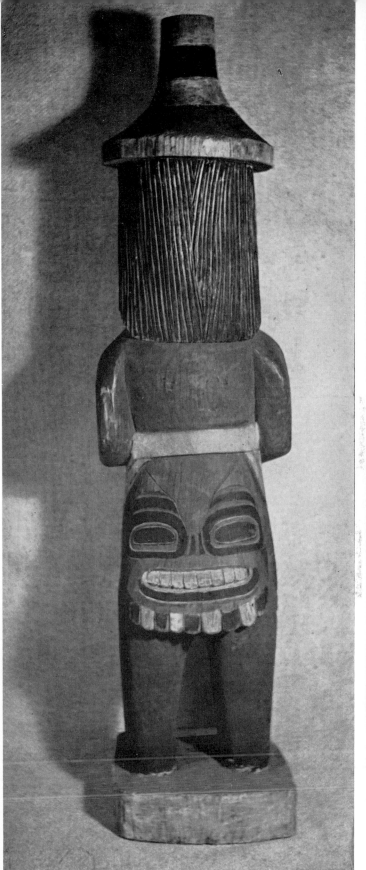

226 (TWO VIEWS)

Tribe: Haida

Height: 27½ in. Depth: 5 in.

Width: 6¼ in. Location: Provincial Museum, Victoria, B.C.

 Museum Number: 244

Collected by J. Deans in the Queen Charlotte Islands, B.C., 1892.

Carved and painted wooden representation of the spirit of death in the form of a man.

Painted blue, black, and red.

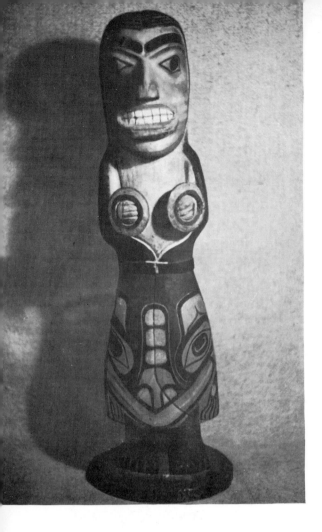

227 LEFT
Tribe: Haida
Height: 2½ in.
Width: 5½ in.
Depth: 5 in.
Location: Provincial Museum, Victoria, B.C.
Museum Number: 235
Collected by J. Dean in the Queen Charlotte
 Islands, B.C., 1892.
Figure of a shaman woman wearing a labret;
the apron shows the sea-bear emblem. The
hands hold two rattles of the ancient circular
type.

228 RIGHT
Tribe: Haida
Height: 19½ in.
Width: 6½ in.
Depth: 4 in.
Location: Provincial Museum, Victoria, B.C.
Museum Number: 240
Collected by J. Dean at Skidegate, Queen
 Charlotte Islands, B.C., 1892.
Wooden figure of a Haida chief wearing
headdress and cape and holding a rattle.

229 FAR RIGHT
Tribe: Haida
Height: 23 in.
Width: 6 in.
Thickness: 4¾ in.
Location: Provincial Museum, Victoria, B.C.
Museum Number: 234
Collected by J. Deans in the Queen Charlotte
 Islands, B.C., 1892.
The figure represents a shaman with a nose
skewer and holding a charm.

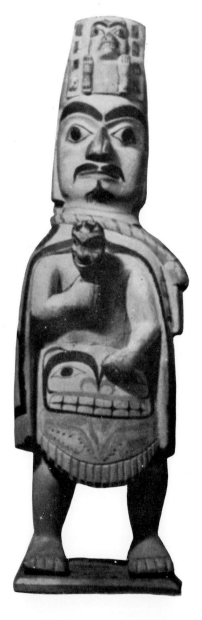
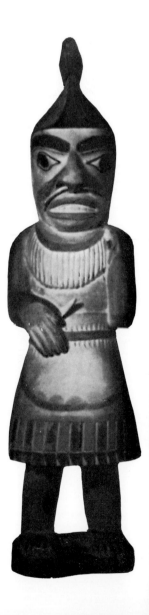

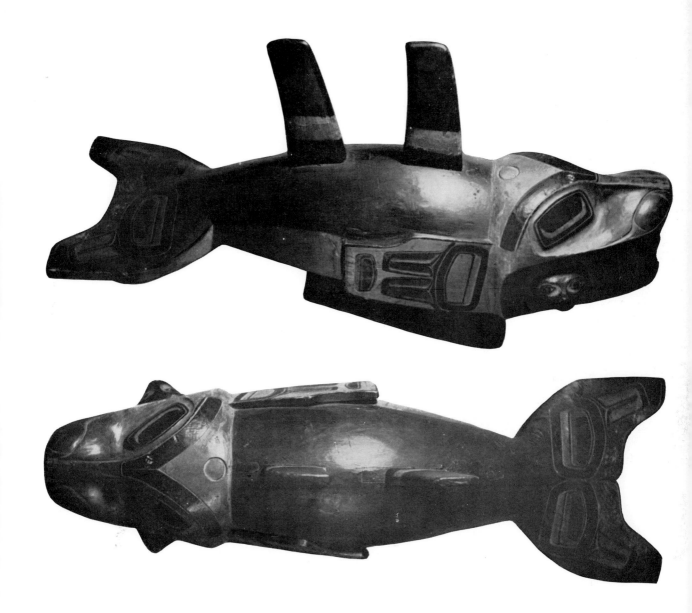

230 (TWO VIEWS)

Tribe: Haida Location: Provincial Museum,
Length: 30 in. Victoria, B.C.
Height: 15 in. Museum Number: 237
Width: 9 in.

Collected by J. Deans in the Queen Charlotte Islands,
 B.C., 1892.

Carved and painted wooden model of a totemic
emblem representing a mythical killer whale. These
figures were placed on top of a memorial column.

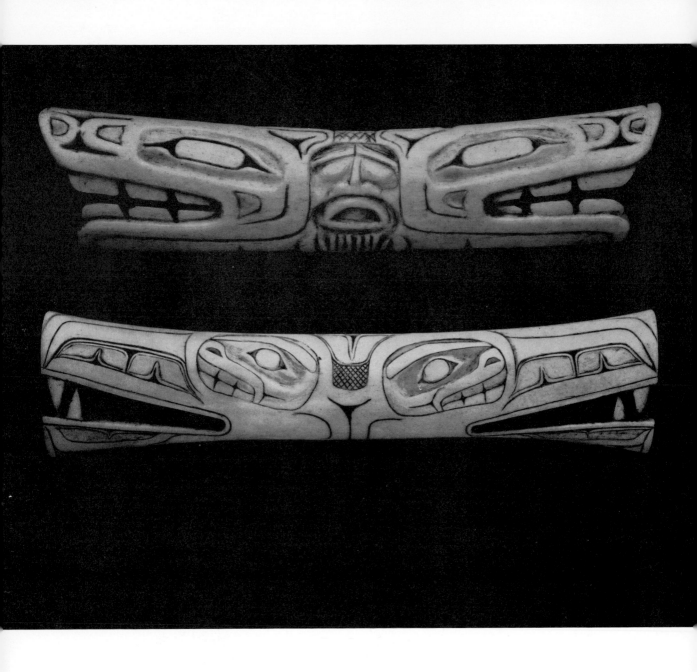

231　UPPER
Tribe: Unknown
Length: 7 in.

Location: Museum of Anthropology,
Univ. California, Berkeley
Museum Number: 2-19100

From the collection of George Davidson.
A "soul catcher," part of a shaman's paraphernalia; carved in ivory.

232　LOWER
Tribe: Unknown
Length: 8 in.

Location: Museum of Anthropology,
Univ. California, Berkeley
Museum Number: 2-19099

From the collection of George Davidson.
A Shaman's "soul catcher" carved in ivory.

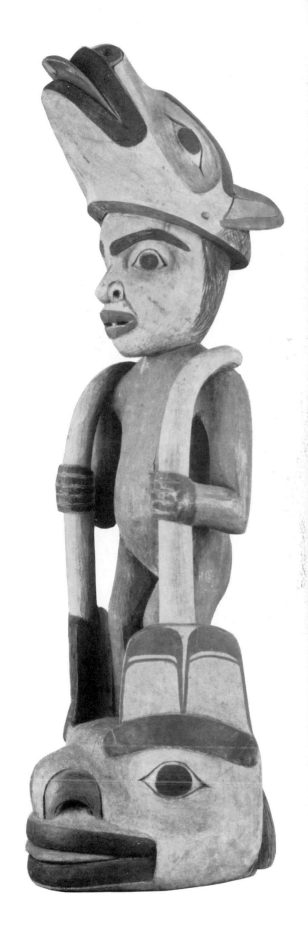

233 RIGHT
Tribe: Tlingit
Height: 18½ in.
Location: Museum of Anthropology, Univ. California, Berkeley
Museum Number: 2-4790
Photograph by Victor Duran
Collected before 1877. This carved cedar figure, painted red, blue, and black, represents a man wearing a wolf headdress and standing on a totemic head.

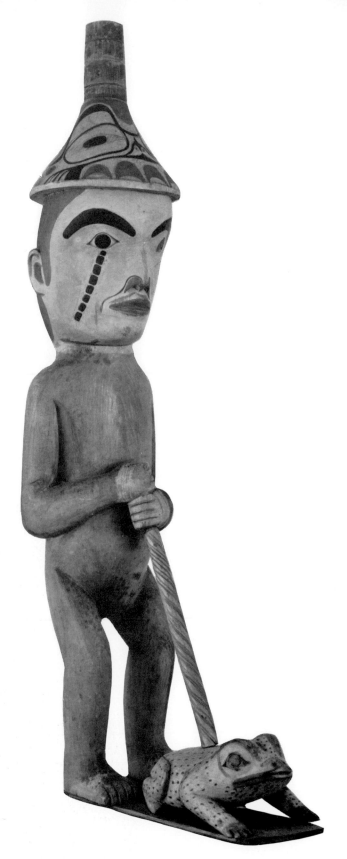

234

Tribe: Tlingit Location: Museum of Anthropology, Univ. California, Berkeley

Height: 19 in. Museum Number:

Photograph by Victor Duran.

This carved cedar figure of a man, painted red, blue, and black, wears a chief's ceremonial hat, at his feet sits a frog. The figure was collected before 1877.

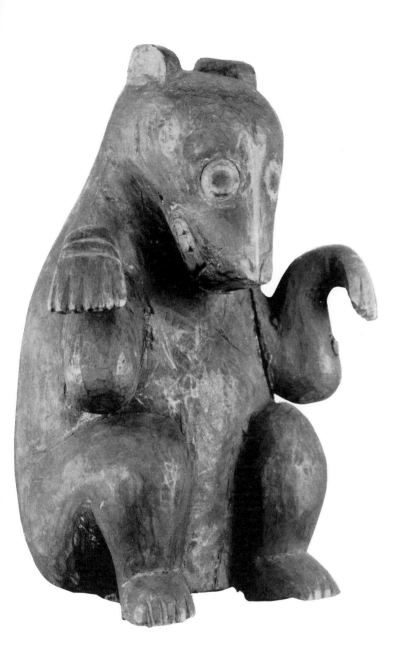

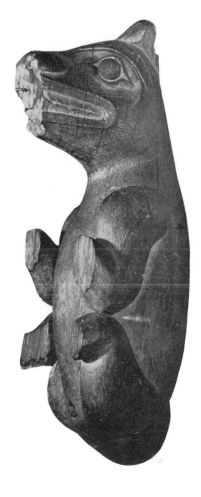

235　ABOVE
Tribe: Unknown　　Location: Museum of Anthropology,
Height 8¾ in.　　　　Univ. California, Berkeley
　　　　　　　　　Museum Number: 2-4784
Photograph by Victor Duran.
Cedar carving of a seated bear painted black and red. The
position of the legs and paws gives the animal an amusing
appearance.

236　RIGHT
Tribe: Unknown　　Location: Anthropological Museum,
Length: 20 in.　　　　Univ. British Columbia, Vancouver,
　　　　　　　　　B.C.
　　　　　　　　Museum Number: A1777, Raley Col-
　　　　　　　　lection.
This carved wooden animal comes from Skidegate, Queen
Charlotte Islands, B.C., and was presented to Dr. Raley by
a chief in 1889.

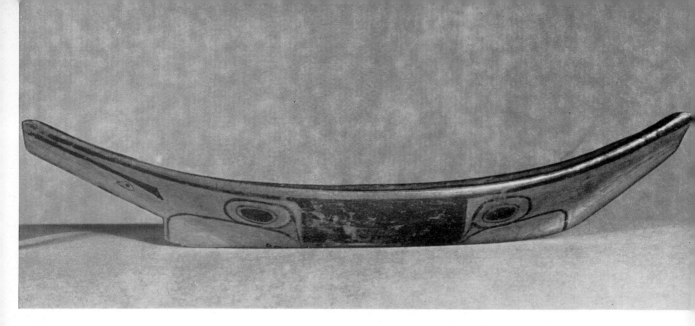

237 ABOVE
Tribe: Haida
Length: 7 in.
Width: 1⅛ in.
Depth: 1⅜ in.
Location: Washington State Museum
Museum Number: 1972
Collected by G. T. Emmons in the Queen Charlotte
 Islands, B.C.
Carved and painted cedar model of a Haida chief's
canoe. This model is included to show the beautiful
lines of the sea-going Haida canoe.

238 FACING PAGE
Photograph taken in 1912.
A large Salish canoe. The hull of this canoe meas-
ures approximately 55 feet in length, 6 feet in
depth with a 6-foot beam, and was hewn from a
single cedar log. The canoe was made to be used
on the west coast of Vancouver Island, at Clo-oose,
but the heavy wind and rip tides of the open
coast made it unmanageable and it was hauled
ashore at the outlet of Nitinat Lake.

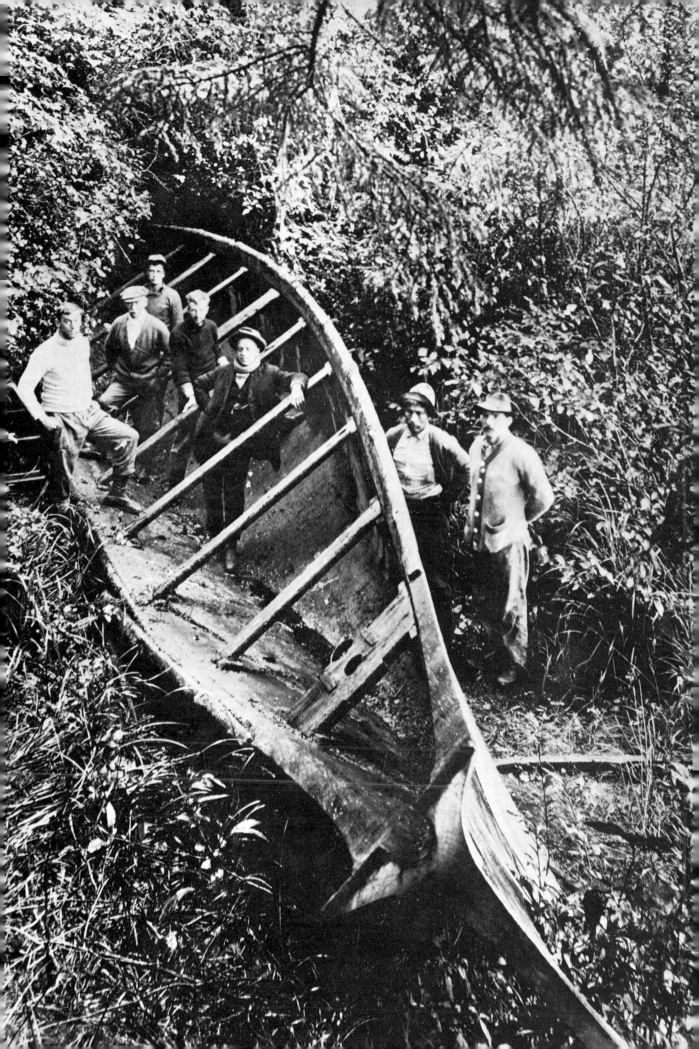

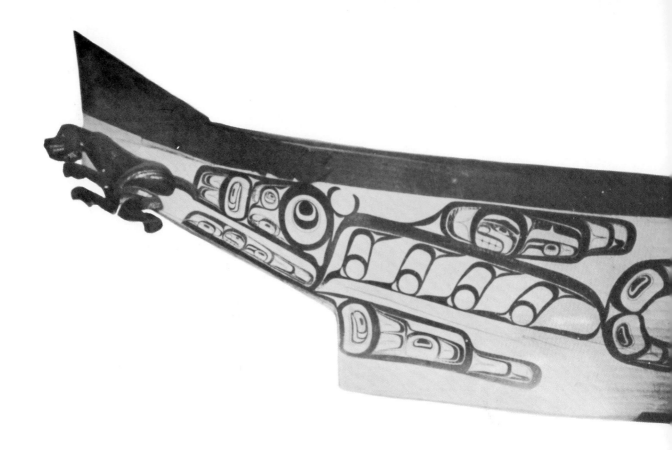

239 (TWO VIEWS)
Tribe: Kwakiutl
Location: American Museum of Natural History
Photographs, American Museum of Natural History.
Haida canoes were made more than sixty feet in length and
were highly ornamented. The bow of this large canoe has a
carved figurehead of an animal and on the sides are painted
two-dimensional designs representing the killer whale. The
stern of the canoe has a two-dimensional design which
represents the raven. The fine, regular adze marks can be
clearly seen as well as the pattern of adzing which changes
from a vertical pattern at the ends to a larger horizontal
pattern at the center. Although this canoe is the typical
Haida shape, it was made by the Kwakiutl.

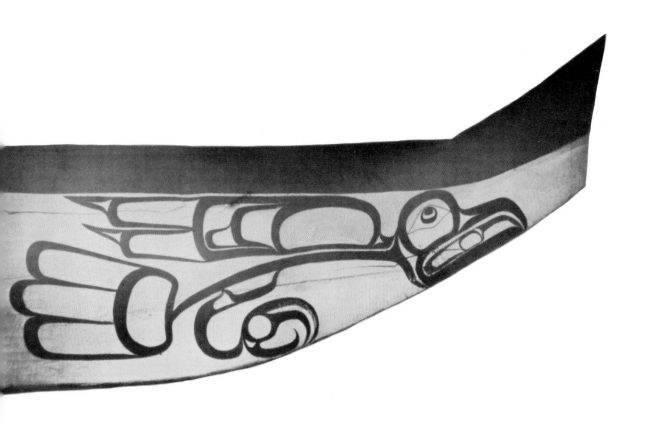

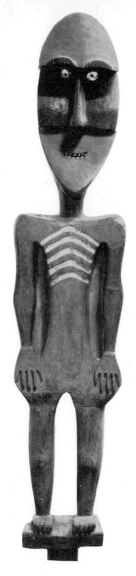

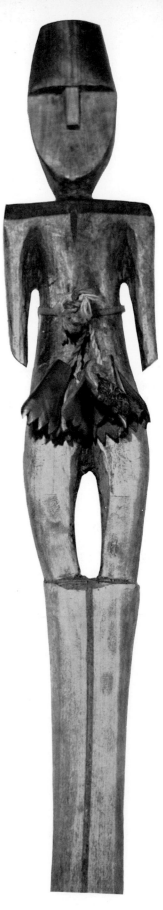

240 ABOVE

Tribe: Salish Location: American Museum of Natural History
Height: 36 in. Museum Number: 16/6946
Photograph, American Museum of Natural History.
Collected by Harlan I. Smith at Bay Center, Washington, 1899.
Carved and painted wooden figure peculiar to the Salish area. Very primitive in concept,
especially the head, note the flat knees, and the indication of the ribs. Figures of this type
were spirit figures and were used near graves or by shamans. The whole Salish art form
has differences which indicate that it is either an older or an intrusive form.

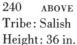

241 RIGHT

Tribe: Salish
Height: 16 in. Thickness: 1¼ in.
Width: 2¾ in. Location: R. B. Inverarity Collection
Although this object appears to be a rattle because of the deer hoofs which are loosely
attached around the middle of the figure and rattle when shaken, it represents the actual
power which the shaman uses when curing the sick. At such times the rattle is held by an
assistant and it *is* the power. The form of the rattle is peculiar to the Salish, but the
manner of carving the head is found in other figures from the Northwest Coast.

242 FACING PAGE

Tribe: Salish Location: American Museum of Natural History
Height: Approximately 9 ft.
Photograph, American Museum of Natural History.
A crudely carved grave marker from the Bella Coola area. The thighs are well modeled,
but the arms are poor. There is considerable naturalism in the position of the figure.

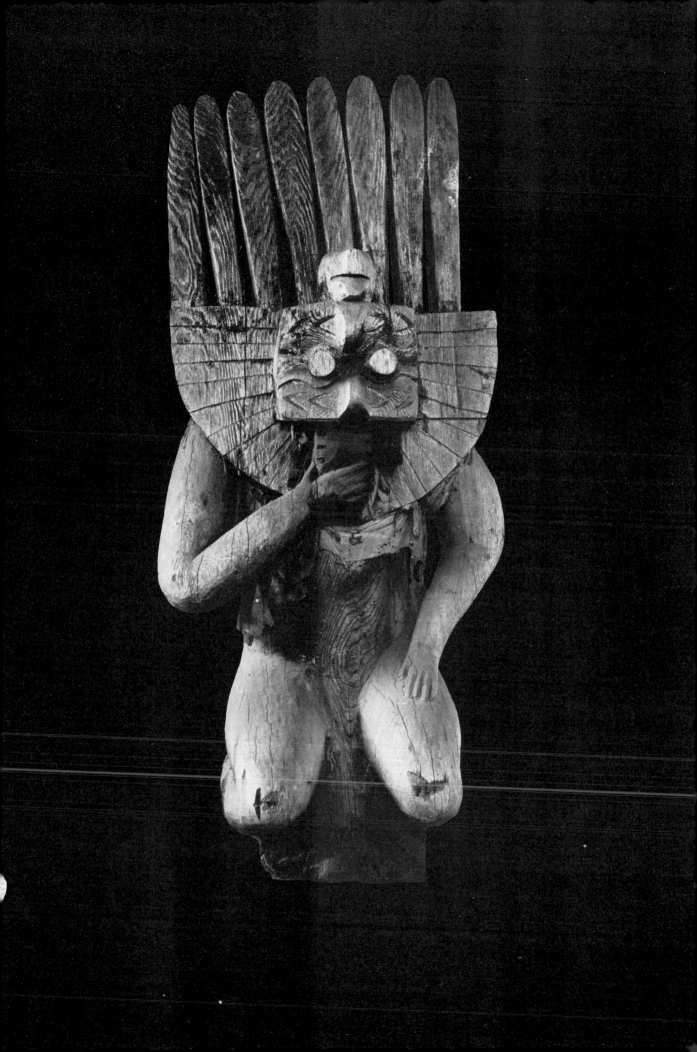

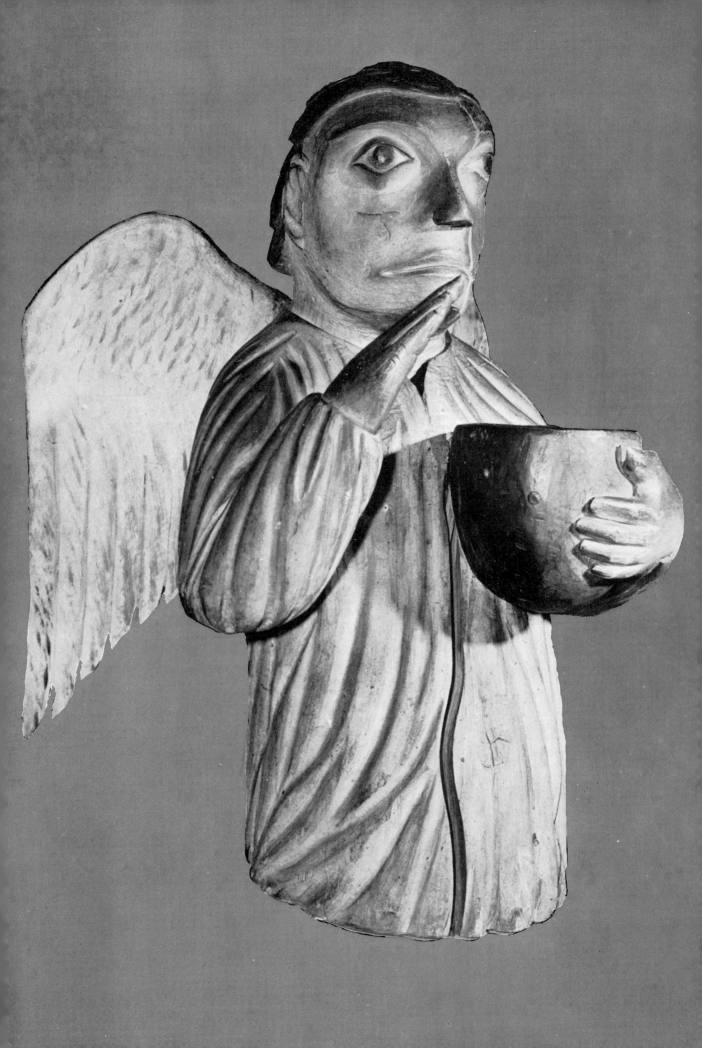

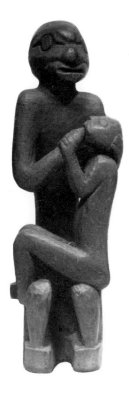

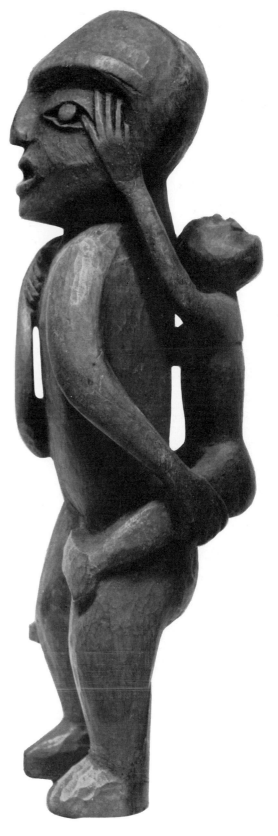

243 FACING PAGE
Tribe: Tsimshian
Height: 3 ft.
Location: Anthropological Museum, Univ. British
 Columbia, Vancouver, B.C.
Museum Number A1796, Raley Collection
Photograph, Visual Education Service, University of
 British Columbia.
This carved wooden angel was made at Port Simpson
by a Tsimshian named Freddy Alexei. It was in-
tended to be a baptismal font in the local church, but
the children were terrified by the angel and it was
removed.

244 ABOVE
245 RIGHT
Tribe: Unknown Location: British Museum
Height 245 (left) : 14¾in.; 244 (right) : 10½ in.
Copyright photographs, British Museum.
Two wooden figures which are early specimens un-
like anything else represented in this book. The free-
dom of rendering the figure is unusual. The subject
matter is uncommon, for the figures are portrayed
doing the simple things which any child or parent
might do. This type of subject matter common to all
people is not common to the general style or subject
of Northwest Coast art, except in a few slate figures.
The carving is primitive, and, except for the eyes in
both figures and the eyebrows in one, these figures
might well have come from Africa or the South
Pacific.

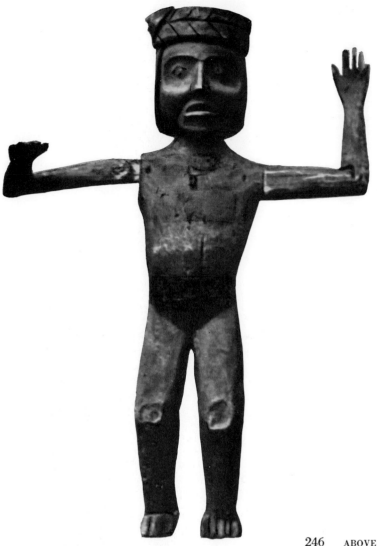

246 ABOVE

Tribe: Kwakiutl Location: Provincial Museum,
Height: 52 in. Victoria, B.C.
 Museum Number: 1851
Collected by C. F. Newcombe, 1912.
Carved wooden figure to be placed on a house at the time of
the secret society ceremonials of the Kwakiutl. The sense
of movement and attitude of speaking are well portrayed
here.

247 AND 248 FACING PAGE

Tribe: Unknown Location: Anthropological Museum,
Height: 5 ft. Univ. British Columbia, Vancou-
 ver, B.C.
 Museum Numbers: A1780 and 1781,
 Raley Collection
Photograph, Visual Education Service, University of Brit-
 ish Columbia.
Carved wooden grave figures depicting mourners in atti-
tudes of grief. These figures are from the Lower Fraser
River area.

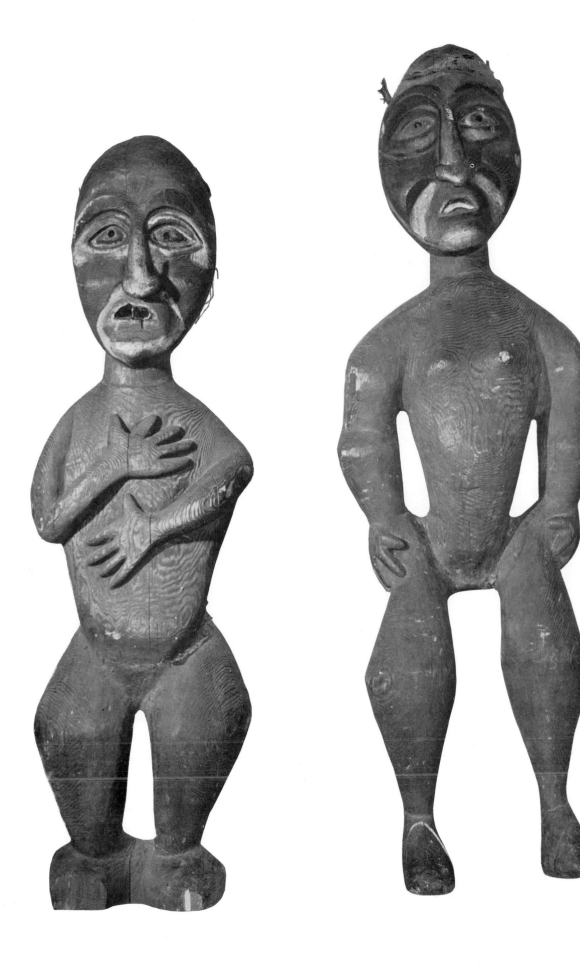

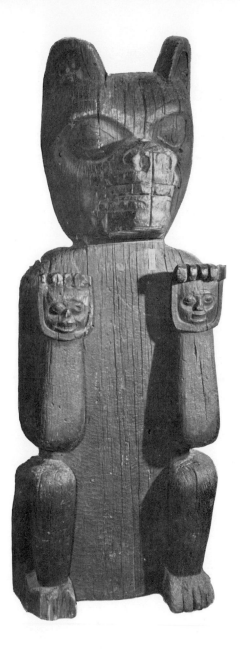

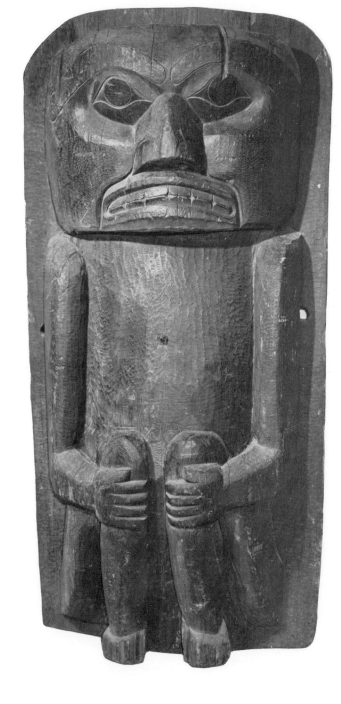

249 AND 250

Tribe: Kwakiutl

Height: 5 ft.

Location: Anthropological Museum, Univ. British Columbia, Vancouver, B.C.

Museum Number: Raley Collection

Photograph, Visual Education Service, University of British Columbia.

House posts from British Columbia.

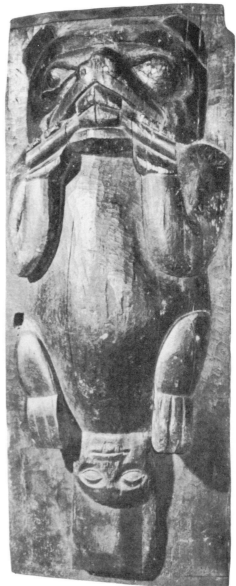

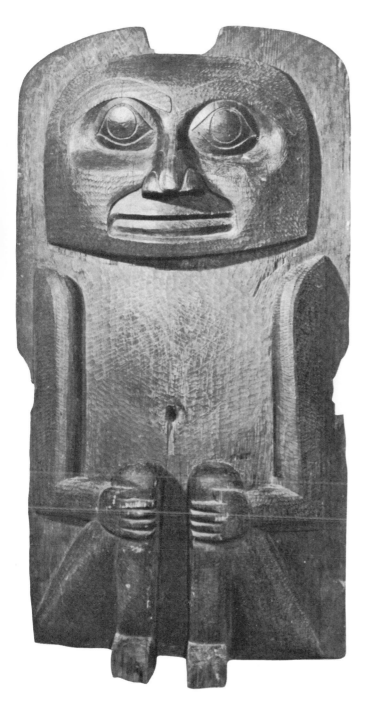

251 AND 252
Tribe: Kwakiutl
Height: 5 ft.
Location: Anthropological Museum, Univ.
Museum Numbers: 1778, 1779, Raley Collection
Photograph, Visual Education Service, University of British Columbia.
House posts from British Columbia.
The carved post on the left represents Kwatluh.

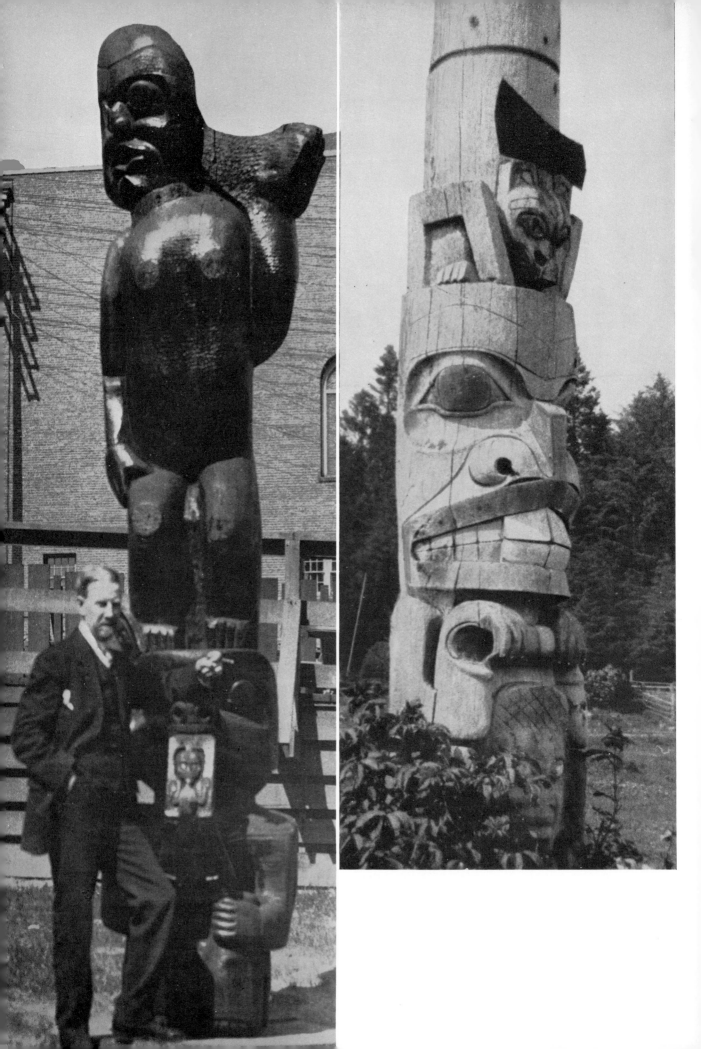

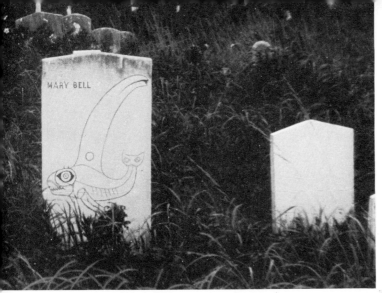

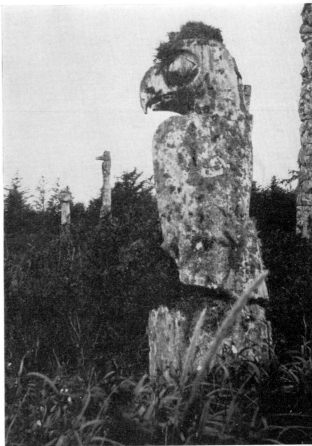

253 FACING PAGE, LEFT

This photograph of an unusual house pole was taken about forty years ago. It was probably the work of the Kwakiutl. It is included here because of the turned head of the main figure and the unusual way in which the hand supports the groove for what was one of the main roof beams of a house.

254 FACING PAGE, RIGHT

Base of a totem pole at Skidegate, Queen Charlotte Islands, B.C. The prominent teeth, forefeet clasping a stick, and the turned up cross-hatched tail indicate a beaver. Note how the copper has been attached to the pole, above the animal head.

255 UPPER

A modern grave stone which I photographed in the Queen Charlotte Islands, B.C., 1930. It is included here to show that totemic designs were being used even in the twentieth century.

256 RIGHT

Tribe: Haida

Height of bird: 5 ft.

Wooden figure of an eagle, much weathered, at Yan, Queen Charlotte Islands, B.C. Large squares of abalone shell originally studded the breast of the eagle. The significance of this free-standing post is not known; perhaps it marked the beginning of eagle territory in the village of Yan.

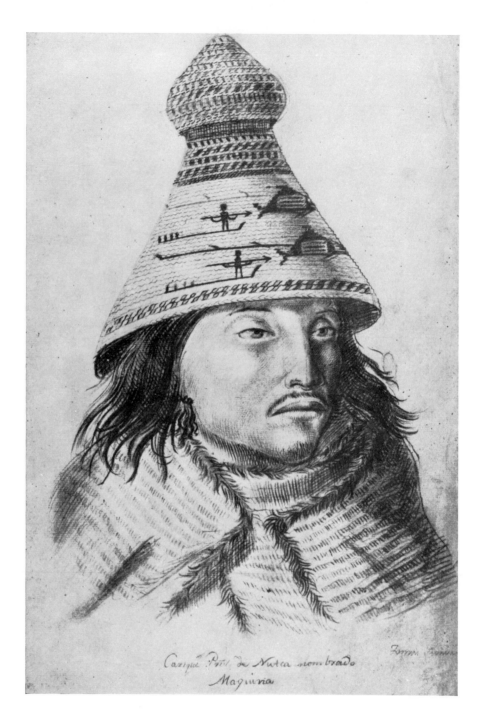

Casique Prin. de Nutca nombrado Maquina

257

A drawing by Tomas de Suría of Chief Maquina of Nootka. Suría, a painter living in Mexico, was appointed by the viceroy to accompany Alejandro Malaspina on his voyage to Northwest America. The object of this voyage, instituted by the government and conducted by a commander in the royal navy, was to discover a passage to the Atlantic described by Lorenzo Maldonado in 1588. Malaspina sailed from Acapulco in May, 1791. Tomás de Suría kept a journal of the voyage, and his sketches, of which one is reproduced here, through the courtesy of Professor Robert F. Heizer, University of California, Berkeley, and Dr. Donald Cutter, are today preserved in the Museo Naval at Madrid.

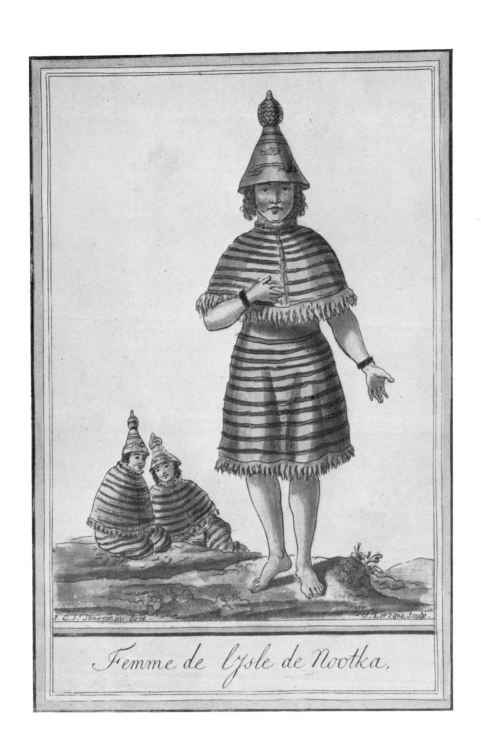

Femme de l'Isle de Nootka.

258
Reproduced from an old colored print. The print shows the
basket headdresses and costume of the women of Nootka.
Note the similarity of the headdresses here and that worn
by Chief Maquina. facing page.

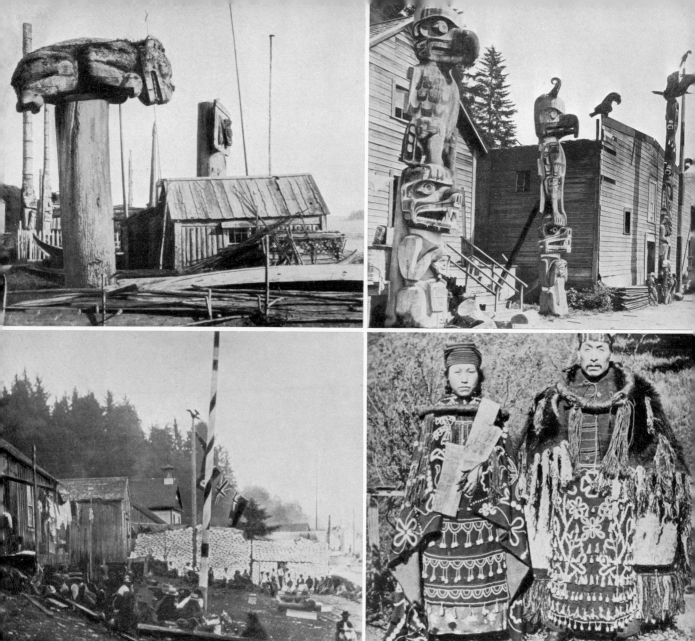

261 UPPER RIGHT
Photograph, National Development Bureau, Department of the Interior, Canada.
The Indian village at Alert Bay, British Columbia. Such a village street lined with house and totem poles was characteristic of the Northwest Coast in the last century.

262 LOWER RIGHT
Photograph, Washington State Museum.
A photograph taken at Fort Rupert, British Columbia, of Bob Harris and his wife in ceremonial costume. Harris was an expert wood carver and was taken to the World's Fair at St. Louis in 1904. The beadwork on the costumes is, of course, intrusive as are also the designs. Mrs. Harris is holding a broken copper which was broken in the prescribed fashion; three pieces having been broken off.

259 UPPER LEFT
Photograph, Washington State Museum.
Weathered poles at Masset, Queen Charlotte Islands, B.C.

260 LOWER LEFT
Photograph, Washington State Museum.
Potlatch held at Alert Bay, British Columbia, 1900. Note the large pile of goods in the middle distance to be distributed at the gathering.

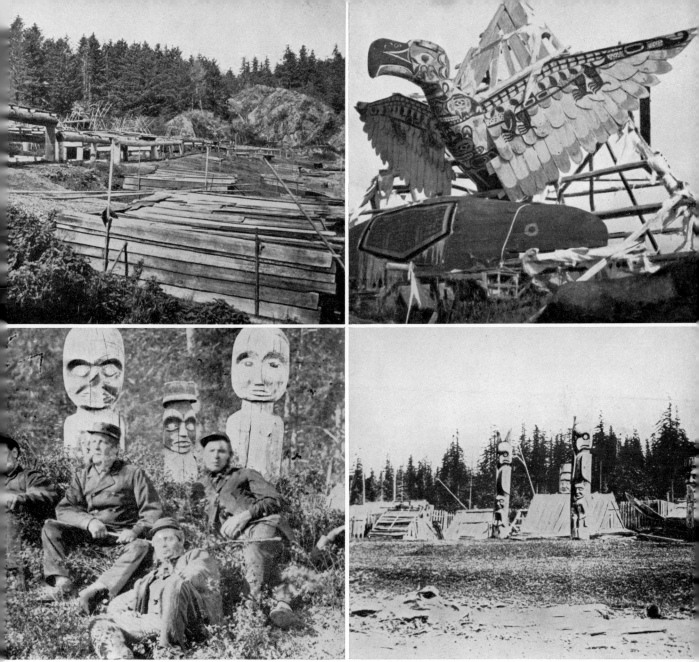

263 UPPER LEFT
Photograph, Washington State Museum.
View of Indian houses at Friendly Cove, Nootka Sound, Vancouver Island, B.C., in 1873. The pitch to the roof in these houses is very slight and they are probably like the houses described by Captain Cook at Nootka Sound in 1778—perhaps the very same. The first house has an interior carved pole.

264 LOWER LEFT
Photograph, Washington State Museum.
A photograph taken by Maynard in 1870 showing grave poles at Comox, Vancouver Island, B.C. The men lounging in front of the poles are Royal Marines.

265 UPPER RIGHT
Photograph, Washington State Museum.
Grave figures of Chief Maquina at Friendly Cove, Nootka Sound, British Columbia. Chief Maquina was either the grandson or the great grandson of the chief of the same name who held the American J. R. Jewett in captivity.

These grave figures may represent the thunderbird carrying a whale or an eagle with a whale. Note the Chilkat blanket attached to the whale and the clutter of goods in the foreground.

266 LOWER RIGHT
Photograph, Washington State Museum.
Early Maynard photograph of totem poles at Comox, Vancouver Island, B.C. Note the simple large figures erected in pairs.

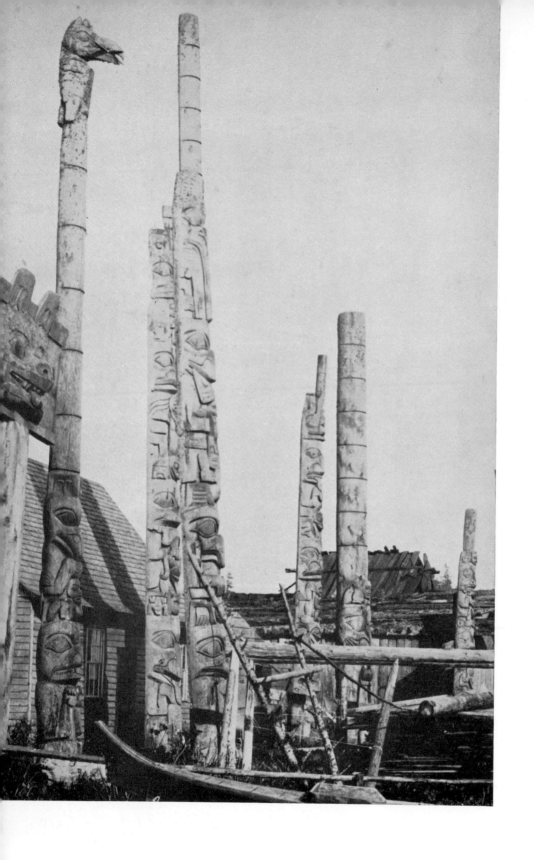

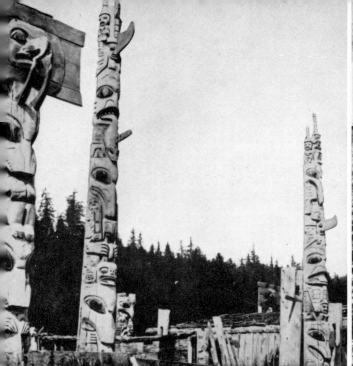

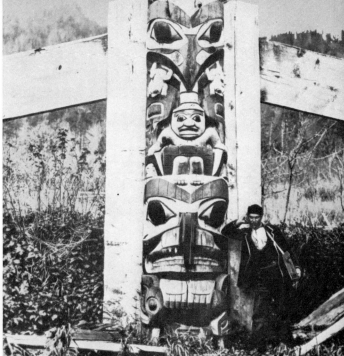

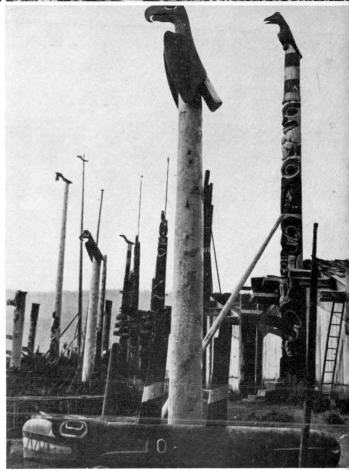

267 FACING PAGE
Photograph, W. Newcombe.
Another Maynard view of totem poles at Masset,
Queen Charlotte Islands, B.C. The circular, un-
carved section on two of the poles represents seg-
ments of a chief's hat; generally the more segments
on a hat the greater the rank of a chief.

268 UPPER LEFT
Photograph, Washington State Museum.
A photograph taken by Maynard in the 1880's at
Skidegate, Queen Charlotte Islands, B.C. The first
pole on the left is a mortuary pole; the strong
Haida carving is clearly shown in this old photo-
graph.

269 UPPER RIGHT
Photograph, Washington State Museum.
House pole at Skidegate, Queen Charlotte Islands,
B.C. This photograph was taken by Maynard in
1884. The pole is now at the Provincial Museum,
Victoria, B.C.

270 LOWER RIGHT
Photograph, Washington State Museum.
View, taken by Maynard, of the village of Heina,
New Gold Harbour, Queen Charlotte Islands, B.C.
This view shows mortuary, house, and totem poles.

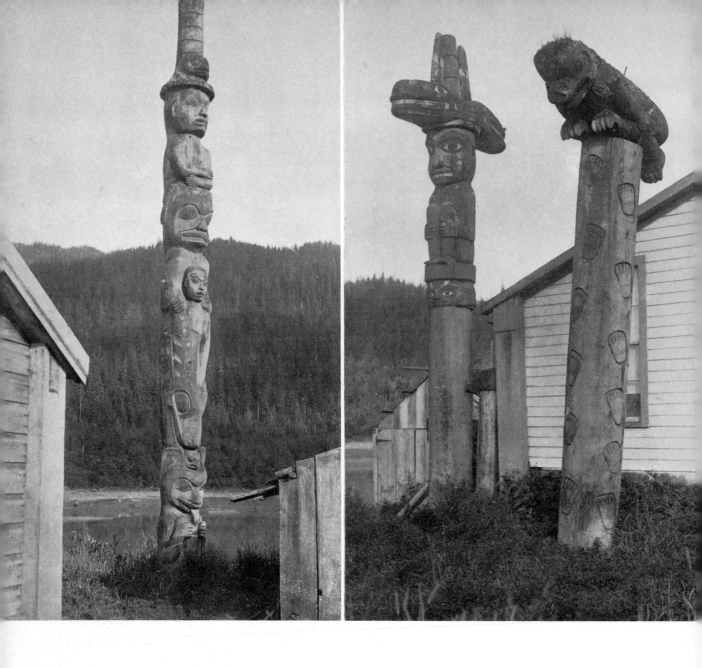

271 UPPER LEFT
Early photograph of a totem pole at Wrangell, Alaska. The top figure wears a chief's hat.

272 UPPER RIGHT
Early photograph of totem poles in front of Chief Shake's house, Wrangell, Alaska. The carved design of the bear's footprints ascending the pole on the right is highly original.

273 FACING PAGE
Photograph, Canadian National Railways.
Totem poles at the village of Kitwanga, British Columbia. The painted areas are clearly visible in this photograph. Note the second pole from the right: the fins of the sea monster are clearly shown here.

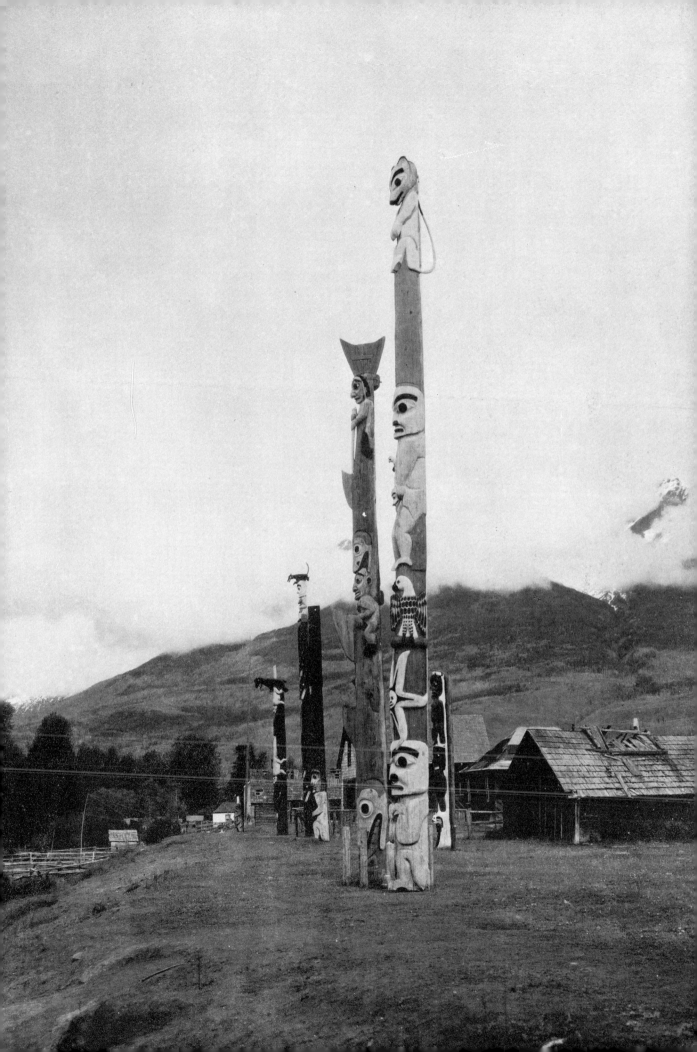

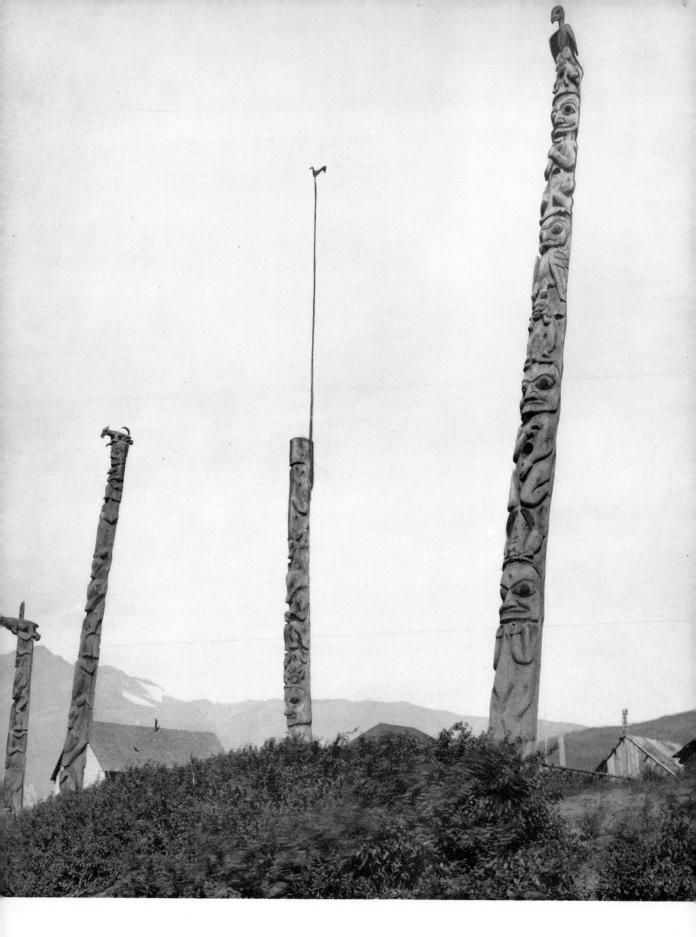

274
Photograph, Department of Mines, Geological Survey,
 Canada.
Totem poles, British Columbia. The pole on the right is a
very well-integrated design; the carving is excellent.

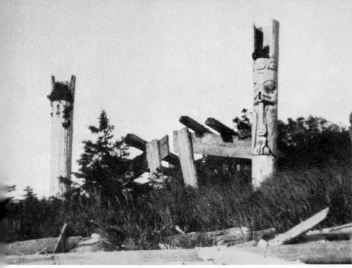

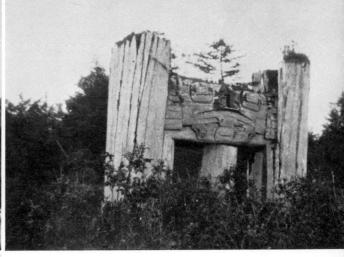

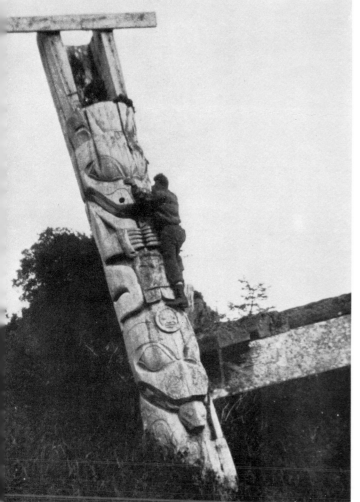

275 UPPER LEFT

View of mortuary poles and ruins of a house at Skedans, Queen Charlotte Islands, B.C. Note the fluted upper half on the left mortuary pole.

276 UPPER RIGHT

A massive mortuary chamber at the village of Yan, Queen Charlotte Islands, B.C. This structure at one time contained a burial box. Most of these mortuary structures in deserted Indian villages have been raided by fishermen and travelers in search of curios.

277 LOWER LEFT

Mortuary pole at Skedans, Queen Charlotte Islands, B.C. This photograph was taken to show the comparison between the human figure and the massiveness and simplicity of Haida carving. The opening at the top of the pole originally contained the remains of the deceased and was covered with a large panel which fitted across the opening and overhung both sides of the pole.

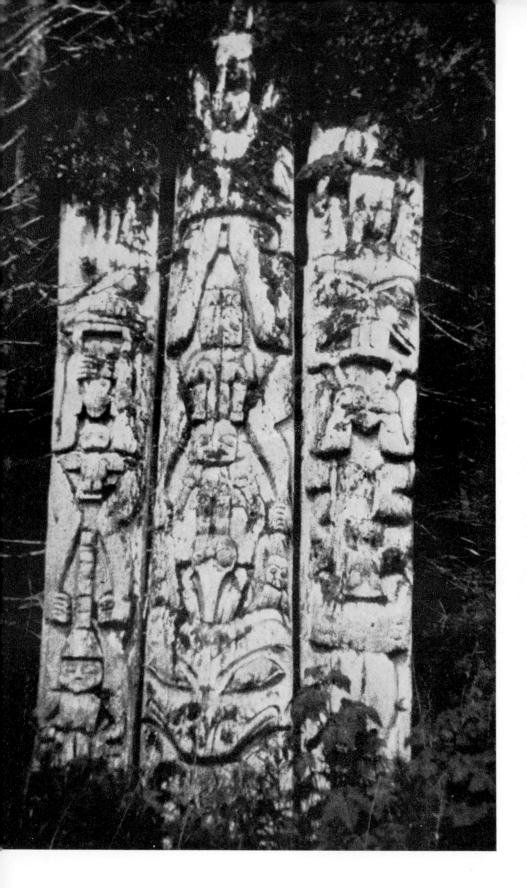

278

Mortuary poles about twelve feet high near the village of
Kiusta, Queen Charlotte Islands, B.C. These badly weath-
ered poles were three of the oldest poles still standing in
1930. Behind the poles stands a fourth, uncarved; all four
are notched out to receive a burial coffin at the top. Careful
analysis of the figures will reveal subtle differences in de-
sign from most of the more recent Haida poles.

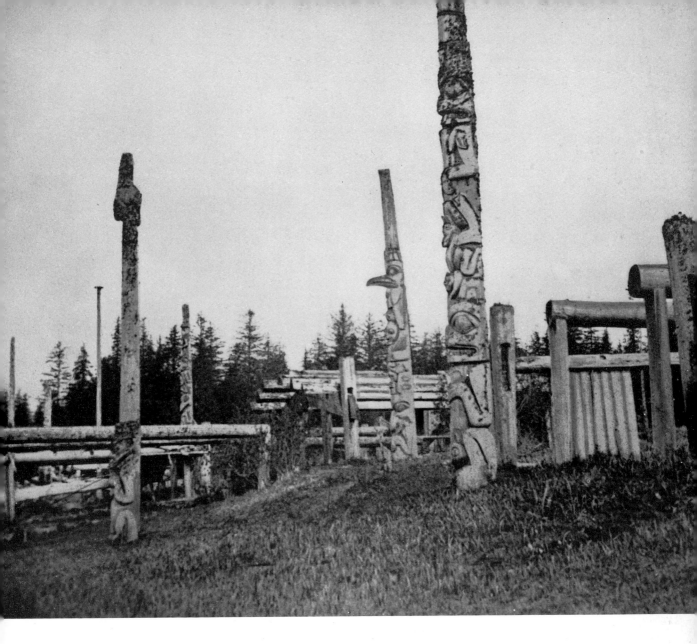

279
Photograph, Washington State Museum.
A photograph by Maynard of totem poles at Kayan, Queen
Charlotte Islands, B.C., taken in 1884.

BIBLIOGRAPHY

ABELL, W. *Representation and Form*. New York, 1946.

ADAM, LEONHARD. *Nordwestamerikanische Indianerkunst*, Orbus Pictus, Bd. 17. Berlin, 1923.

———. *Primitive Art*. London, 1940.

BAER, K. E. VON. *Statistische und Ethnographische Nachrichten über die Russischen Besitzungen und der Nordwestkuste von Amerika*. St. Petersburg, 1839.

BALCH, E. S. *Art and Man*. Philadelphia, 1918.

BARBEAU, C. MARIUS. "The Modern Growth of the Totem Pole on the Northwest Coast," International Congress of Americanists, *Proceedings*, 23rd sess., pp. 505–511. 1928.

———. "Totem Poles; A Recent Native Art of the Northwest Coast of America," Smithsonian Institution, *Report*, pp. 559–570. Washington, D.C., 1931.

———. *Totem Poles of the Gitksan, Upper Skeena River, British Columbia*, National Museum of Canada, Dept. 8 Mines, Bulletin 61, Anthropological ser. 12, Ottawa, 1929.

BARNETT, H. G. "Coast Salish of Canada," *American Anthropologist*, 40, no. 1, n.s. (1938), pp. 118–141.

BELL, CLIVE. *Art*. New York, 1928.

BENEDICT, RUTH. *Patterns of Culture*. New York, 1946.

BERG, L. *et al. The Pacific-Russian Scientific Investigations*, Academy of Sciences, Leningrad, 1926–1928.

BEST-MAUGARD, ADOLFO. *A Method for Creative Design*. New York, 1927.

BOAS, FRANZ. "Decorative Art of the Indians of the North Pacific Coast," American Museum of Natural History, *Bulletin* 9, pp. 123–176. New York, 1897.

———. *Facial Paintings of the Indians of the North Pacific Coast*, American Museum of Natural History, Memoirs, 2, pt. 1. New York, 1898.

———. *The Kwakiutl of Vancouver Island*, American Museum of Natural History, Memoirs, 8, pt. 2. Publication of the Jesup North Pacific Expedition, 5, pp. 307–516. New York, 1905–1909.

———. *Primitive Art*, Instituttet for Sammenlignende Kulturforskning, VIII, ser. B. Oslo, London, Cambridge, Mass., 1927.

———. "The Social Organization of Secret Societies of the Kwakiutl Indians," U. S. Natural Museum, *Report, 1895*, pp. 311–733. Washington, D.C., 1897.

———. "The Use of Masks and Head-ornaments on the Northwest Coast of America." *Internationales Archiv für Ethnographie*, III (1890), pp. 7–15.

BOSANQUET, BERNARD. *History of Aesthetics*. London, 1904.

BRITISH MUSEUM. *Handbook to the Ethnographical Collections*. London, 1925.

CAAMANO, JACINTO. "The Journal of Jacinto Caamaño," translated by Capt. Harold Greenfell, R.N., ed. with an introduction and notes by H. R. Wagner and W. A. Newcombe, *British Columbia History Quarterly*, VII (1939).

CARR, H. A. *Introduction to Space Perception*. New York, 1935.

CHENEY, SHELDON. *Expressionism in Art*. New York, 1934.

COOK, JAMES. *A Voyage to the Pacific Ocean*. London, 1784.

COOMARASWAMY, ANANDA. *The Transformational Nature in Art*. Cambridge, Mass., 1934.

CROCE, BENEDETTO. *Aesthetics as Science of Expression and General Linguistic*, translated by Douglas Ainslee. London, 1922.

DALTON, O. M. "Notes on an Ethnographical Collection from the West Coast of North America . . . Hawaii, and Tahiti, Formed During the Voyage of Captain Vancouver, 1790–1795," *Internationales Archiv für Ethnographie*, X (1897), pp. 225–245.

DAWSON, GEORGE MERCER. *Report on the Queen Charlotte Islands*, Geological Survey of Canada, Report on Progress, 1878–1879.

DEWEY, JOHN. *Art as Experience*. New York, 1934.

D'HARCOURT, RAOUL. *Arts de l'Amerique*. Paris, 1948.

DIXON, GEORGE. *A Voyage Round the World; But more Particularly to the North-west Coast of America*, London, 1789.

DOUGLAS, FREDERIC H. *Totem Poles*, Denver Art Museum, Leaflet 79 and 80. Denver, 1936.

DOUGLAS, FREDERIC H. and RENE D'HARNONCOURT. *Indian Art of the United States*, New York, 1941.

DOWNEY, JUNE E. *Creative Imagination*. New York, 1929.

DRUCKER, PHILIP. *Culture Element Distributions; XXV, Northwest Coast.* University of California Anthropological Records, 9:3. Berkeley, 1950.

EMMONS, GEORGE T. "Portraiture Among the North Pacific Coast Tribes," *American Anthropologist,* XVI (1914), pp. 59–67.

———. "The Art of the Northwest Coast Indians," American Museum of Natural History, *Natural History,* XXX (1930), pp. 282–292.

———. *The Basketry of the Tlingit,* American Museum of Natural History, Memoirs, 3, pt. 2, pp. 229–277. New York, 1903.

EMMONS, GEORGE T. and FRANZ BOAS. *The Chilkat Blanket, With Notes on Blanket Designs,* American Museum of Natural History, Memoirs, 3, pt. 4, pp. 329–400. New York, 1907.

FERNANDEZ, JUSTINO. *Tomás de Suría y su Viaje con Malaspina.* Mexico, 1939.

FLEURIEU, COMTE CHARLES PIERRE DE CLARET. *Voyage Autour du Monde, pendant les Années 1790, 1791, et 1792, par Etienne Marchand.* ... Paris, 1798; English edition, London, 1801.

FRAZER, SIR JAMES GEORGE. *The Golden Bough; A Study in Magic and Religion.* New York, 1907–1915.

FRY, ROGER. *Vision and Design.* London, 1920.

GARFIELD, VIOLA. *Tsimshian Clan and Society,* University of Washington, Publications in Anthropology, 7. Seattle, 1939.

GARFIELD, VIOLA and LINN A. FORREST. *The Wolf and the Raven.* Seattle, 1948.

GODDARD, PLINY EARLE. *Indians of the Northwest Coast,* American Museum of Natural History, Handbook No. 10. New York, 1934.

GOLDSCHNEIDER, LUDWIG. *Art Without Epoch.* Oxford, 1937.

GUILLAUME, PAUL and THOMAS MONRO. *Primitive Negro Sculpture.* London, 1926.

GUNTHER, ERNA. *Klallam Ethnography,* University of Washington, Publications in Anthropology, 1, no. 5. Seattle, 1927.

HADDON, A. C. *Evolution in Art; As Illustrated by the Life Histories of Design.* London, 1895.

HAEBERLIN, HERMANN K. and ERNA GUNTHER. *The Indians of Puget Sound,* University of Washington, Publications in Anthropology, 4, no. 1. Seattle, 1930.

HARDING, ANNE D. and PATRICIA BOLLING. *Bibliography of Articles and Papers on North American Indian Art,* U. S. Dept. of Interior, Indian Arts and Crafts Board. Washington, D.C., n.d.

HARRINGTON, MARK RAYMOND. "The Northwest Coast Collections of the University of Pennsylvania," *Museum Journal,* III (1912), pp. 10–15.

HARRISON, JANE. *Ancient Art and Ritual.* New York, 1935.

HILER, HILAIRE. *From Nudity to Raiment.* New York, 1930.

HILL-TOUT, CHARLES. "British Columbia Ancestors of the Eskimos," *Illustrated London News* (Jan., 1932).

HIRN, YRJO. *The Origins of Art.* London, 1900.

HODGE, FREDERIC W., ed. *Handbook of the American Indians North of Mexico,* Bureau of American Ethnology, Bulletin 30, Pts. I and II. Washington, D.C., 1907, 1910.

INVERARITY, ROBERT BRUCE. *Manual of Puppetry.* Portland, Ore., 1936.

———. *Movable Masks and Figures of the North Pacific Coast Indians,* Cranbrook Institute of Science. 1941.

———. *Northwest Coast Indian Art,* Washington State Museum, University of Washington, Museum Series, 1. Seattle, 1946.

JEANCON, JEAN A. and FREDERIC H. DOUGLAS. *Northwest Coast Indians,* Denver Art Museum, Leaflet, No. 1. Denver, 1930.

JEFFERYS, THOMAS. *Voyages from Asia to America.* London, 1761.

JENNESS, DIAMOND, ed. *The American Aborigines; Their Origin and Antiquity.* Toronto, 1933.

———. *The Indians of Canada,* National Museum of Canada, Dept. of Mines, Bulletin 65. Ottawa, 1932.

JEWETT, JOHN R. *A Narrative of the Adventures and Sufferings of John R. Jewett; only Survivor of the Crew of the Ship "Boston," during a Captivity of Nearly Three Years among the Savages of Nootka Sound; with an Account of the Manners, Mode of Living, and Religious Opinions of the Natives.* New York, 1816.

JUNG, CARL. *Psychological Types,* translated by H. Goodwin Baynes. New York, 1923.

KANE, PAUL. *Wanderings of an Artist among the Indians of Northwest America.* London, 1859.

KERMODE, FRANCIS. "Descriptive List of Northwest Collections, 1915," Provincial Museum of British Columbia, *Report for 1915.*

KOTZEBUE, OTTO VON. *A Voyage of Discovery into the South Seas and Beering's Straits . . . in the Years 1815–1818.* London, 1821.

KRAUSE, AUREL. *Die Tlinkit Indianer.* Jena, 1888.

KRIEGER, HERBERT W. "Aspects of Aboriginal Decorative Art in America, Based on Specimens in the U. S. National Museum," Smithsonian Institution, *Report, 1930,* pp. 519–556. Washington, D.C., 1930.

———. *Smithsonian Explorations 1926: Archaeological and Ethnological Studies in Southeast Alaska.* Smithsonian Institution Miscellaneous Collections, 78, No. 7. Washington, D.C., 1927.

KROEBER, ALFRED L. "American Culture and the Northwest Coast," *American Anthropologist,* XXV (1923), pp. 1–20.

———. *Anthropology.* New York, 1923.

———. "Primitive Art," *Encyclopaedia of the Social Sciences.* New York, 1935.

KROEBER, ALFRED L. and T. T. WATERMAN. *Source Book in Anthropology.* Berkeley, 1920.

LAGUNA, FREDERICA DE. *The Archeology of Cook Inlet, Alaska.* Philadelphia, 1934.

LANGSDORFF, GEORGE HEINRICH VON. *Voyages and Travels in Various Parts of the World.* London, 1813–1814.

LA PEROUSE, JEAN FRANÇOIS GALAUP DE. *A Voyage Around the World, Performed in the Years 1785, 1786, 1787, and 1788.* London, 1798.

LEVY-BRUHL, LUCIAN. *How Natives Think.* New York, 1926.

LISIANSKY, UREY FEDEROVICH. *A Voyage round the World, in the Years 1803, 4, 5 & 6. . . .* London, 1814.

LISTOWEL, WILLIAM FRANCIS HARE, EARL OF. *A Critical History of Modern Aesthetics.* London, 1933.

LUGUET, G. H. *The Art and Religion of Fossil Man,* translated by J. Townsend Russell. New Haven, 1930.

MACFIE, MATTHEW. *Vancouver Island and British Columbia.* London, 1865.

MACKENZIE, ALEXANDER. "Descriptive Notes on Certain Implements, Weapons, etc., from Graham Island, Queen Charlotte Islands, B. C.," Royal Society of Canada, *Proceedings and Transactions,* 9, ser. 2., pp. 45–59. 1891.

McMAHON, A. PHILLIP. *The Meaning of Art.* New York, 1930.

MAYNE, R. C. *Four Years in British Columbia and Vancouver Island.* London, 1862.

MALINOWSKI, BRONISLAW. "Culture," *Encyclopaedia of the Social Sciences.* New York, 1931.

MARCHAND, ETIENNE. See FLEURIEU.

MEARES, JOHN. *Voyages Made in the Years 1788 and 1789 from China to the Northwest Coast of America* . . . London, 1790.

MENZIES, T. P. O. *Haida Indian Carving,* Art, Historical & Scientific Association of Vancouver, B. C., Museum Notes, 2, no. 1. Vancouver, 1927.

MORRIS, E. G. *100,000 Years of Art.* Boston, 1930.

MOURELLE, FRANCISCO ANTONIO. "Journal of a Voyage in 1775. To Explore the Coast of America Northward & California . . ." in *Miscellanies of the Honorable Daines Barrington.* London, 1781.

MULLER, K. O. *Ancient Art and Its Remains,* translated by F. G. Walker. London, 1850.

MUNRO, THOMAS. *Scientific Method in Aesthetics.* New York, 1928.

NEWCOMBE, C. F. *Guide to Anthropological Collections in the Provincial Museum, Victoria, B. C.* Victoria, 1909.

———. "Report on a Trip to the Northwest Coast for 1913, with a List of the Specimens Collected, "Provincial Museum of British Columbia, *Report, 1913.* Victoria, 1913.

NEWCOMBE, W. A. "Archaeology," Provincial Museum of British Columbia, *Report, 1930.* Victoria, 1930.

NEWCOMBE, W. A., and J. A. TEIT. "List of Illustrations of Specimens of Northwest Coast," Provincial Museum of British Columbia, *Report, 1914.*

NIBLACK, ALBERT P. "The Coast Indians of Southern Alaska and Northern British Columbia," U. S. National Museum, *Report 1888.* Washington, D. C., 1888.

OGDEN, C. K., I. A. RICHARDS, and JAMES WOOD. *The Foundations of Aesthetics.* London, 1925.

OGDEN, R. M. *The Psychology of Art.* New York, 1938.

OLSON, RONALD L. *Adze, Canoe, and House Types of the Northwest Coast,* University of Washington, Publications in Anthropology, 2. Seattle, 1927.

———. "The Indians of the Northwest Coast, "American Museum of Natural History, *Natural History,* 35 (1935), pp. 183–197.

———. The Quinalt Indians, University of Washington, Publications in Anthropology, 6, no. 1. Seattle, 1936.

PIJOAN, JOSE. *Summa Artis,* Vol. I. Madrid, 1944.

POOLE, FRANCIS. *Queen Charlotte Island.* London, 1872.

PRALL, D. *Aesthetic Analysis*. New York, 1929.

———. *Aesthetic Judgment*. New York, 1929.

RADER, MELVIN M., ed. *A Modern Book of Esthetics*. New York, 1935.

RANK, OTTO. *Art and Artist: Creative Urge and Personality Development,* translated by Charles F. Atkinson. New York, 1932.

READE, CHARLES. H. "An Account of a Collection of Ethnographical Specimens Formed During Vancouver's Voyage in the Pacific Ocean," Royal Anthropological Institute, *Journal,* 21, o.s. (1891), pp. 99–108.

READ, HERBERT E. *Art and Industry*. New York, 1936.

REINACH, SOLOMON *Cultes, Mythes, et Religions*. Paris, 1905.

SAPIR, EDWARD. "Sayach'apis, A Nootka Trader," in E. C. Parsons, ed., *American Indian Life*, pp. 297–323. New York, 1922.

SANTAYANA, GEORGE. *The Sense of Beauty*. New York, 1896.

SCHNEIDER, ELIZABETH. *Aesthetic Motive*. New York, 1939.

SHOTRIDGE, LOUIS and FLORENCE. "The Indians of the Northwest," University of Pennsylvania, *Museum Journal,* 4 (1913), pp. 71–99.

SHOTRIDGE, LOUIS. "War Helmets and Clan Hats of the Tlingit Indians," University of Pennsylvania, *Museum Journal,* 10 (1919), 49–67; 117–148.

SLOAN, J. and OLIVER LA FARGE, eds. *Introduction to American Indian Art,* Exposition of Tribal Arts, Part 5. New York, 1931.

STITES, RAYMOND S. *The Arts and Man*. New York, 1940.

SWAN, JAMES G. *The Haidah Indians of Queen Charlotte's Island*. Smithsonian Contributions to Knowledge, 21, art. 4. Washington, D.C., 1876.

———. *The Indians of Cape Flattery,* Smithsonian Contributions to Knowledge, 16, art. 8. Washington, D.C., 1870.

SWANTON, JOHN R. *Contributions to the Ethnology of the Haida,* American Museum of Natural History, Memoirs, 8, pt. 1, Publications of the Jesup North Pacific Expedition, 5. New York, 1905.

———. *The Haida of Queen Charlotte Islands,* American Museum of Natural History, Memoirs, 5, pt. 1, Publications of the Jesup North Pacific Expedition, 5. New York, 1905.

SYDOW, ECKART VON. *Die Kunst der Naturvolker und der Vorzeit*. Berlin, 1923.

TEIT, JAMES A., H. K. HAEBERLIN, and H. ROBERTS. "Coiled Basketry in British Columbia and Surrounding Regions," Bureau of American Ethnology, *Report,* 41, pp. 119–484. Washington, D.C., 1924.

THURSTONE, L. L. *Primary Mental Abilities*. Chicago, 1938.

THRUSTON, CARL and PHILANDER HAMMOND. *The Structure of Art*. Chicago, 1940.

VAILLANT, GEORGE C. *Indian Arts in North America*. New York, 1939.

VANCOUVER, CAPTAIN GEORGE. *A Voyage of Discovery to the North Pacific Ocean and Round the World . . . in the Years 1790, 1791, 1792, 1793, 1794, and 1795 . . .* London, 1798.

WAGNER, HENRY R. *Cartography of the Northwest Coast of America to the Year 1800*. Berkeley, 1937.

242

———., ed. "Journal of Tomás de Suría of His Voyage with Malaspina to the Northwest Coast of America edited & translated by ..." *Pacific Historical Review*, V (Sept., 1936), pp. 234–276.

WATERMAN, T. T. "Some Conundrums in Northwest Coast Art," *American Anthropologist*, 25 (1923), pp. 435–451.

———. *The Whaling Equipment of the Makah Indians*, University of Washington, Publications in Anthropology, 1. Seattle, 1920.

WATERMAN, T. T. and G. COFFIN. *Types of Canoes on Puget Sound*, Museum of the American Indian, Heye Foundation, Indian Notes and Monographs, Misc. 5. New York, 1920.

WOELFFLIN, HEINRICH. *Principles of Art History*, translated by M. D. Holtinger. New York, 1932.

WOLDT, A. *Capitain Jacobsens Reise an der Nordwestküste Americas, 1881–1883*. Leipzig, 1884.